CAPTURING
SPACE

CAPTURING
SPACE

DRAMATIC IDEAS FOR RENOVATING YOUR HOME

Edited by Marta Serrats

HDi

**HARPER
DESIGN
international**

An Imprint of HarperCollins*Publishers*

Editor and Texts
Marta Serrats

Editor in Chief
Haike Falkenberg

Translation
Michael Brunelle

Design
Argüelles Gutiérrez Disseny

Layout
David Maynar, Mar Nieto

Editorial Project
Bookslab, S.L.
publishing@bookslab.net

First published in 2004 by:
Harper Design International, an imprint of HarperCollins Publishers
10 East 53rd Street
New York, NY 10022

Distributed throughout the world by:
HarperCollins International
10 East 53rd Street
New York, NY 10022
Tel.: (212) 207-7000
Fax: (212) 207-7654
www.harpercollins.com

HarperCollins books may be purchased for educational, business, or sales promotional use. For information, please write: Special Markets Department, HarperCollins Publishers Inc., 10 East 53rd Street, New York, NY 10022

Library of Congress Cataloging-in-Publication Data

Serrats, Marta.
 Capturing space: dramatic ideas for reshaping your home / Marta Serrats.
 p. cm.
 ISBN 0-06-058911-6
1. Interior architecture. 2. Room layout (Dwellings) I. Title.
 NA2850.S46 2004
 729--dc22

 2004000367

Printed by Viking. Barcelona, Spain.
DL: B-21.170-2004

First Printing, 2004

contents

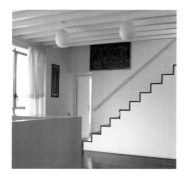

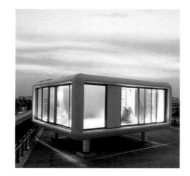

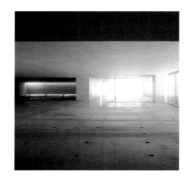

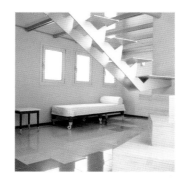

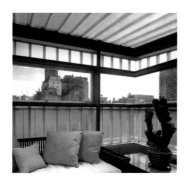

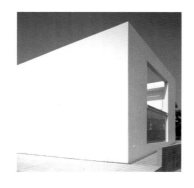

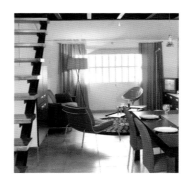

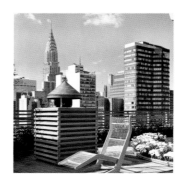

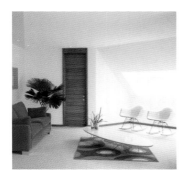
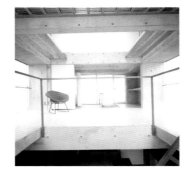
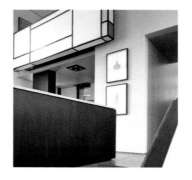
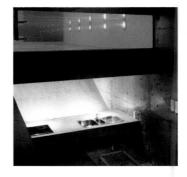
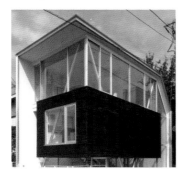
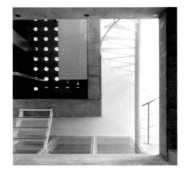
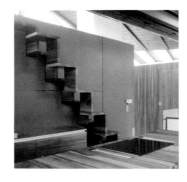
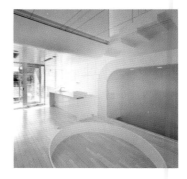
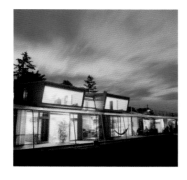
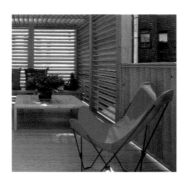
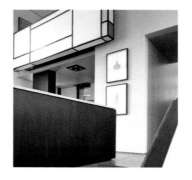
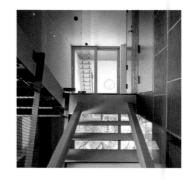
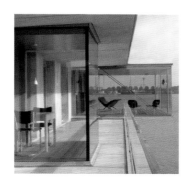
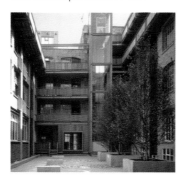
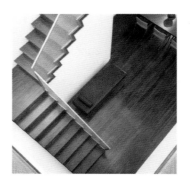

Introduction

The future has arrived, but not as many of us had expected. Utopian visions of the twenty-first century predicted an unattainable reality with flying cars and smart skyscrapers built of the fragments of conquered metropolises. Yet some details of current designs, driven by the functional changes of houses and the new demands of clients, show the first signs of this kind of progress and begin to approach the architectural postulates of such greats as Le Corbusier, who defined the house of the future as "a machine to live in."

The only thing that is clear is that every aesthetic is an old aesthetic. Contemporary trends repeat the known paradigms, following the same rational design principle that gives precedence to quality and spatial expressivity. Interiors are sold to increase inhabitable space. This does little to facilitate the generation of spaces with character inside the dwelling itself.

Rooms distributed on two levels, attics that reach as high as they can to capture light, garrets that adapt themselves to the irregular structure of the roof in quest of unique interiors, even flying buildings that offer to take us one step further toward the mobile home of the future ... these are only some of the examples inside the book you are holding. They are a reflection of the microurbanism of the interior, of how design has the capability to mold space into a personalized, functional, and aesthetically pleasing interior.

High living has long meant living in heaven. These new structures restate the canons of Gothic architecture, which conceived buildings as svelte spires surging skyward to bring us close to the maximum and the supreme, an omnipresent God. While some of the new, urbanistic plans stubbornly insist on believing the opposite, they still invite us to live better in direct proportion to how high we live. Through the centuries, the human ego has confirmed the belief that the higher we are, the more superior we feel toward the rest of mortals. The current example is the new cosmopolitanism; in cities where anonymous individuals live a stressed existence among the streets, large office buildings go up around them, with the best offices on the highest floors as a symbol of nearly unattainable status, leaving the chaos of the city below. And it is true that high living becomes an ideal refuge in which to experience the best qualities of the city. The interior opens out onto plays of light that fall directly from the highest points. Meanwhile, the exterior is composed of terraces, roofs, and rooftop gardens, offering us a calm, peaceful vision of the crowded city.

Capturing Space is a collection of the finest projects whose aims, in such high work, accentuate architectural character. Attics, one-family units, duplexes, and converted lofts all have their place in this book. The blend shows a wide array of new urban dwellings by architects of international renown, whose projects mark a change in the concept of traditional homes.

It could happen that, as predicted some time ago, cities will be like burnt forests. Meanwhile, we might do well to listen to Werner Aisslinger—architect of the Loftcube project shown in these pages and winner of Berlin's first design festival, DesignMai—in his prediction that the day will come when we can exploit the plane surfaces of roofs and turn them into urban lots to build on and commercialize. When cars fly, will our garages be in our attics?

PENTHOUSE IN PARIS

Several apartments once occupied the top floor of this building in Paris, which was converted into a 1500-square-foot loft. Located directly under the roof, it creates a play of volumes with the terrace roof that keeps the interior illuminated. The architects took advantage of this feature by preserving the original framework of the ceiling, in which the old system of beams is still visible, with various skylights allowing the midday sun to enter directly. The ceiling was painted white, completely covering the original color of the wood beams to maximize the light projected into the interior.

The essence of Paris can easily be enjoyed from this penthouse, thanks to the stairs designed by the architects. They go up one more level in the interior of this apartment to the top of the building, where the best views of the City of Light are available.

The original structure of the terrace roof permitted the consolidation of a space without enclosures, where the flow between the different daytime areas, the kitchen, dining room, living room, and the studio, is obvious and dynamic. The separation between them is defined by the fireplace. The team of architects took this key detail into account and created a dividing wall that is functional as well as aesthetic. The interior was conceived as a single open space where the elements take advantage of the ideal lighting to stand out in this bright and spacious environment.

ARCHITECT: **Littow Architectes**
PHOTOGRAPHER: **Littow Architectes**

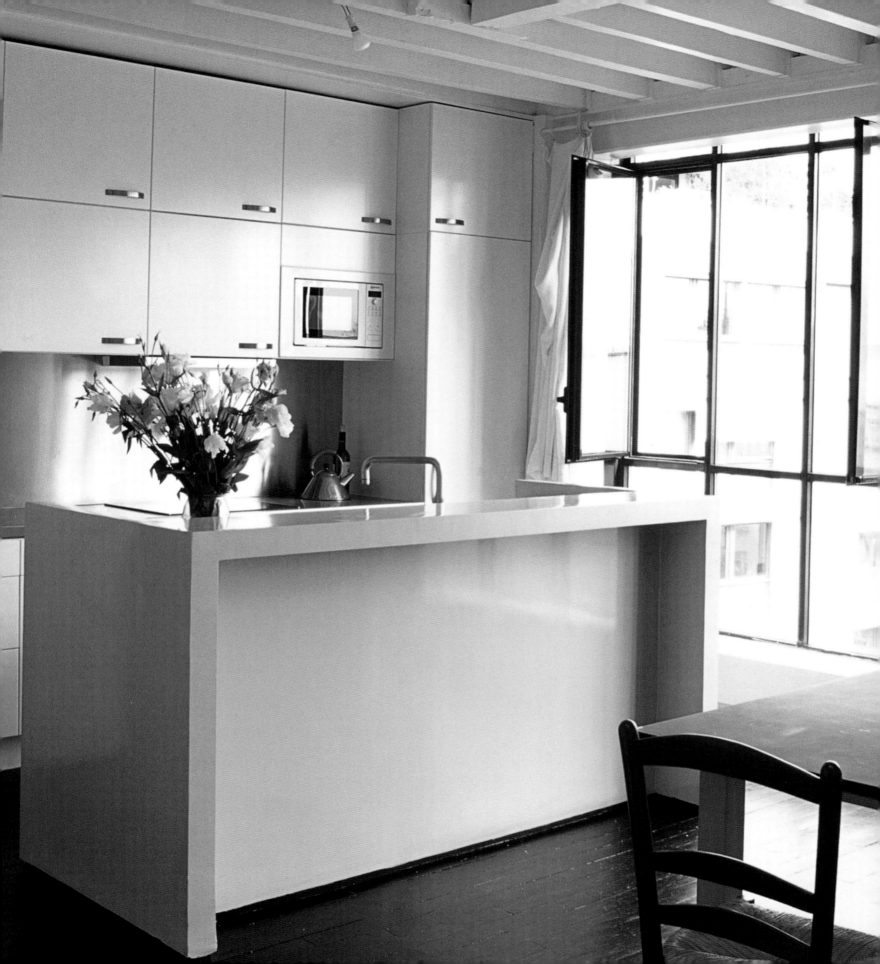

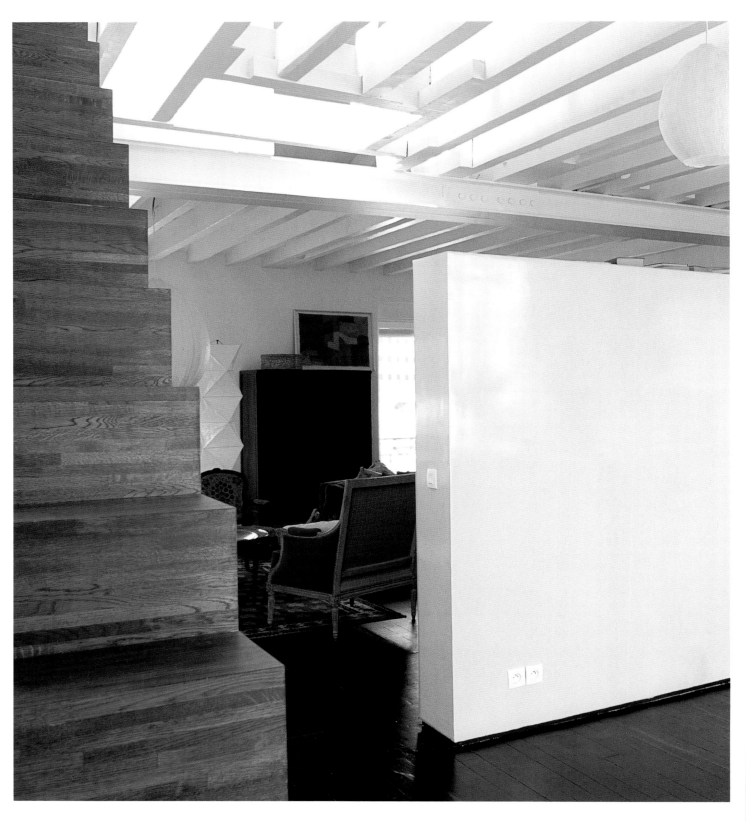

The penthouse roof was preserved, along with its remarkable system of original beams.
The skylights allow the midday sun into the interior.

The interplay of the roof structure and the shape of the terrace roof allow light to shine through and make the interior space seem larger.

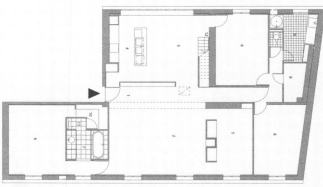

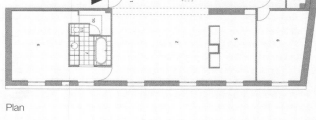

Plan

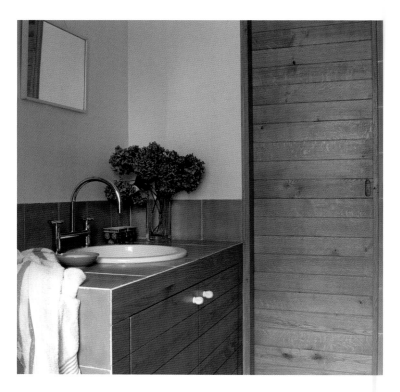

The architect designed the stairs that lead to the building's terrace roof, where the best views of the city can be enjoyed.

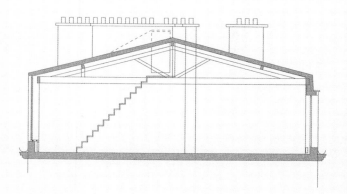

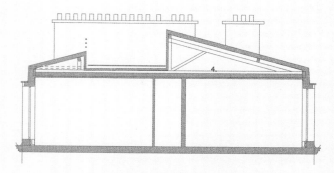

Sections

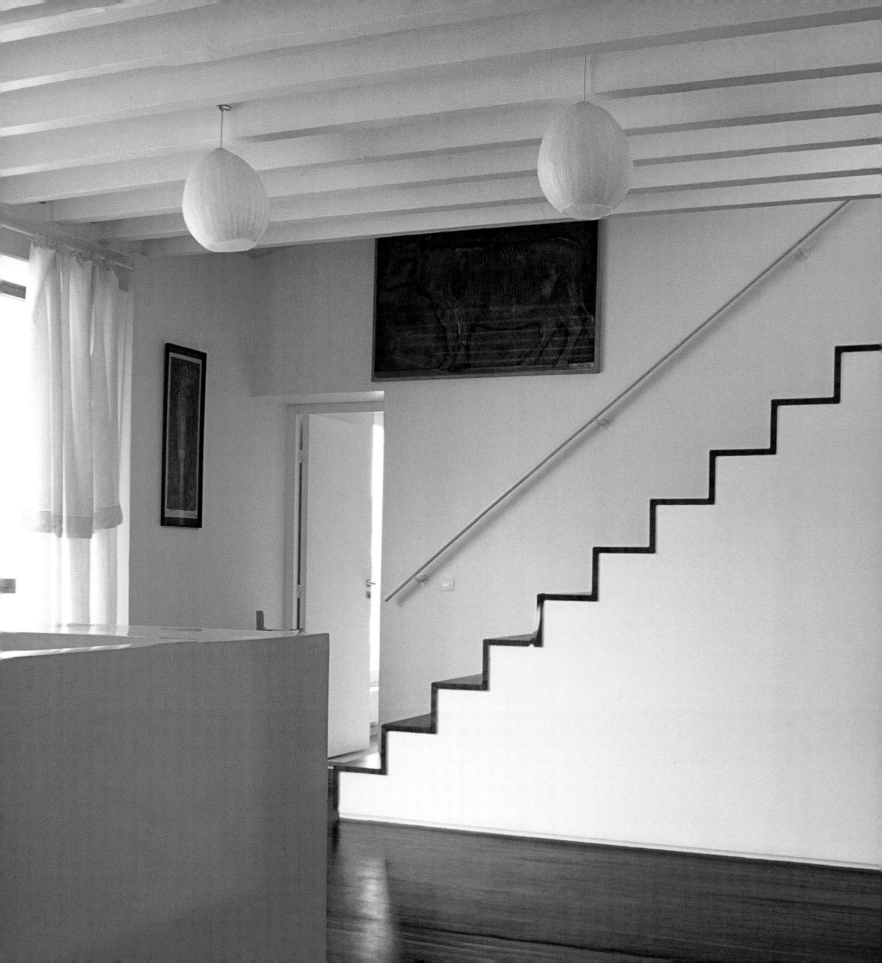

LOFTCUBE

Loftcube was one of the most daring and attractive entries in the first DesignMai festival of design in Berlin. Located on the roof of a refrigerated warehouse, next to the Spree River in Berlin, it has become a prototype for the nomadic population that would live in a mobile unit by choice. The architects only needed to look at the architecture of previously erected buildings to see that rooftops, which are usually wasted urban spaces, could be used and commercialized, and often could be turned into sunny oases in the centers of urban areas.

These dwellings are a feasible proposal for the future, completely viable for the sectors of the population whose lives are a continuous pilgrimage from one populated city to another. The architects deal with issues like transportation, the installation of railings, and access to utilities so that the cubes can easily be put into use.

The 430-square-foot interior is designed for living and working in surroundings that are adaptable to the requirements of the owner, who may choose the color, the material, and the wind-resistant surfaces. It is even possible to adjust the amount of light that enters the unit and to choose the option of opening or closing the skylight. A wide range of materials, like Corian, Zodiaq, and Antron by DuPont has been used in this project and for the portable furniture systems, called Case and Cube, which were designed by Interlübke.

ARCHITECT: **Studio Aisslinger**
PHOTOGRAPHER: **Steffen Jänicke**

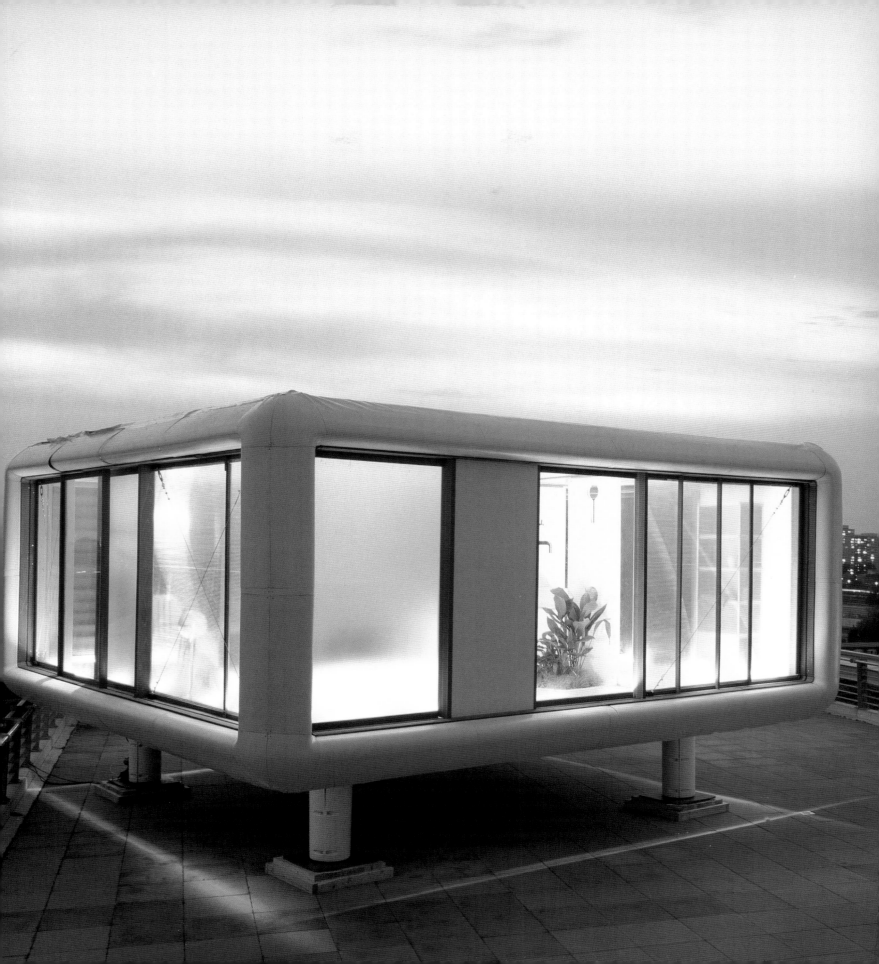

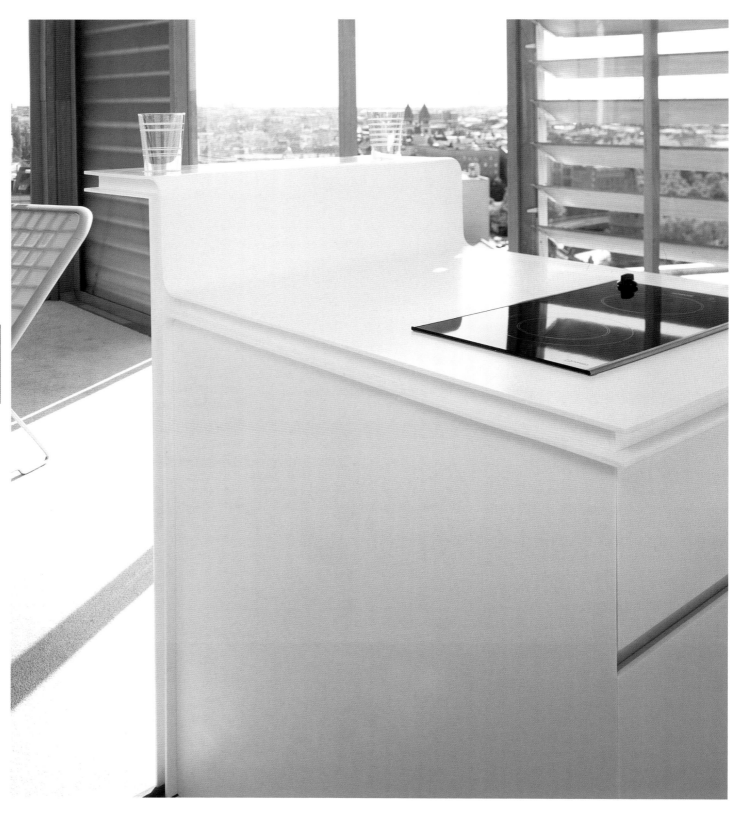

This mobile unit contains compact elements, like a kitchen that adds a futuristic flair to the new temporary dwelling.

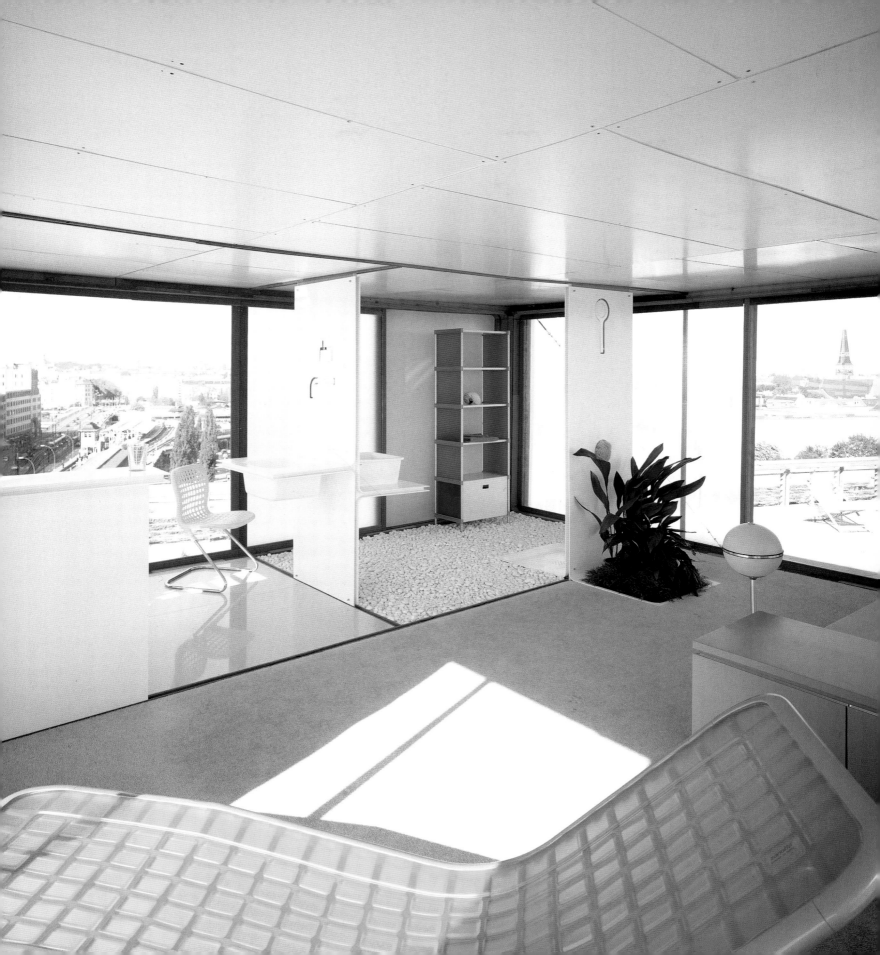

Materials like Corian, Zodiaq, and Antron by DuPont have been used for the Loftcube, as well as for the portable furniture designed by Interlübke.

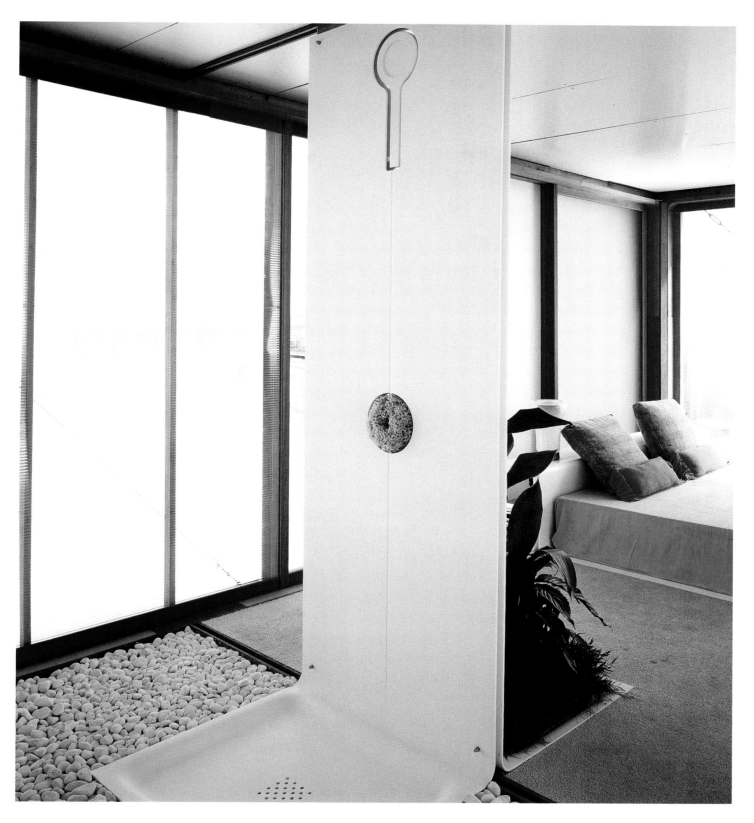

Although installing the portable housing units on rooftops may pose problems, Loftcube's thoughtful design resolves the issues of transportation, installation, and connecting to utilities.

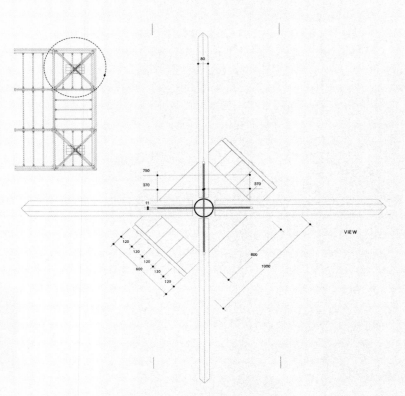

Structure detail

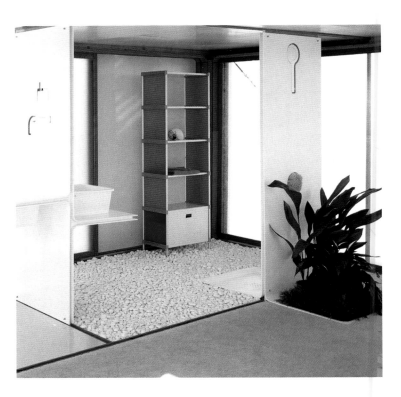

Urban living on a small scale promotes the design of practical spaces
that adapt more and more to the lifestyle of a nomadic society.

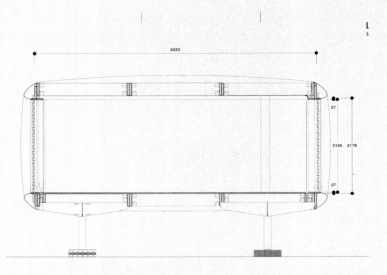

Section

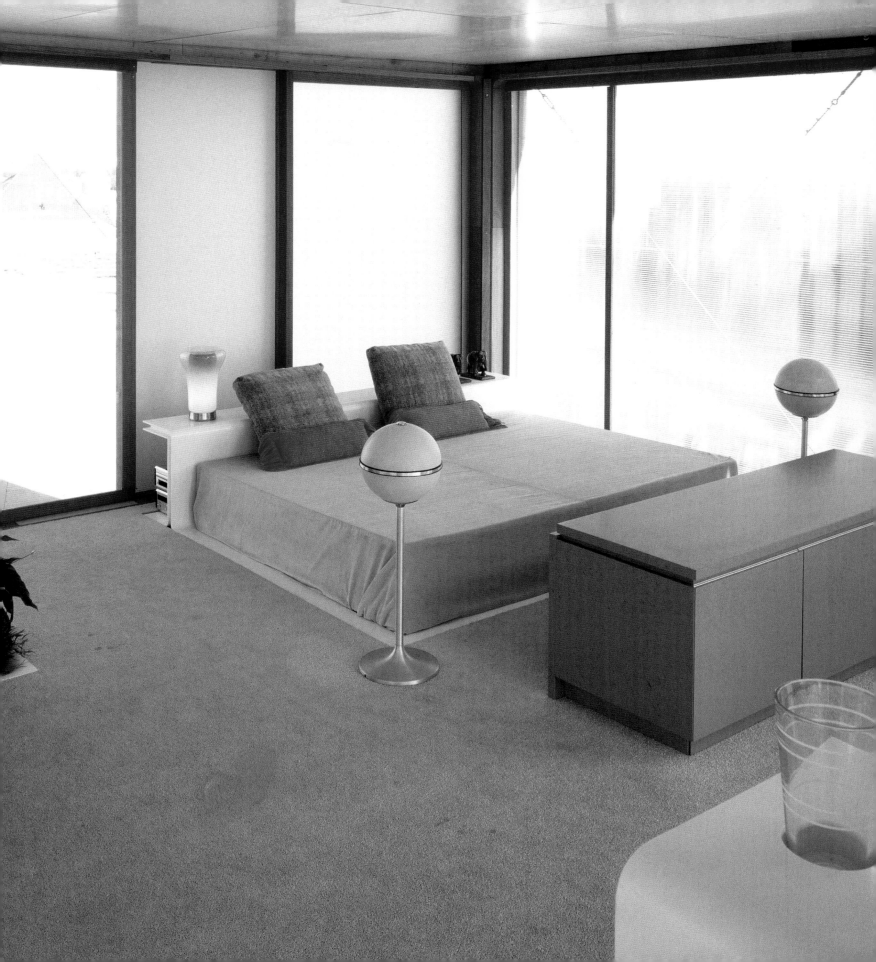

ATELIER IN WHITE

Like a horizontal grid that sinuously climbs toward the sky, the interior of this building was designed to rise vertically, thanks to the stairs that connect it to the top floor. Inside, the walls are arranged to create different spaces where the light is projected with varying intensities depending on the angle of the sun. This relationship between the position of the sun and its impact on the space creates a world of sensations that would not be possible without the skylight above or the network of fibers that form the stairway. The light descends from the skylight and is channeled through the central opening in the ceiling. In this design, the architect has made the light that floods the space into its focal point.

The architect compares the gradation of the interior light with the various qualities of light refracted by water in different containers. The light assumes the lead role, the details of the interior disappear, and the white surfaces contribute the strength and vitality necessary in a studio of such great proportions.

The interior space is formed by two exterior walls that configure the structure of the building, with a central wall between them. As one ascends the stairs, the space extends through the third floor, where just a single wood beam creates a feeling of tension amid this diaphanous place; on the fourth floor the light becomes softer. The framework of fibers in the stairway allows this same light to filter down to the lower levels, where it reaches the quality and the brightness desired by the architect.

ARCHITECT: **CASA Akira Sakamoto Architect & Associates**
PHOTOGRAPHER: **Kei Sugino**

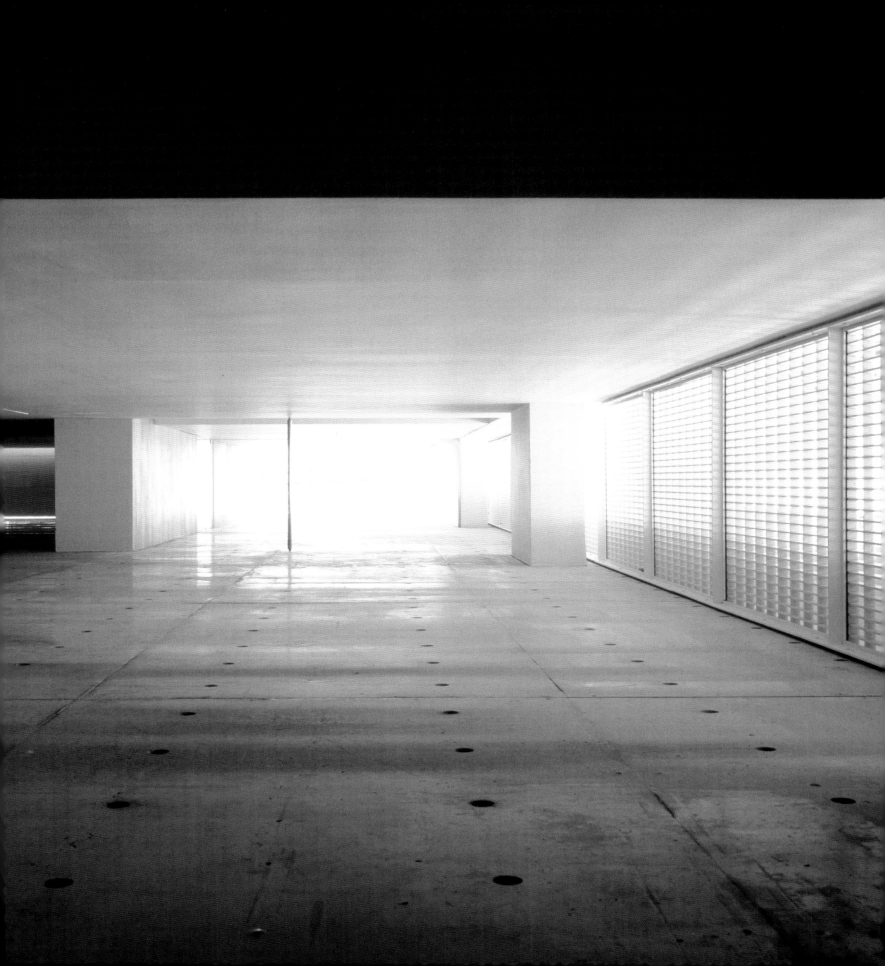

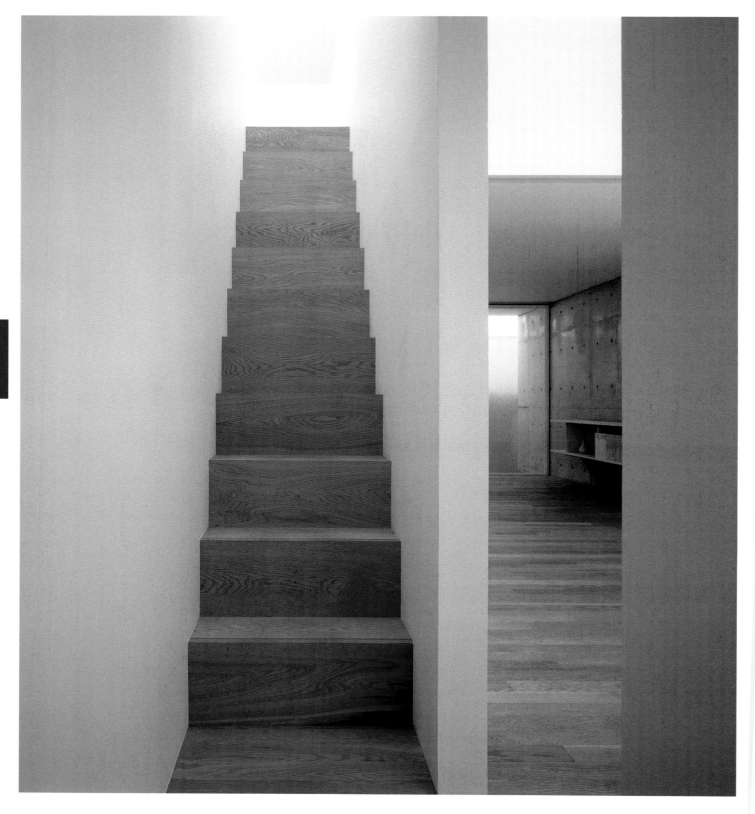

The stairs lead to the third floor, where the seemingly limitless space extends horizontally.

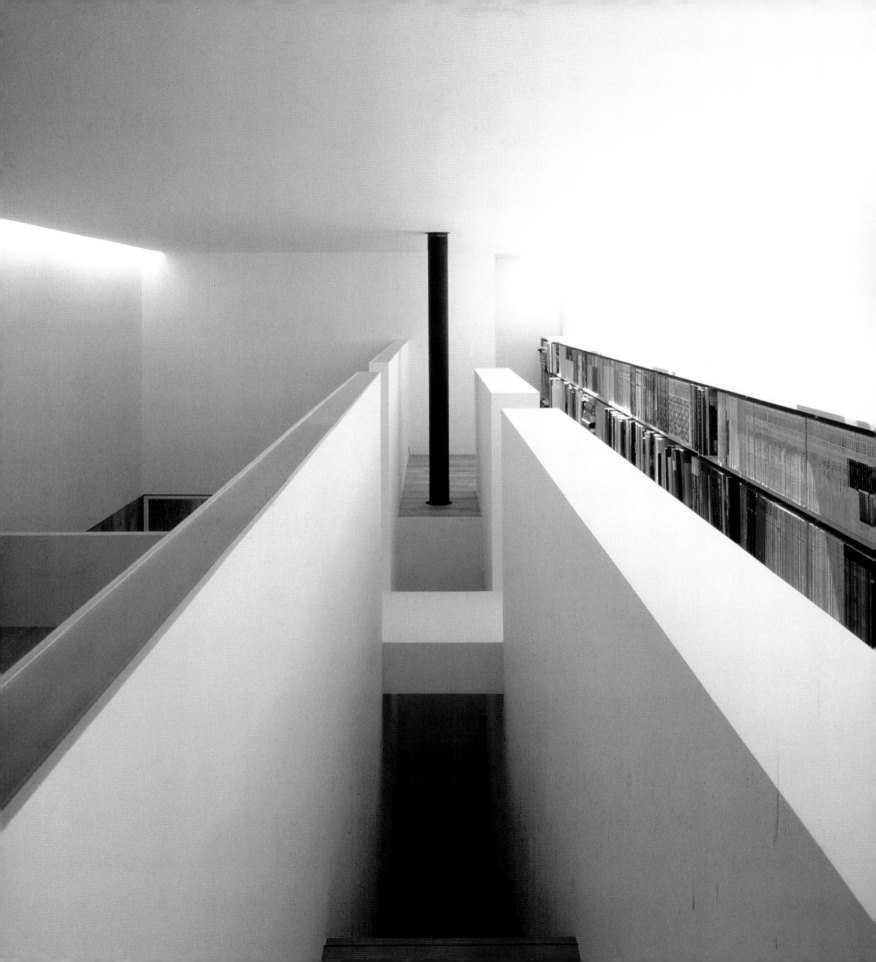

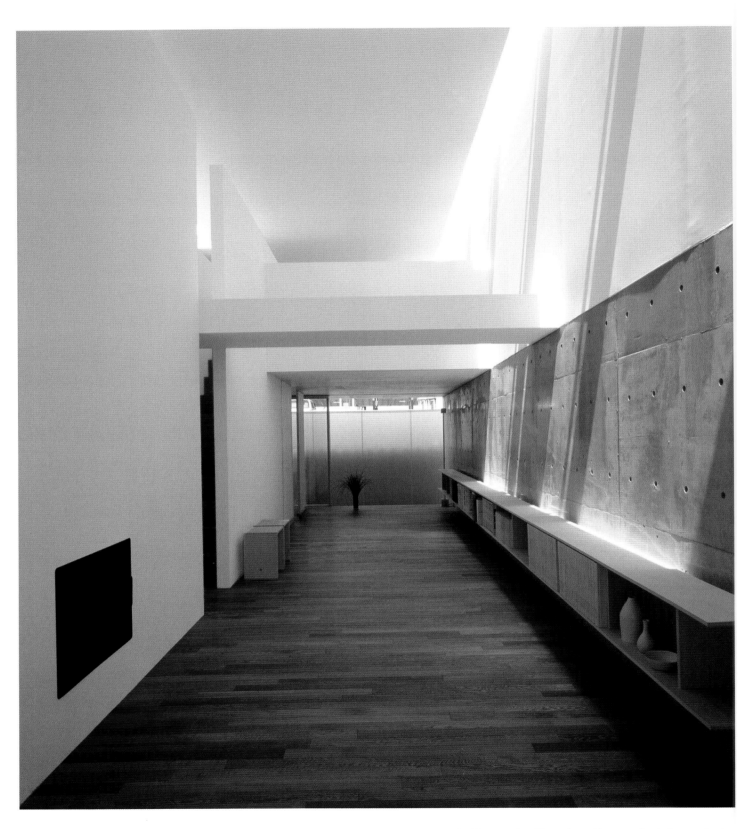

Light shines into the building, creating different intensities according to the way it enters the structure.

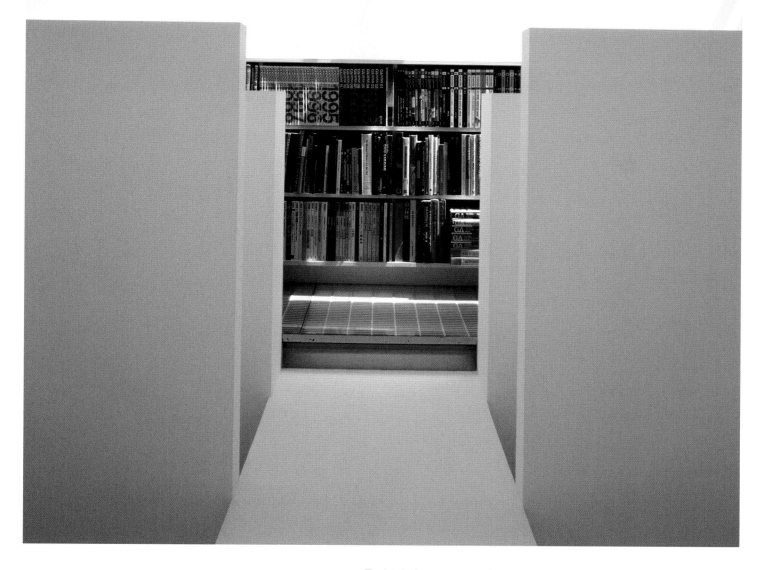

The interior houses an extensive collection of books, which are exhibited along the sides, emphasizing the horizontality of the structure.

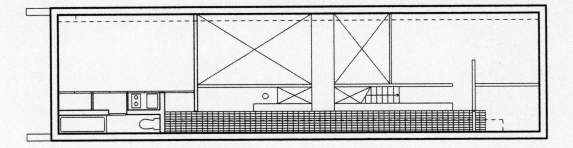

Plan

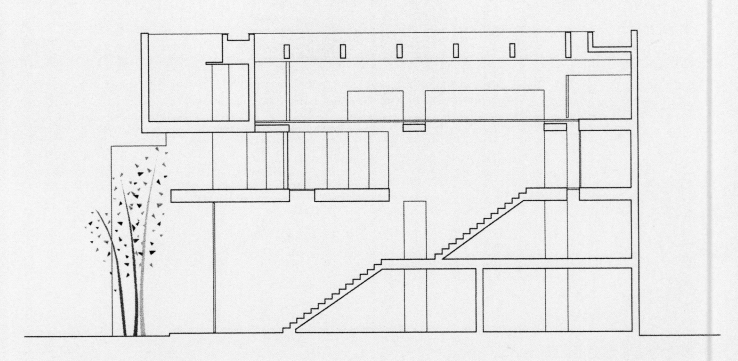

Section

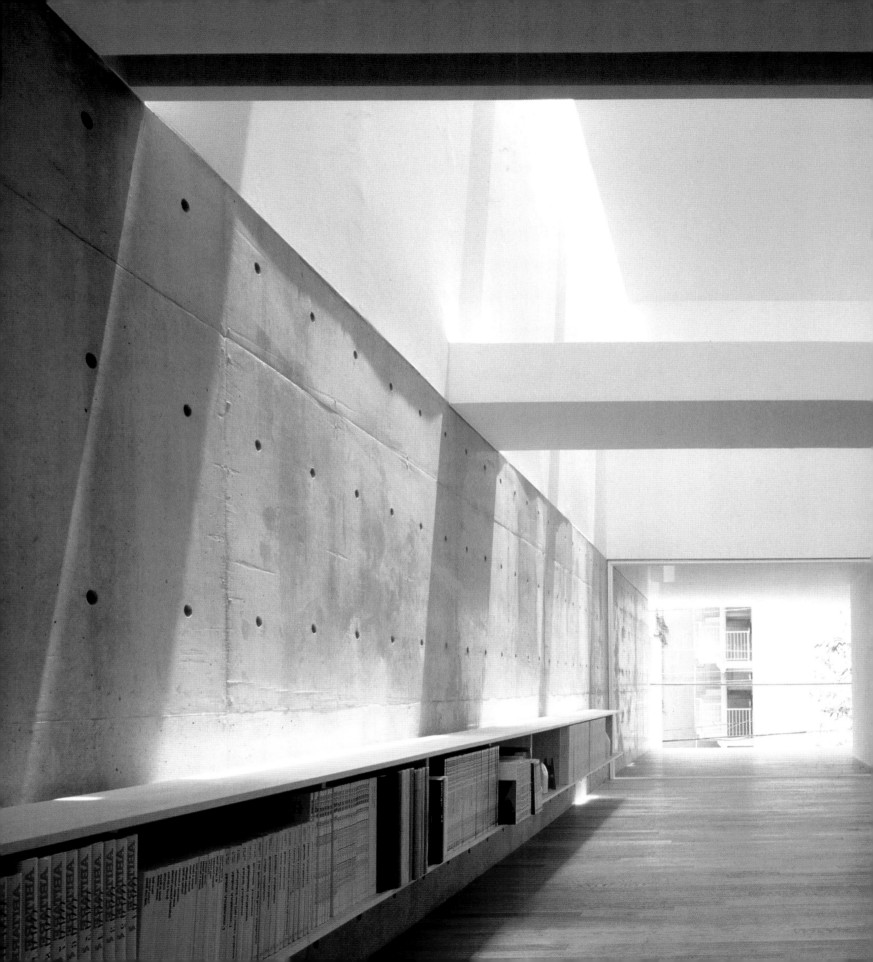

ATTIC APARTMENT IN GRAN VÍA

The originality of this attic apartment, located on the Gran Vía in the Eixample district of Barcelona, comes from the uniqueness of the place and the functional requirements requested by the client. The objective of the project consisted of transforming two elegant apartments that were in very poor condition into a single main space, composed of three well-defined areas, each one an entity with its own function and personality. This type of re-modeling is what the team of architects defines as "three in one."

This multiresidence, located in a property with great historical value, was conceived for a family with two children and is designed to fulfill their daily needs. Each one of the family members has a complete living space, laid out as a small apartment inside a larger container. This way, each area is autonomous, with an independent kitchen, bath, bedroom, and living room, which can be converted into "rooms" in the large space of the central apartment.

The architects define the apartment as an interior with no physical boundaries. The curved walls appear to disin-tegrate as they rise up to the ceiling, which is 13 feet high and still has the original decorative motifs. The loft bedrooms contrast with the glass floors, which allow unexpected views of the spaces. All of these are theatrical architectural elements that blur the perimeter. The use of movement and fragmentation in the interior within a completely regular and defined dimension is what makes it possible to create a flexible residence, like the one that was originally defined in the functional plan.

ARCHITECT: **AIA Albert Salazar/Joan Carles Navarro**
PHOTOGRAPHER: **Jordi Miralles**

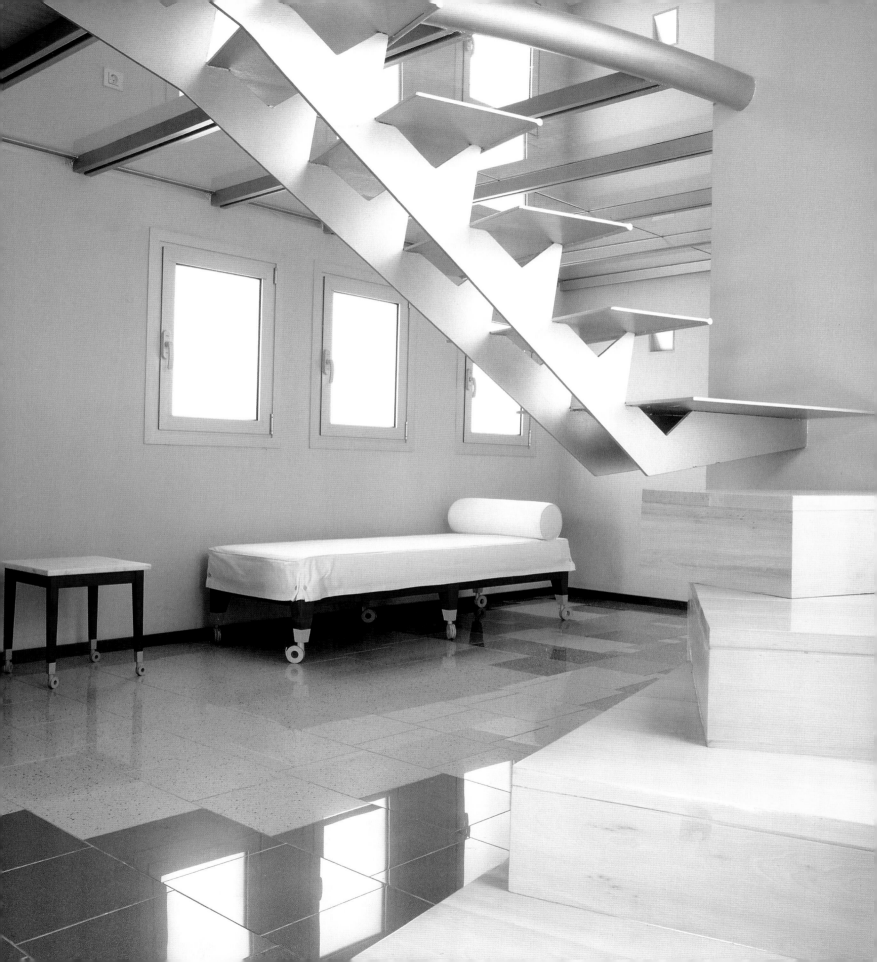

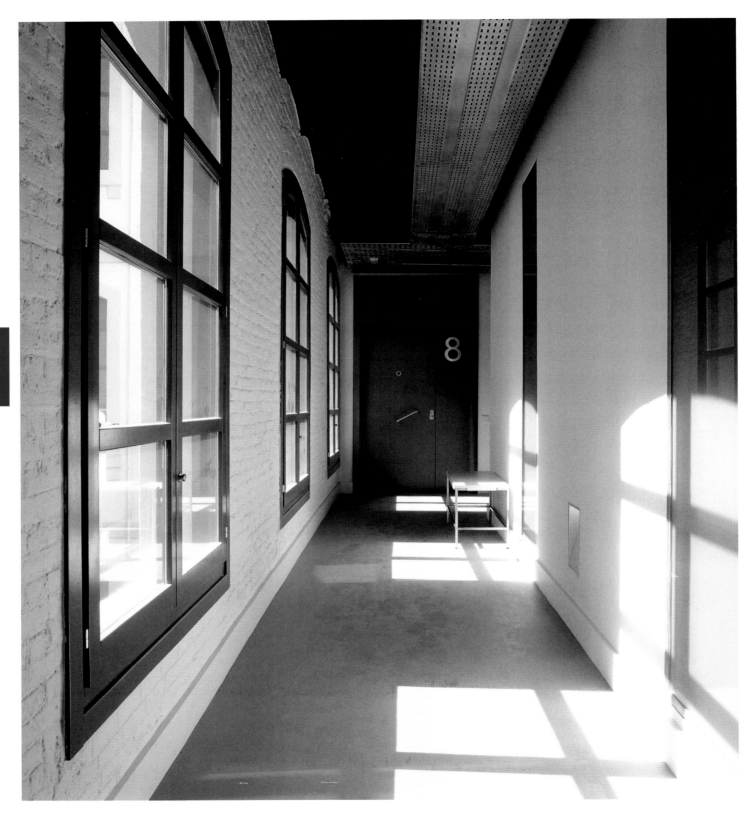

The project took place in a historic building, where two apartments in poor condition were greatly altered.

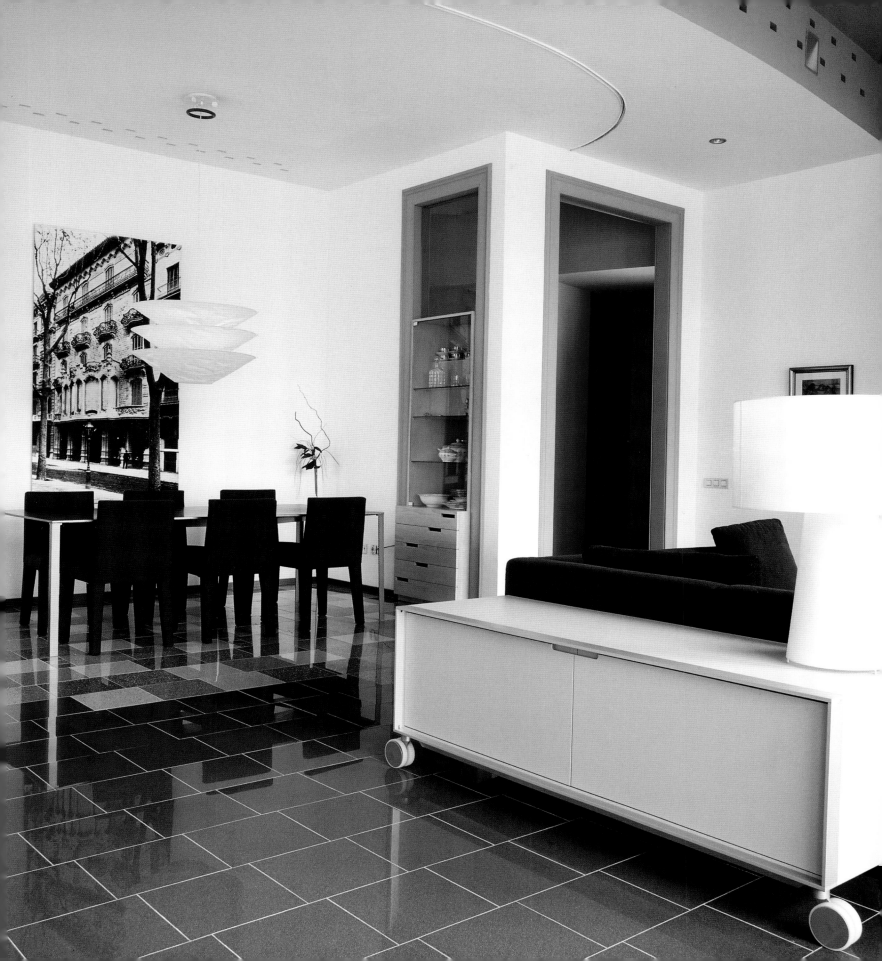

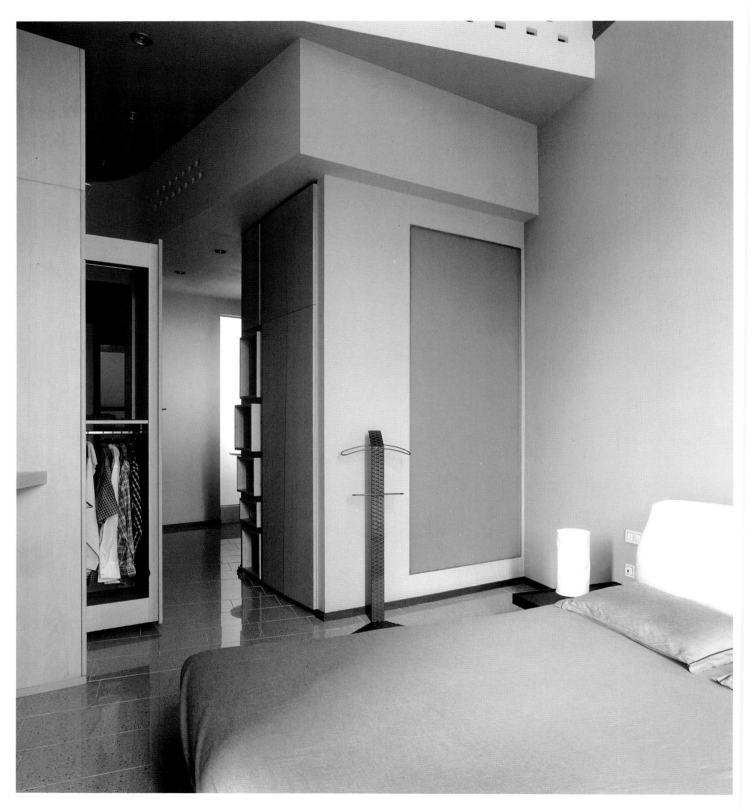

In carrying out the project, the structures of the pre-existing spaces were completely modified, and in some instances, images of the past were reinstated.

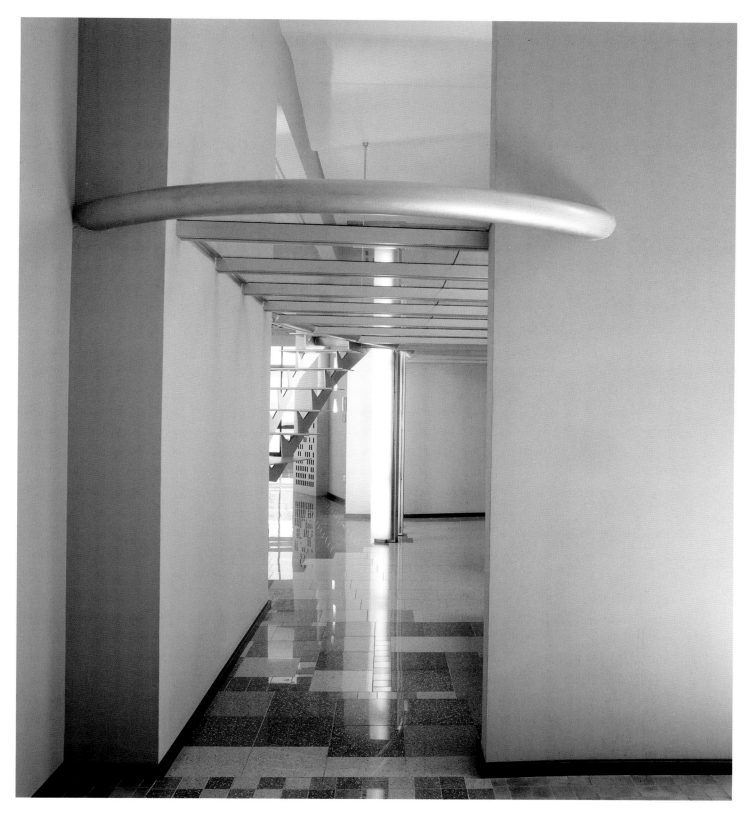

The succession of different spaces establishes the transition from one apartment to another.

The furnishings are used both to integrate and generate their own spaces. The design concept omits other boundaries where the furniture is located.

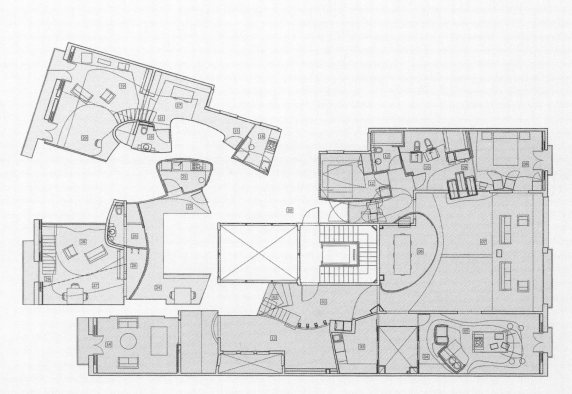

Plan

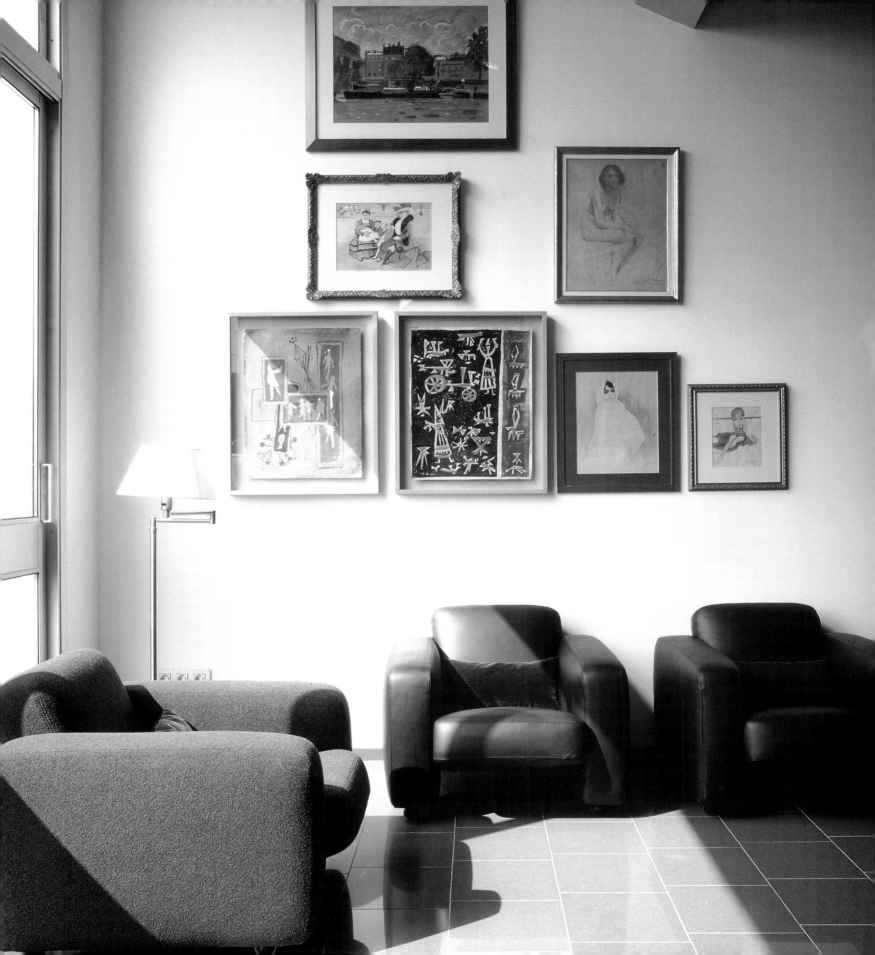

GREENWICH VILLAGE PENTHOUSE

This project was carried out on the 14th floor of a postwar building in the historic district of Greenwich Village in New York City. The idea was to renovate two apartments with a total surface of 2,200 square feet, with a 1,400-square-foot terrace in the back of the building and a 400-square-foot greenhouse.

The layout was born from the idea of creating a space that worked as an extension of the outside urban context, while keeping the original structure and façade. To achieve this result, an addition to the terrace was designed; it became the most industrial space of the project, constructed with a wide range of materials like glass, steel, aluminum, and slate. This area, located in the highest part of the house, is a gathering place, and it offers excellent views of the city of New York to anyone wishing to relax.

The same concept was applied to the interior. The architects created a movable system of sliding doors that divide the room into two completely different areas, but at the same time blur the boundaries between the interior and the area that forms part of the covered terrace. The material used for the floor was beech with ebony inlays. Some of the materials from the terrace were used in the dining room, an approach that highlights the visual connection between both areas of the residence.

The result of the project is a setting that places the owner in a perfect position in the highest part of the city, where he can choose between a comfortable interior or a relaxed exterior with excellent views of Manhattan.

ARCHITECT: **Rogers Marvel Architects, PLLC**
PHOTOGRAPHER: **Paul Warchol Photography**

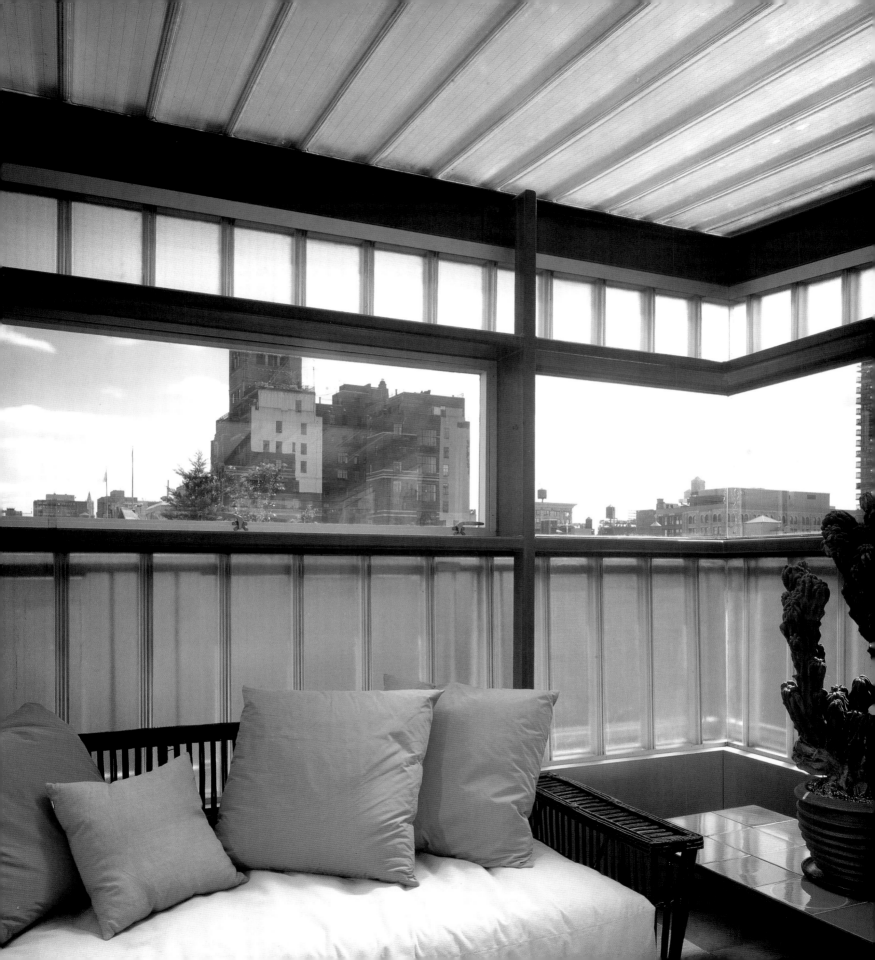

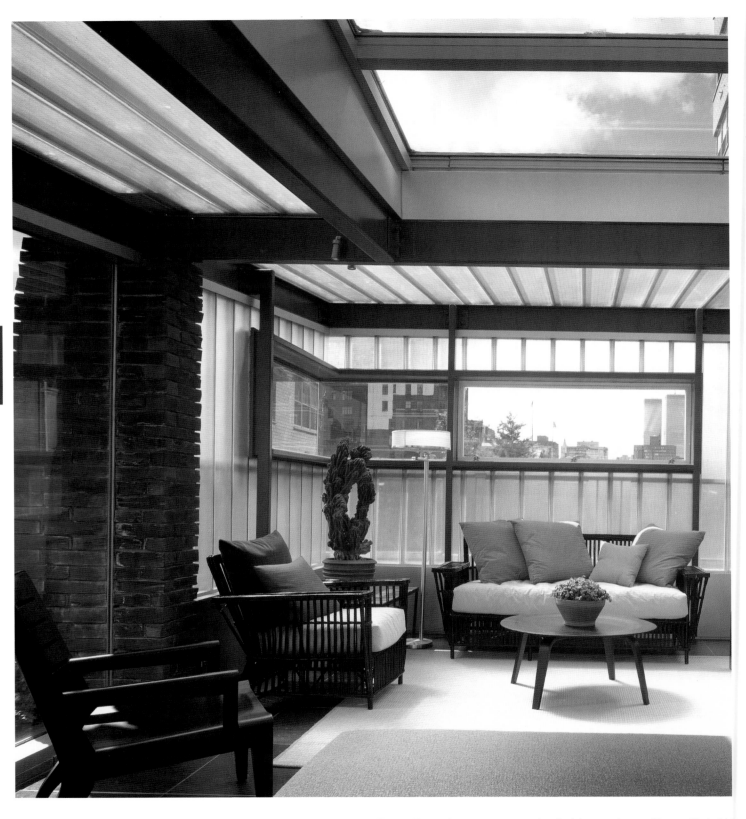

The addition to the terrace, connected to the living area, is one of the most industrial spaces of the project and the transition point between the interior and exterior.

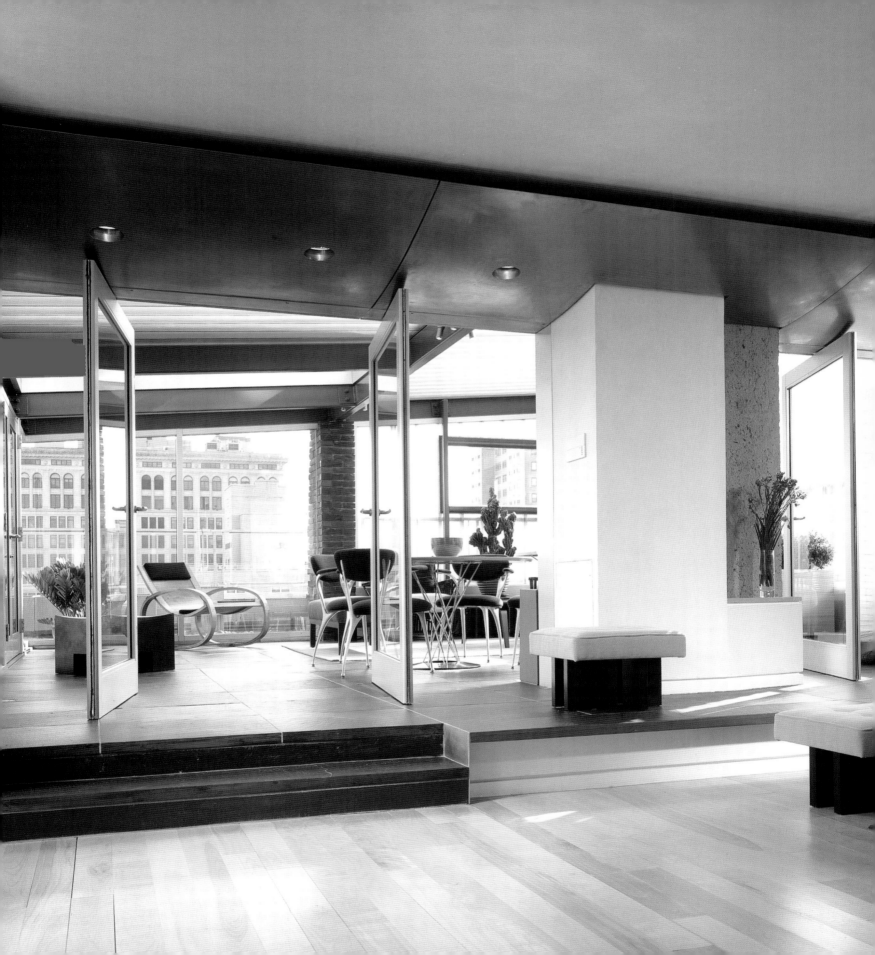

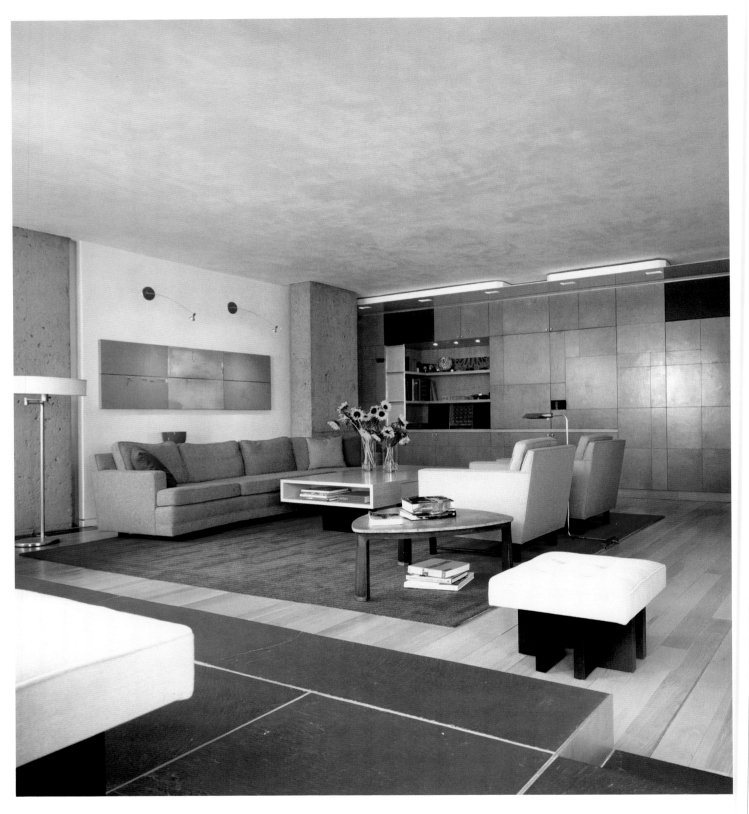

The terrace was designed to express the spirit of Manhattan in a more relaxed and comfortable space.

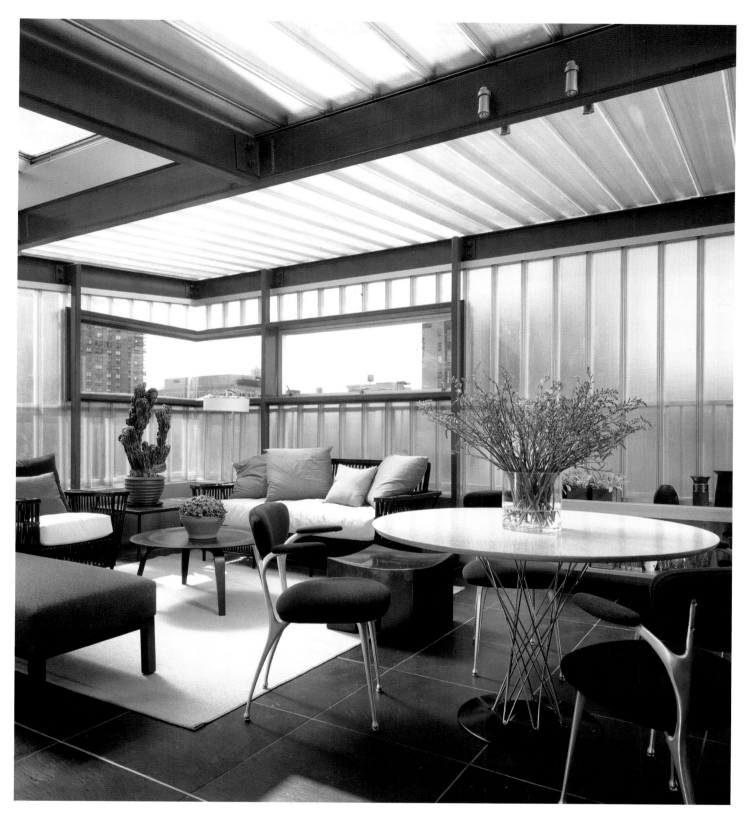

The covered terrace is one of the most well-lit areas of the residence, since its structure allows light to filter through the skylight above and enter through the side windows.

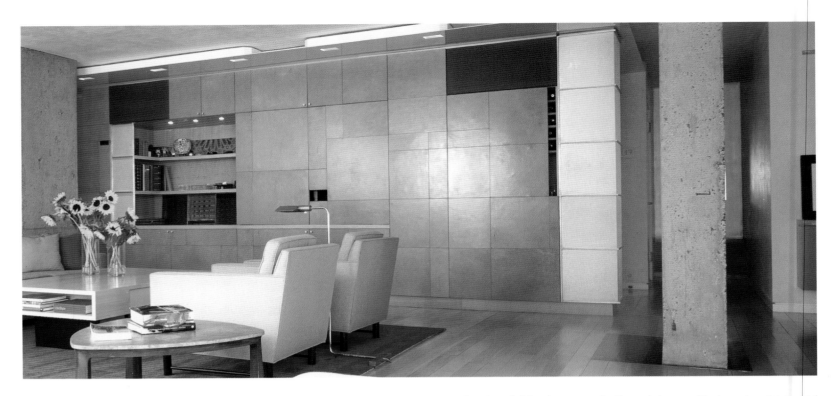

A system of sliding doors separates the central space of the home from the covered terrace, blurring the boundaries between the interior and outside.

Plan

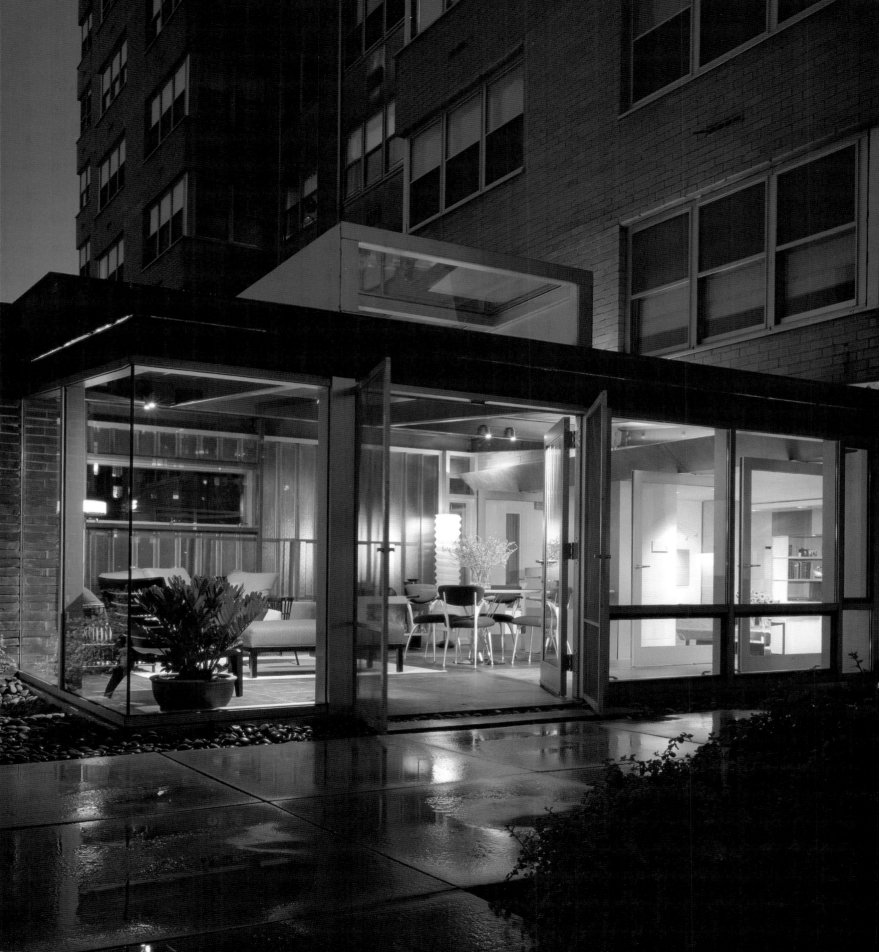

FOB HOMES 1

The architects began with the idea of creating an apartment complex as an alternative to mass-produced residences. The building stands as an example of modern architecture in one of the residential neighborhoods of the city of Osaka.

The interior of FOB Homes 1 is based on the principle of visual continuity, so an open space was created with sparing use of detail. A metal stairway climbs to the top of the residence, where an L-shaped interlocking system of bedrooms is laid out along the inner space of the unit, so that the sequence of rooms can be seen from any part of the interior garden. The highest level of this project has as its soul the empty central area. In the middle of this empty space is the garden, with the building wrapping around it to protect the inner area from the exterior. Inside, the elements are distributed according to the original architectural guidelines, which specify a functional interior with austere details.

Visually, the structure is cubic, hermetic, and solid, a completely white volume that rises rationally and discretely from the building lot. However, even though on the outside it seems to be an enclosed and perfect architectural form, a few openings in the façade allow light to enter into the interior courtyard. For the architects, this is a functional and livable minimalist box, in which the bedrooms on the highest level establish the upper limits of a discreet and dignified building.

ARCHITECT: **FOB Architecture**
PHOTOGRAPHER: **Hirai Photo Office/Hiroyuki Hirai**

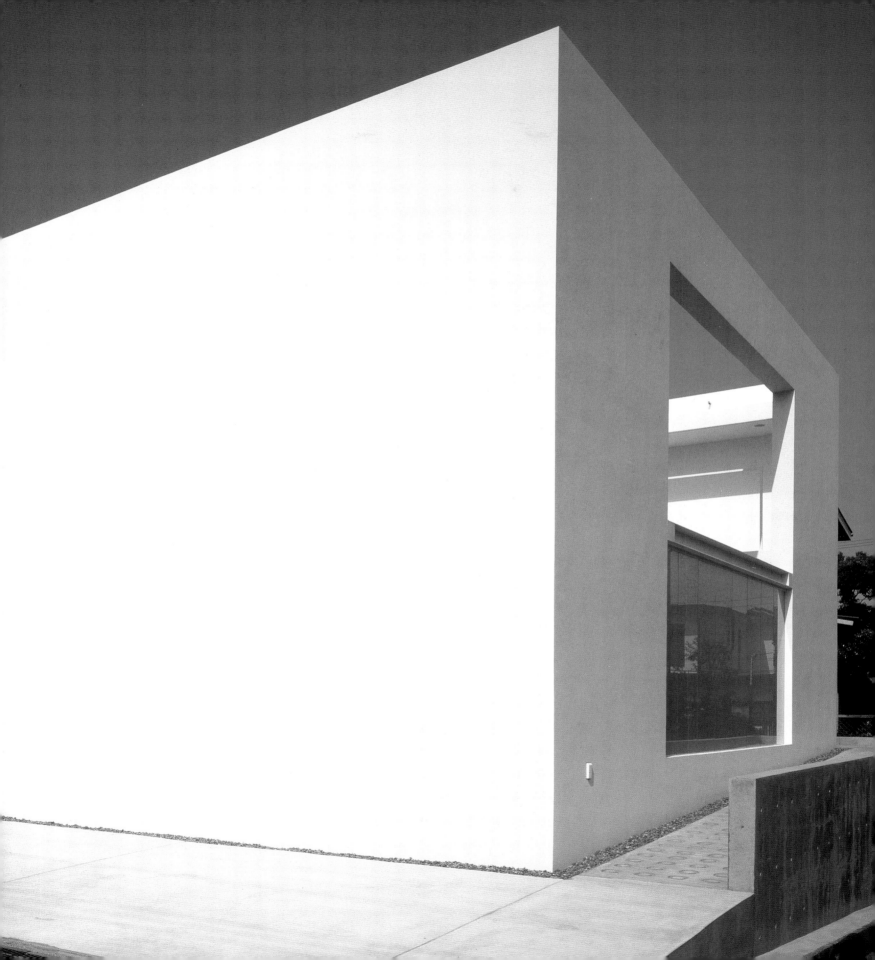

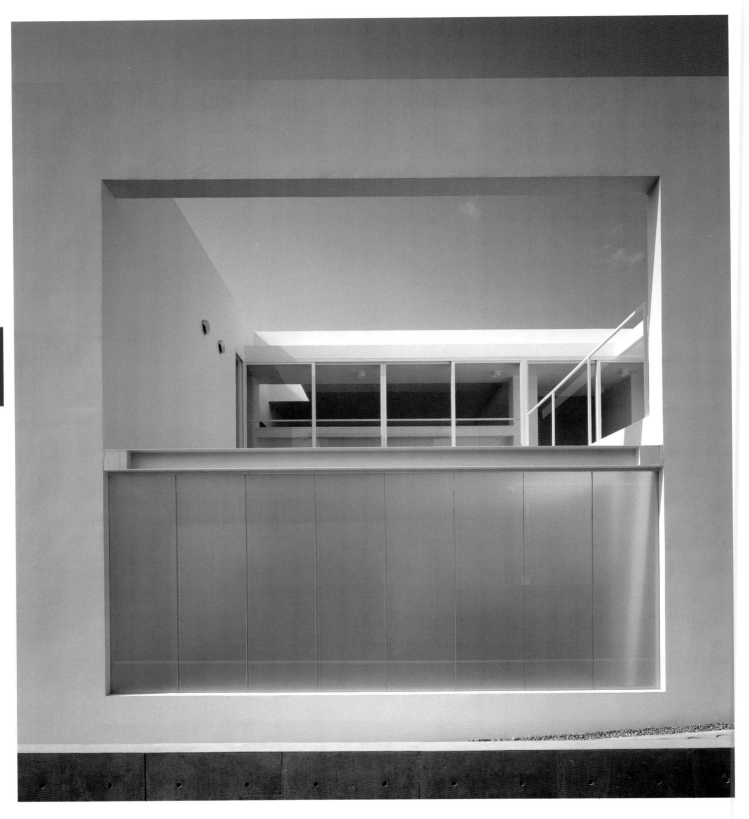

A metal stairway leads to the top floor of the apartment, where an interlocking system of bedrooms is laid out in an L shape.

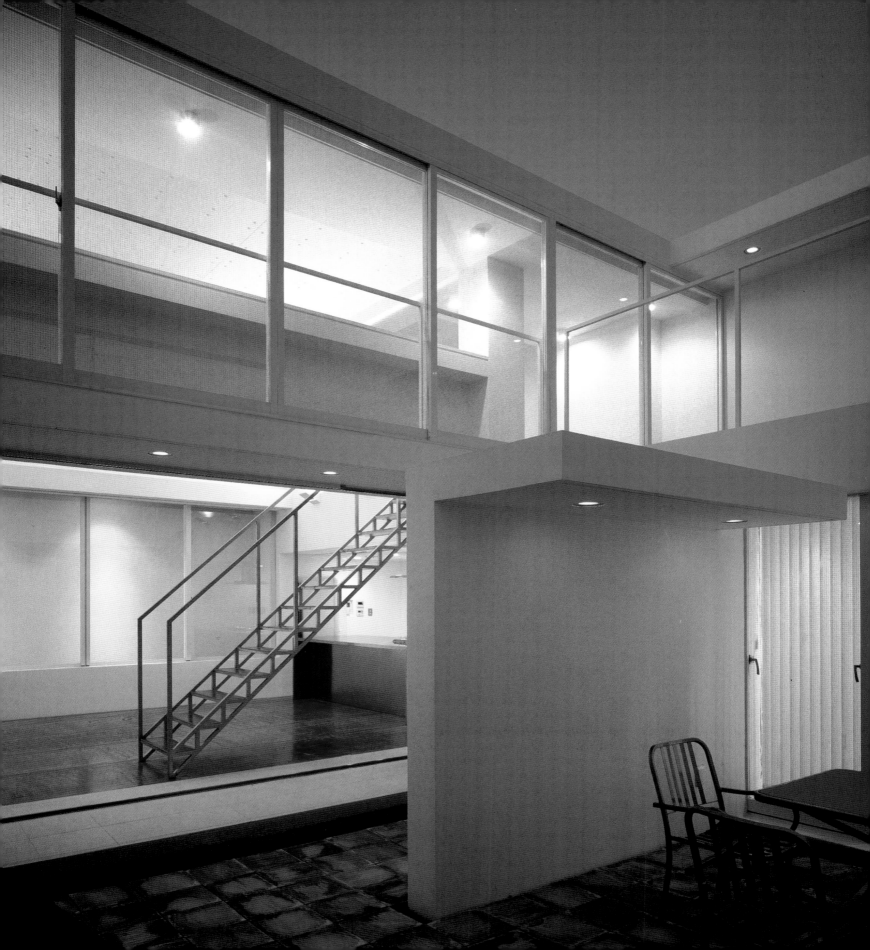

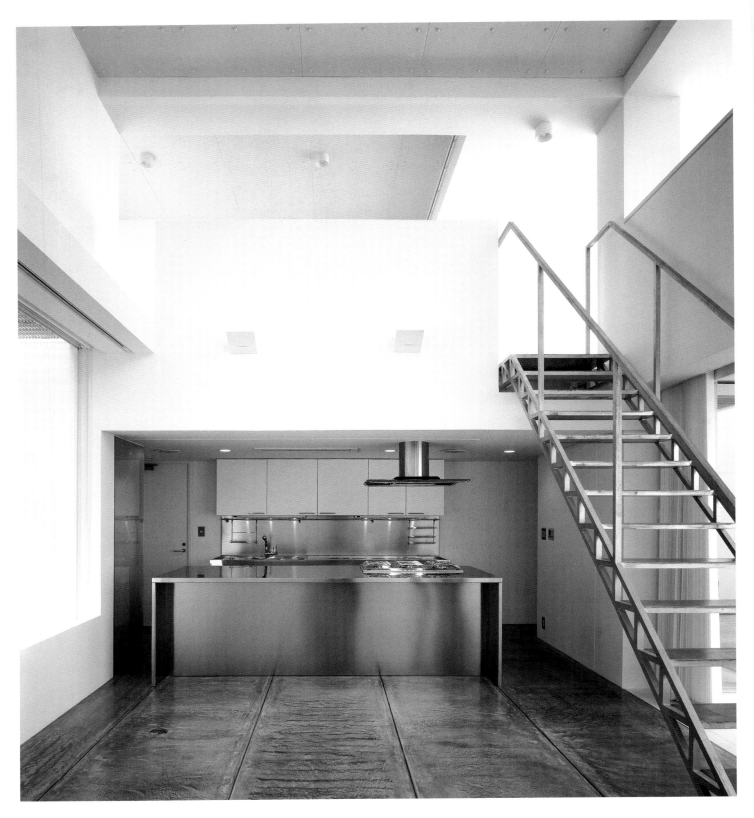

The cubic shape of the building allowed the installation of various lights, which were channeled through the windows around the structure.

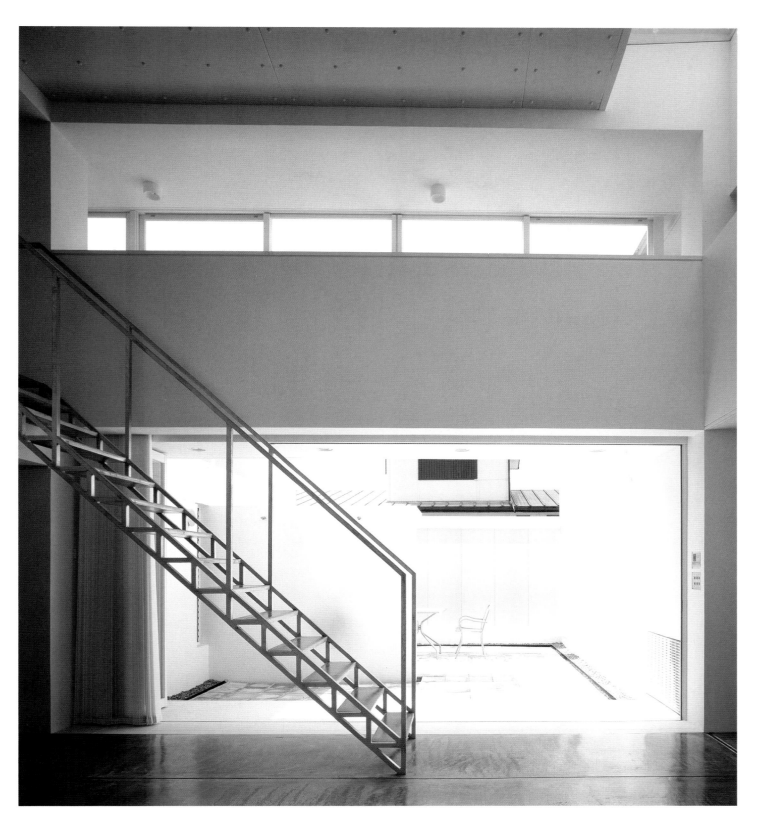

An interior courtyard was designed in the empty space in the center, from where the linear distribution of the private rooms can be seen.

Although the structure appears to be a closed cube, its linear design allows the midday sunlight to enter the courtyard.

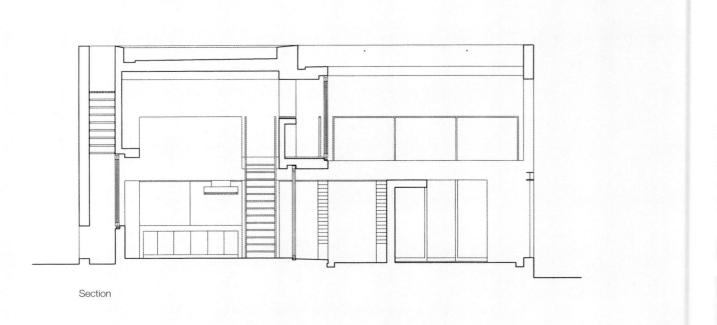

Section

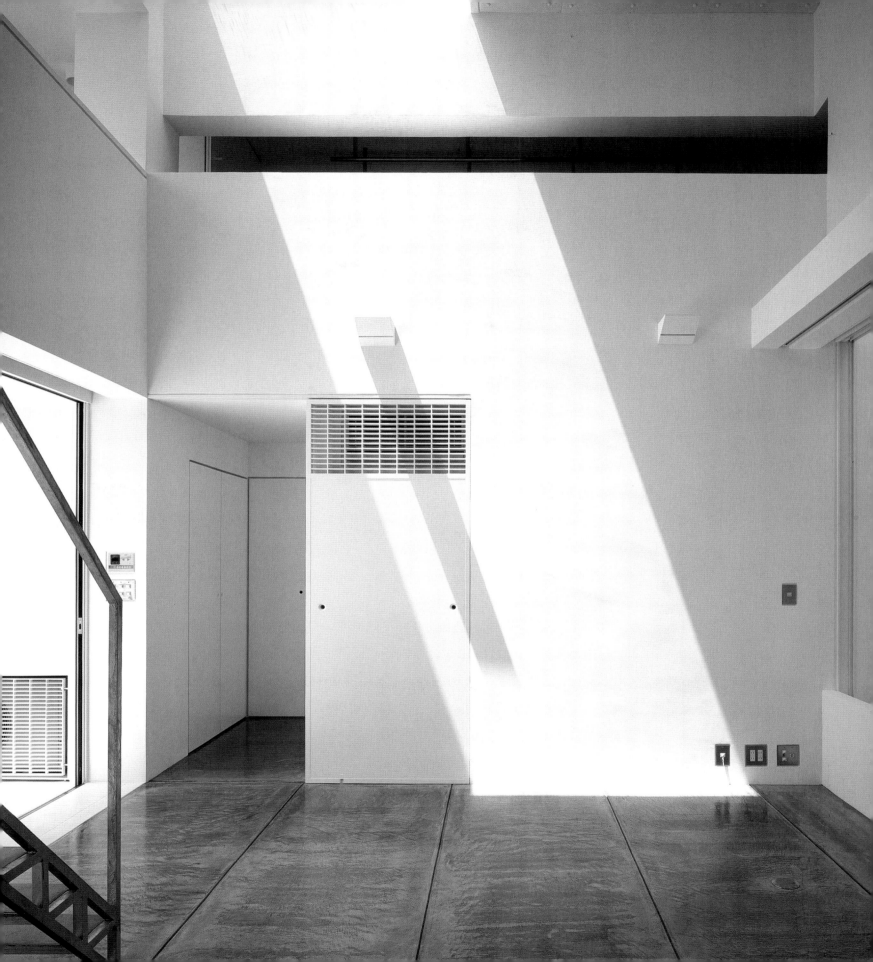

FROM FACTORY TO RESIDENCE

This loft is located in an old factory that is still being used as a warehouse for construction materials, although only in one area of the interior. The owners designed the conversion of the small studio, which is at one end of the building, into a loft of approximately 750 square feet. The apartment enjoys all the advantages of a home without ignoring the activity that takes place in the rest of the building. The starting point for the project was redefining the floor plan, which was long and narrow. The architects were forced to design an open space, free of obstacles that would get in the way of the layout.

On the lower level, a remarkable system of wood beams accentuates the original style of the structure. From this area an open stairway with wood steps leads to the loft bedroom. This extra level was made possible by the height of the ceiling, which allowed for additional living space after the vertical distribution had been redefined. Walnut-stained pine is the material that was used in this additional level, and the original ceiling was preserved to create the feeling of an attic room. The oak bed and the custom closets made of wood with an aluminum frame complete this small and unique space located in the highest level of this refurbished factory. The living room, dining room, and kitchen are located under the loft, in a functional and colorful space that receives direct light through the factory's original industrial windows.

ARCHITECT: **Manel Torres & Raquel López/IN Creació d'Espais Interiors, S.L.**
PHOTOGRAPHER: **José Luis Hausmann**

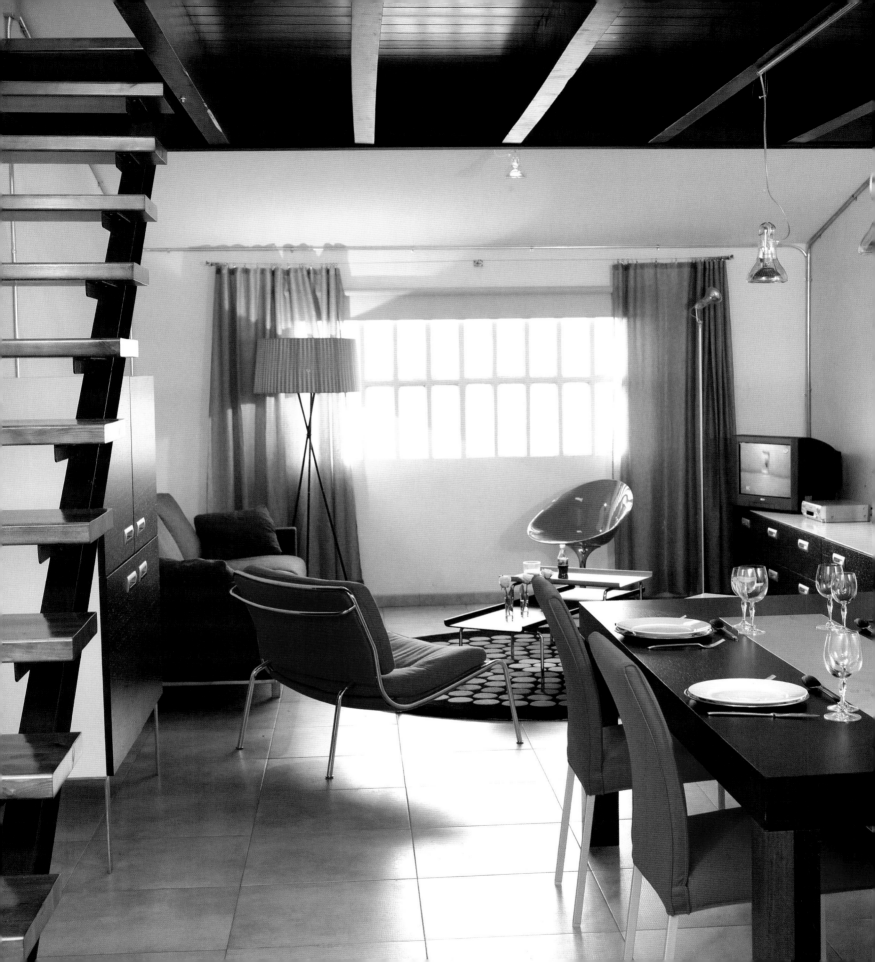

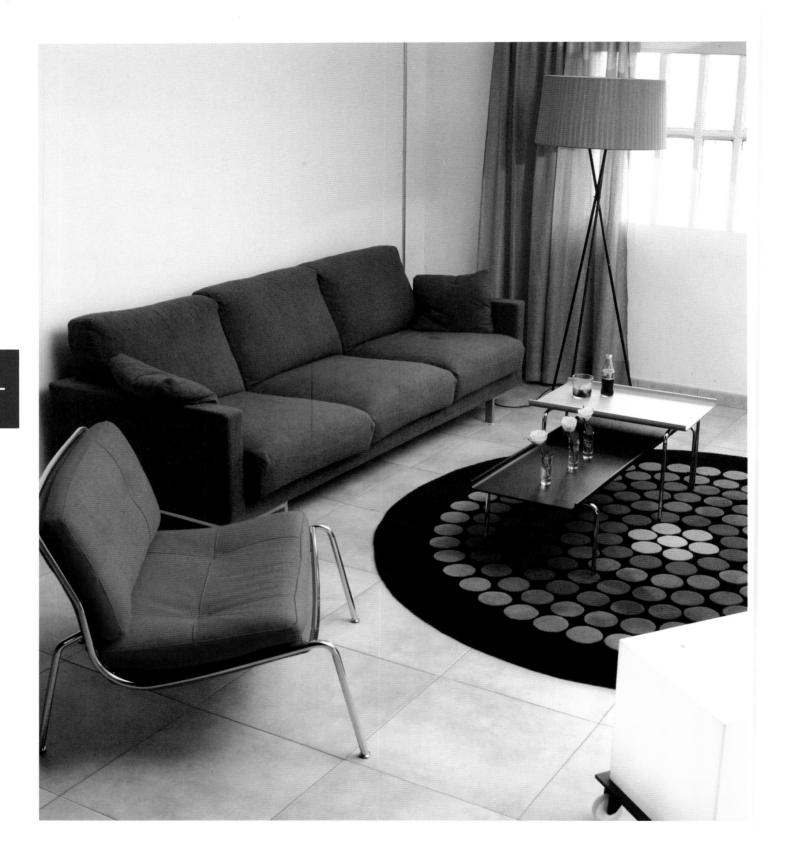

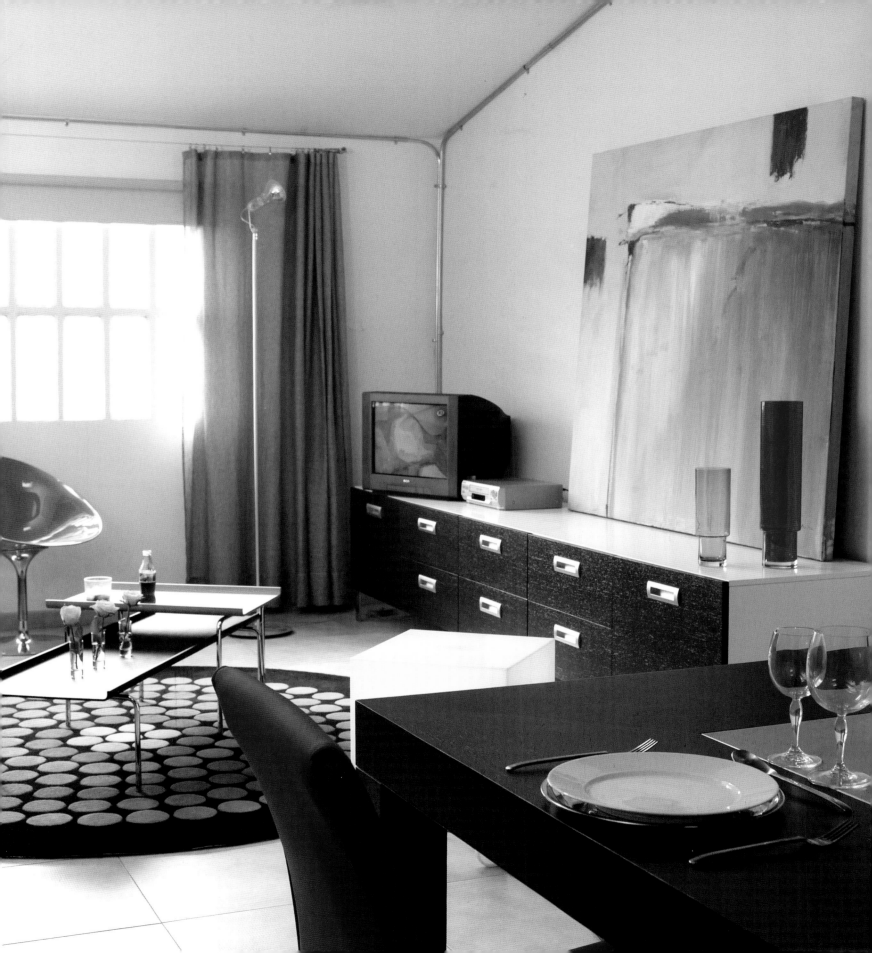

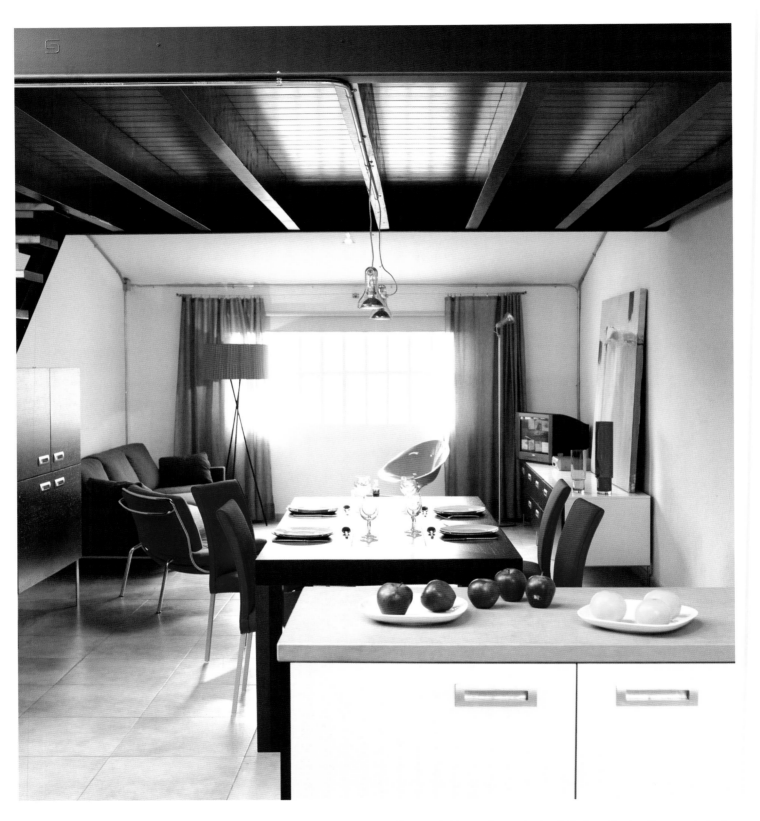

The remarkable wood beam structure in the lower floor's ceiling accentuates the industrial character of the factory.

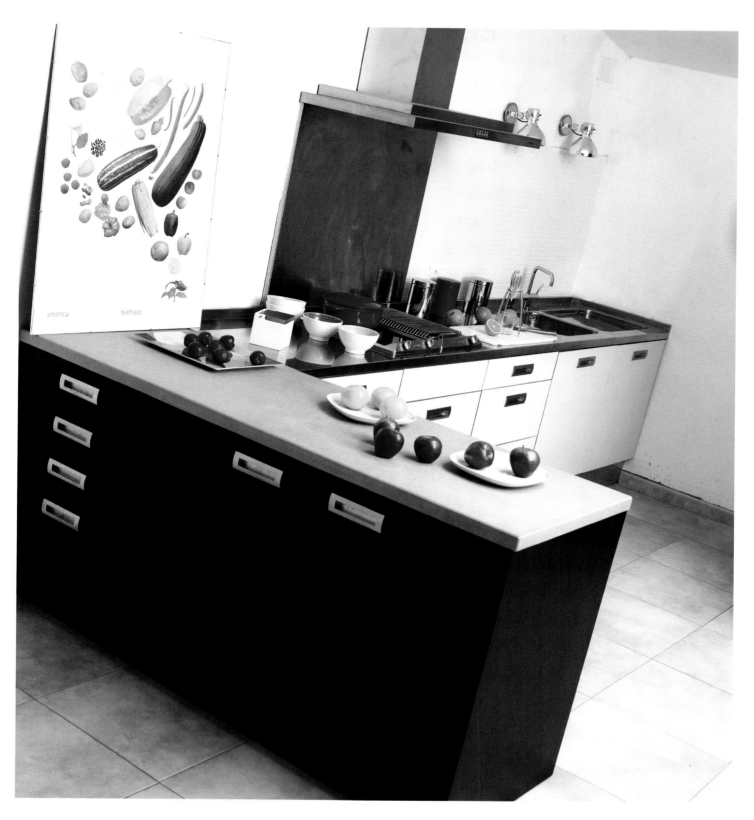

The kitchen, located in the rear, has an L-shaped countertop that facilitates communication with the rest of the spaces.

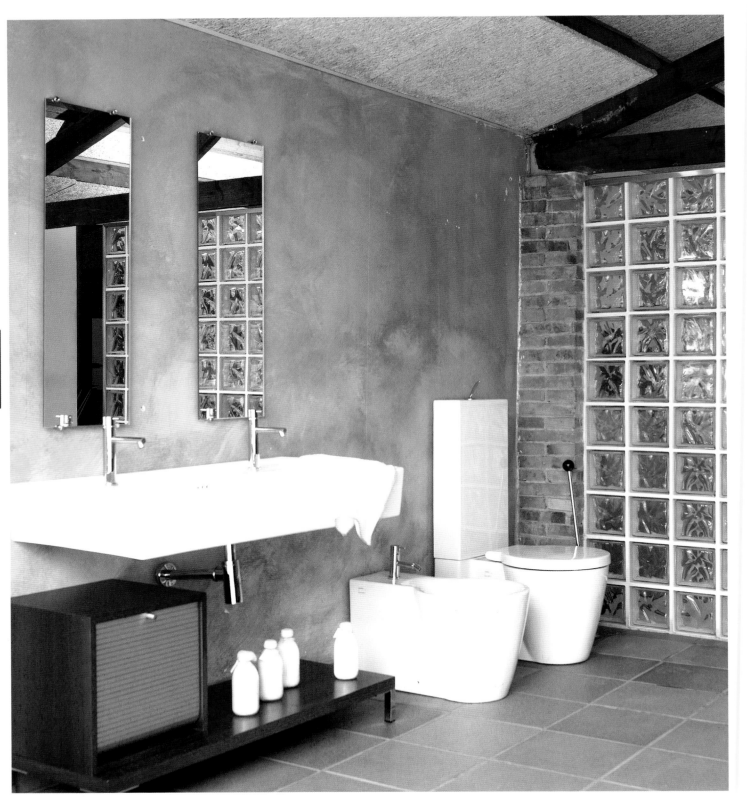

In the bathroom, the rustic style of the walls and beams is mixed with high-design fixtures.

MIDTOWN ROOF GARDEN

The firm Graftworks captured the essence of New York City with their design for this roof garden, located on the top floor of a building owned by a family with two children. The garden enjoys magnificent views of the mythical skyline of Midtown Manhattan, the Chrysler Building, and the East River.

The architects began by improving the original structure of the roof, which had a combination of uneven levels. The clients requested that the surface be remodeled to create more shaded space and a place for their gardening tools. The design proposed by Graftworks reconfigured the geometry of the views. The cedar screen on three of the four sides of the project was designed to reflect the horizontal details seen on some of the surrounding buildings. The fourth wall, also in two tones of cedar, was created to enclose the space. To create a bit of shade, a series of horizontal fir beams was added, designed in the shape of a trellis. This was one of the most remarkable engineering accomplishments of the project, considering that the unit offers the greatest support with the least possible material.

With this remodeling project, the architects were able to create a connection between the exterior architecture and the inside of the garden, whose structure seems to rise up to the sky, its crossbeams visible against the most impressive skyscrapers of the city.

ARCHITECT: **Graftworks**
PHOTOGRAPHER: **Raimund Koch**

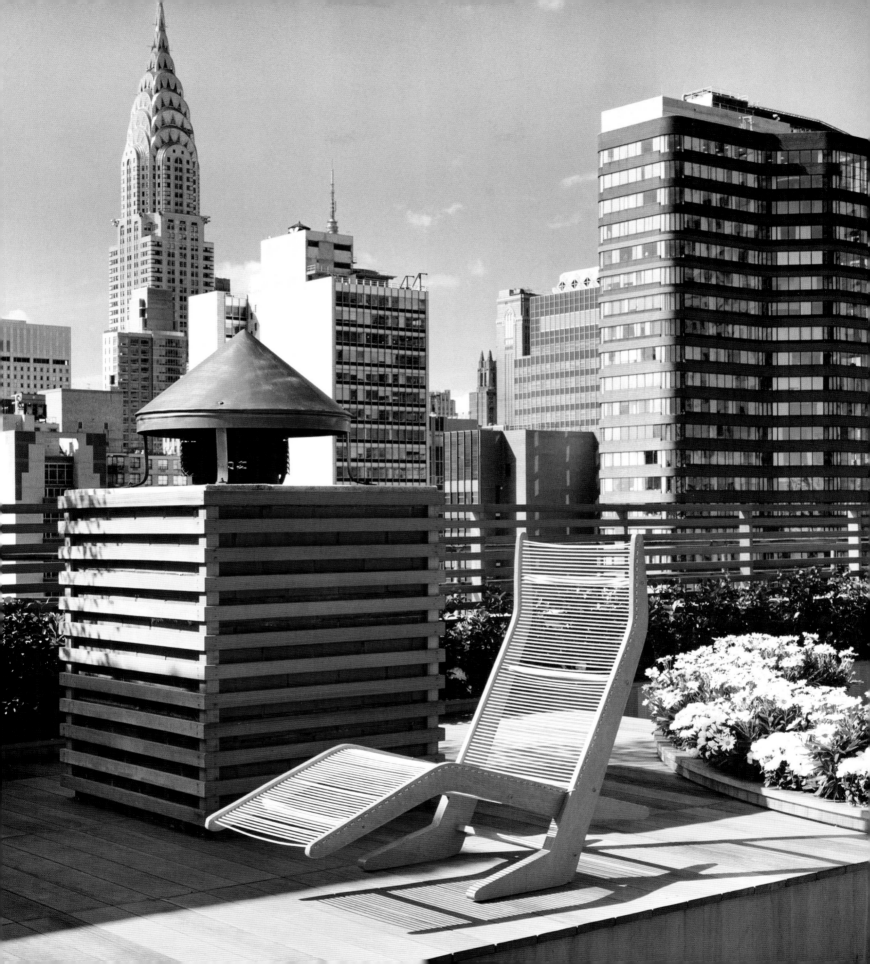

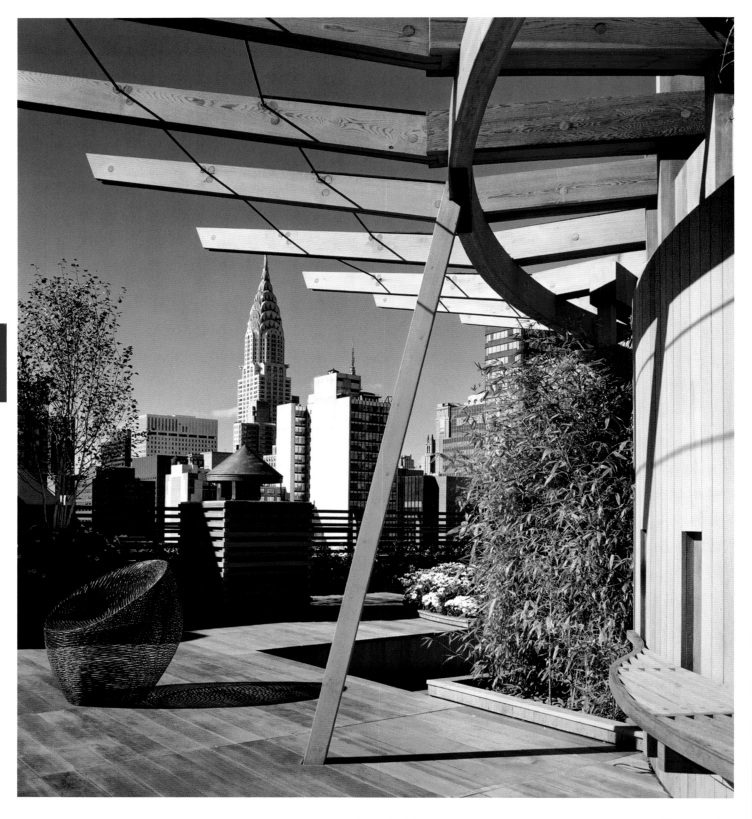

The horizontal crossbeams in the garden reflect the geometric features of the surrounding architecture in an attempt to capture the style of the city.

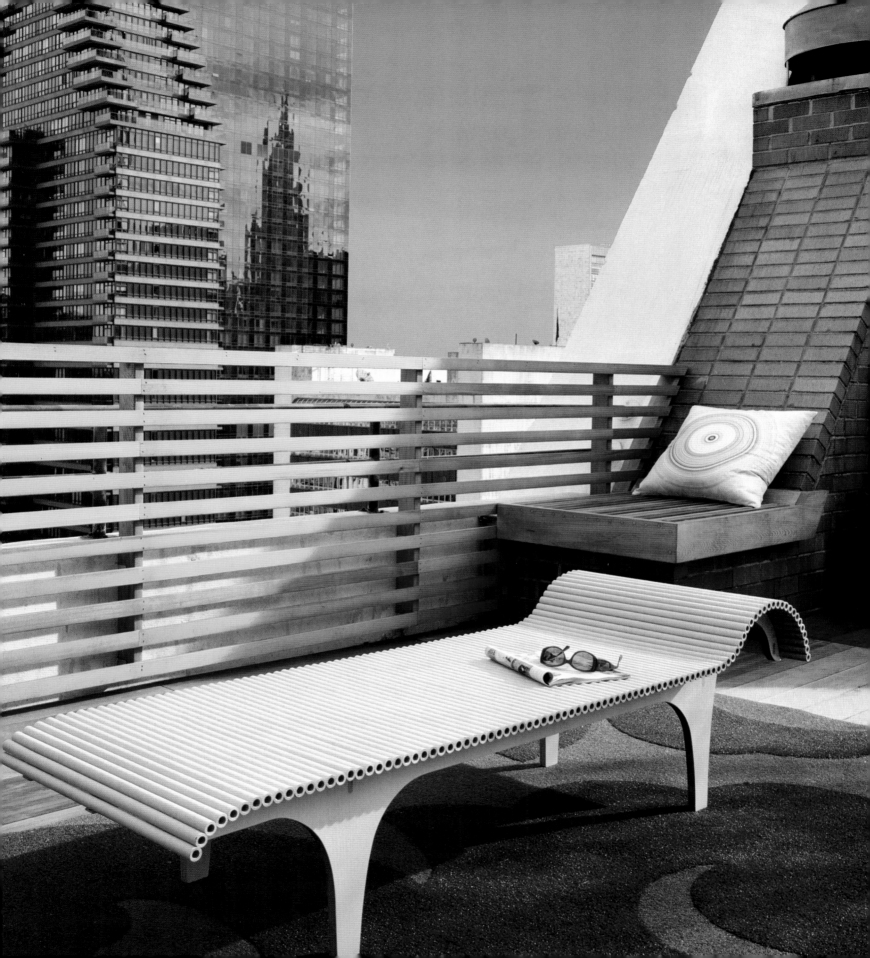

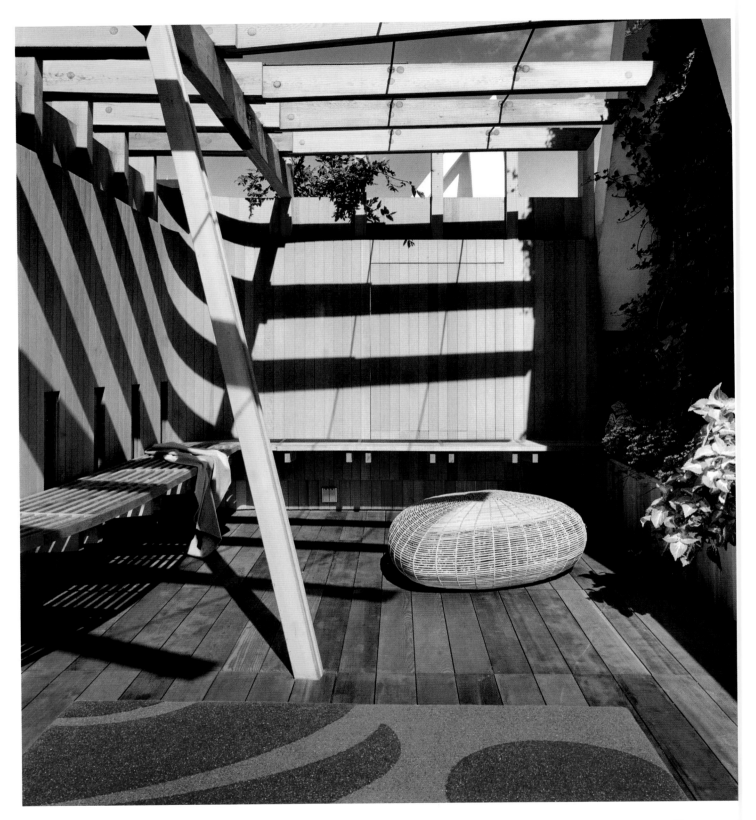

The structure of horizontal fir crossbeams, in the form of a trellis, creates different areas of shade in a space that is exposed to light 24 hours a day.

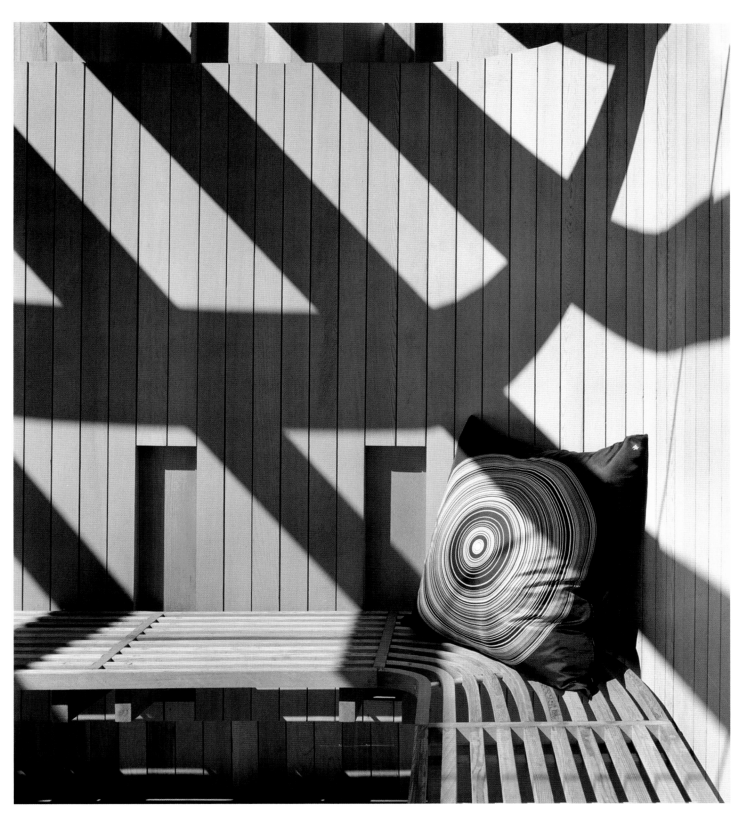

One of the goals of this remodeling project was to create more shaded areas for relaxing or reading away from the sun in any part of the garden.

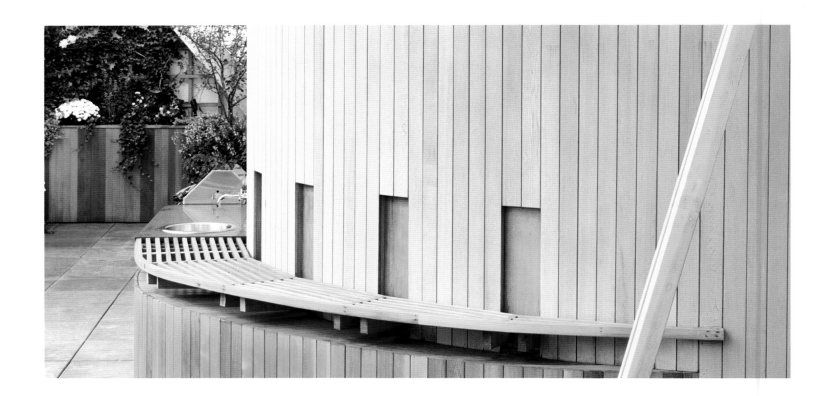

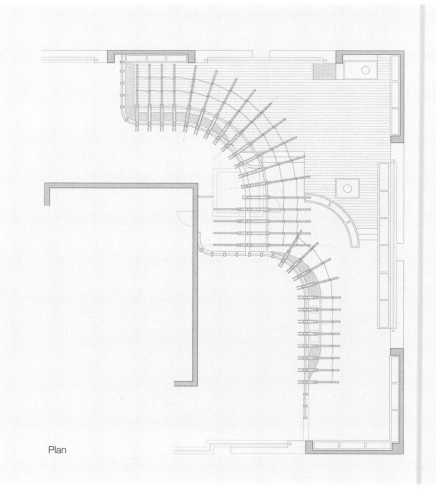

The remodeled area on the rooftop is a scenic and
architectural solution that fits in perfectly with the surrounding
skyscrapers.

Plan

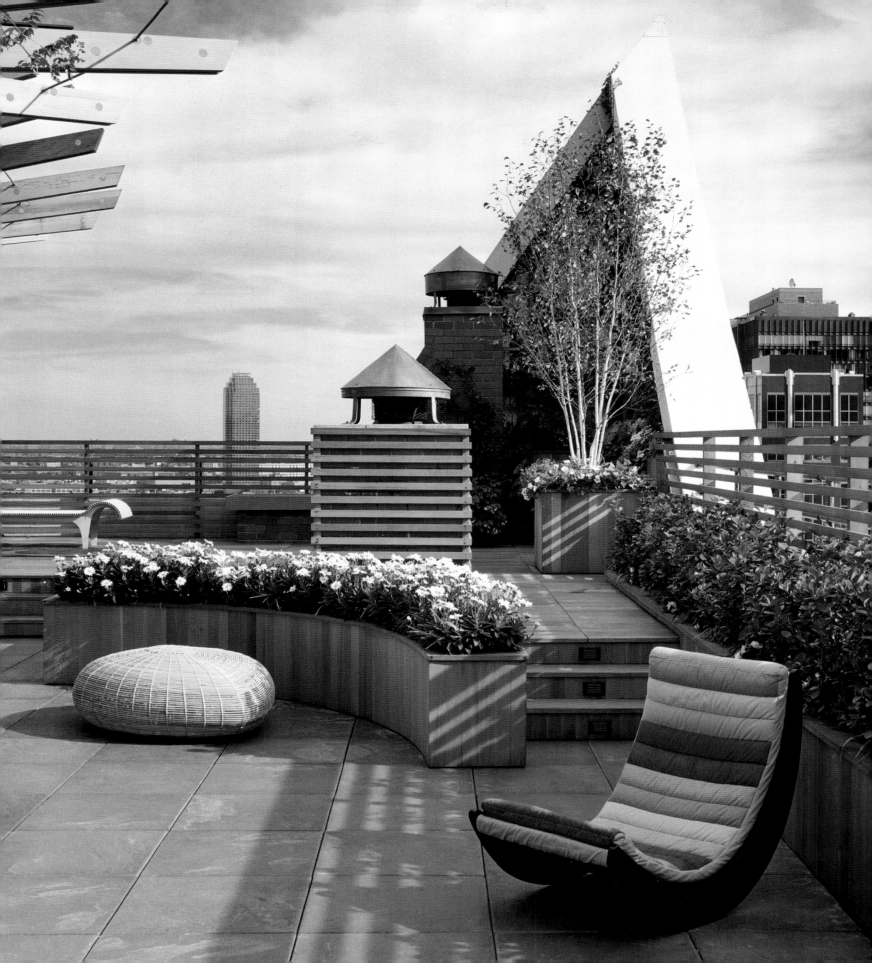

DUPLEX APARTMENT IN BOGOTÁ

This apartment, located in a commercial building in Bogotá, consists of two floors that enjoy excellent views of the city's hills to the east. Initially, the original space housed a series of separate rooms (four average-sized bedrooms on the first floor and an entry hall), designed this way for commercial reasons. The architect's contribution consisted of restructuring the entire level and creating a single space, which is subtly divided with freestanding walls that create separations between environments, like the entry hall, the living room, and the dining room.

The narrow stairway, which was preserved from the original structure, facilitated communication between the lower and upper levels. It could not be made wider, but it was given a feeling of greater space by a skylight placed in the ceiling, which was opened to create more height. As a result of this system, the space not only gained in height and dimension, but also became brighter and roomier as well. This approach was also used in the foyer on the second floor. On the upper level, the bedrooms were placed under the sloped ceiling to take advantage of the roof, in which several skylights were placed to provide light for the rooms. The original structure of the outside was preserved, keeping the slope of the roof intact and changing only the inside.

After opening up the interior, the architect observed that the floor plan of the apartment was completely irregular. Material like white walls and fine-grained wood flooring were selected to remedy this problem by unifying and harmonizing the interior.

ARCHITECT: **Guillermo Arias**
PHOTOGRAPHER: **Alejandro Bahamón**

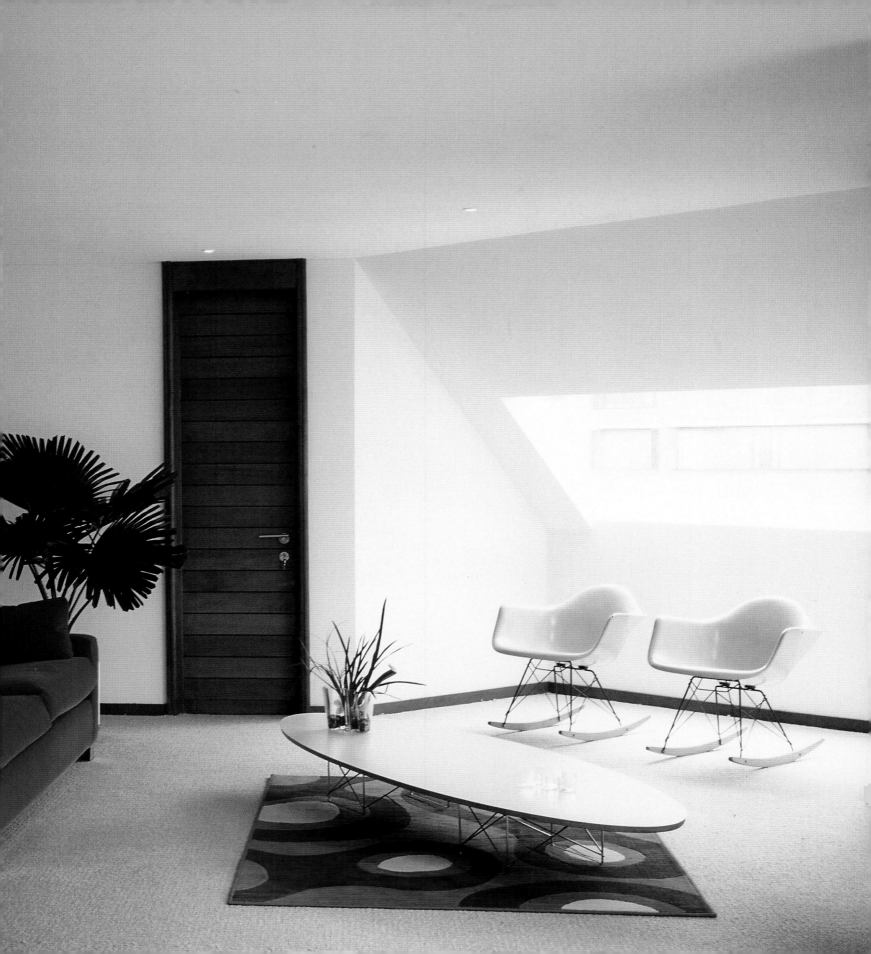

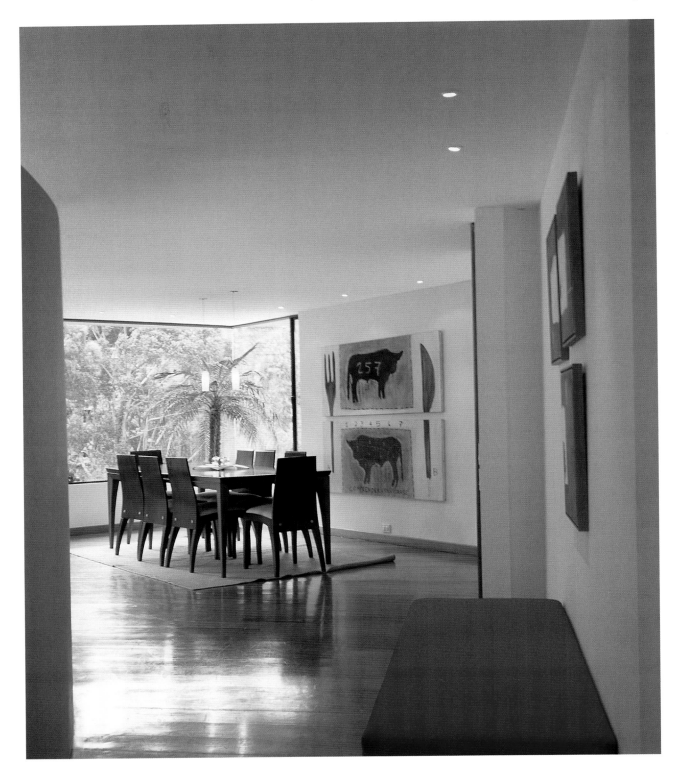

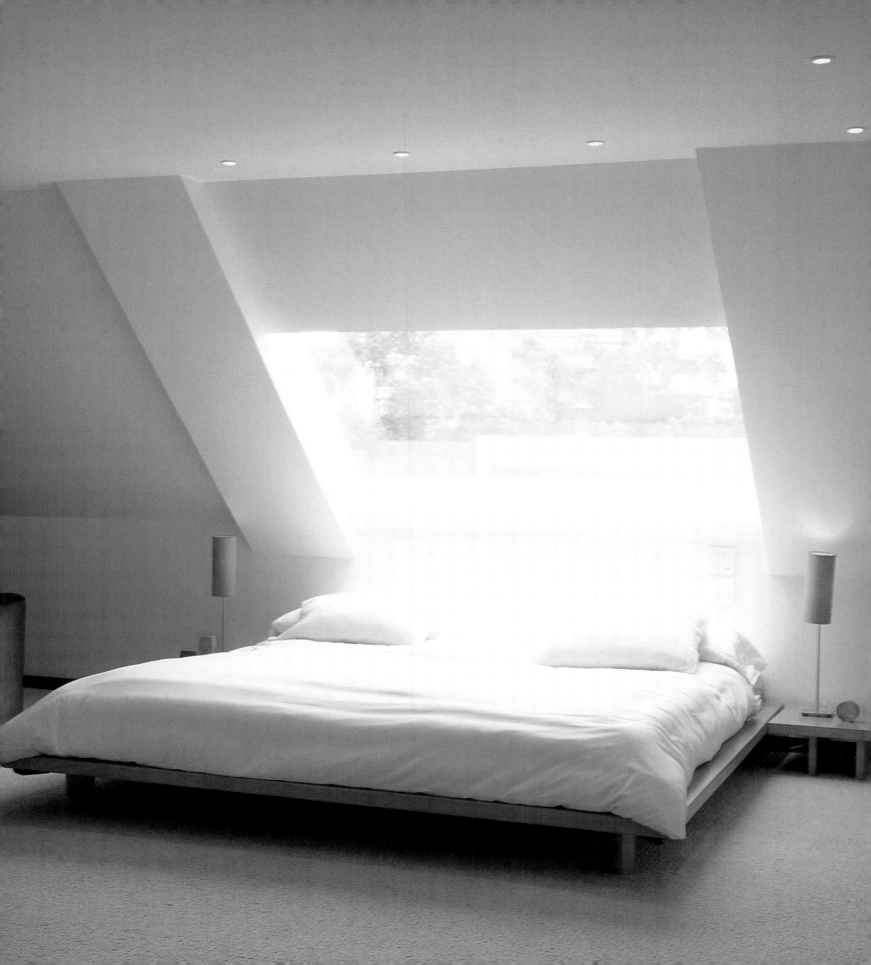

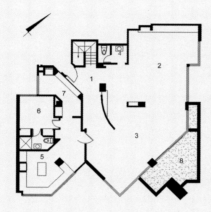

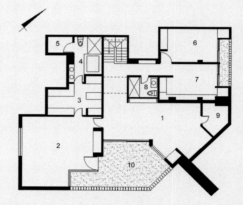

First floor

Second floor

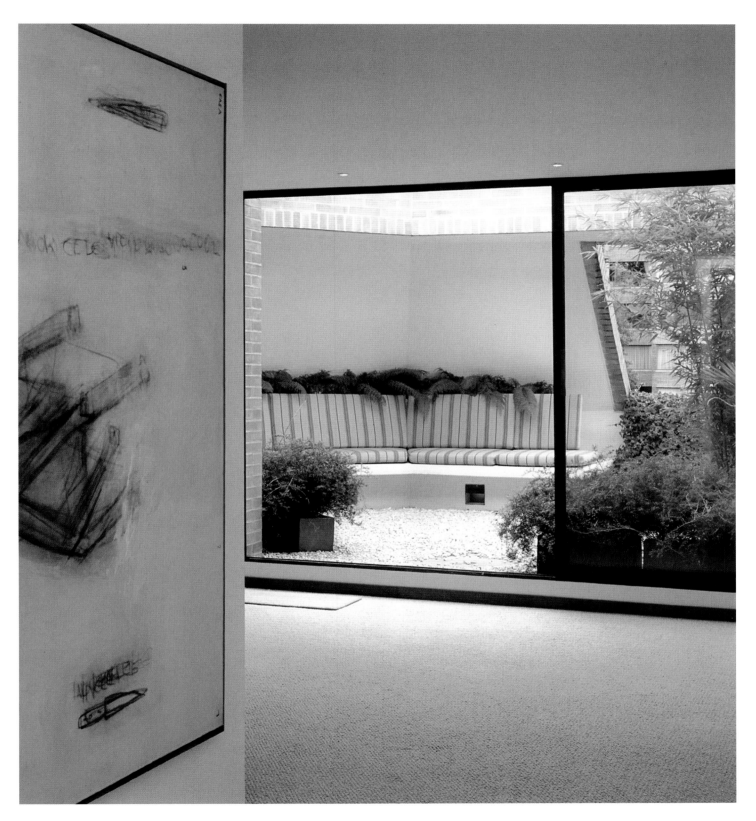

The light flows from the top of the penthouse to the interior, where the white walls and wood floors stand out.

HEALTECTURE KOMORI

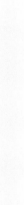

This building, located in a suburban neighborhood in the city of Osaka, is home to two generations of a Japanese family. It is laid out in two clearly defined areas: the work area is on the first floor, and the rest of the building is designated for living quarters. The client, a former researcher for a major pharmaceutical company, needed a space for attending his patients and for medical research. The building, located in a densely populated area, was designed to be a flat and open structure. The dynamism of its external shape, which was inspired by the energies of the body, responds to the need for a dialogue with the activity that takes place around it, and hides any stagnant and obstructive elements.

To increase the field of view from inside, a glass façade was designed so that the front part of the structure is always unobstructed and lets in light. The other sides of the building were covered with undulating steel panels that were shaped to fit its curving form up to the top of the building.

The first floor includes two clearly defined areas in a single open space: a pharmacy for Chinese medicine and an acupuncture clinic. The rest of the living space, which is oriented east to west, is arranged on the two upper floors. A spiral staircase connects the lowest level to the third floor; from there a fourth level containing the attic can be accessed. The building is topped with a north-facing gallery, from which the beautiful panoramic views can be contemplated. Through it the light bathes the bedrooms located on the north side of the building. Crowning the roof is the glassed-in deck, which constitutes the top level of the house. Constructed with a translucent double layer, it allows the light to flow downwards into the different levels of the structure.

ARCHITECT: **Endo Shuhei Architect Institute**
PHOTOGRAPHER: **Toshiharu Matsumura**

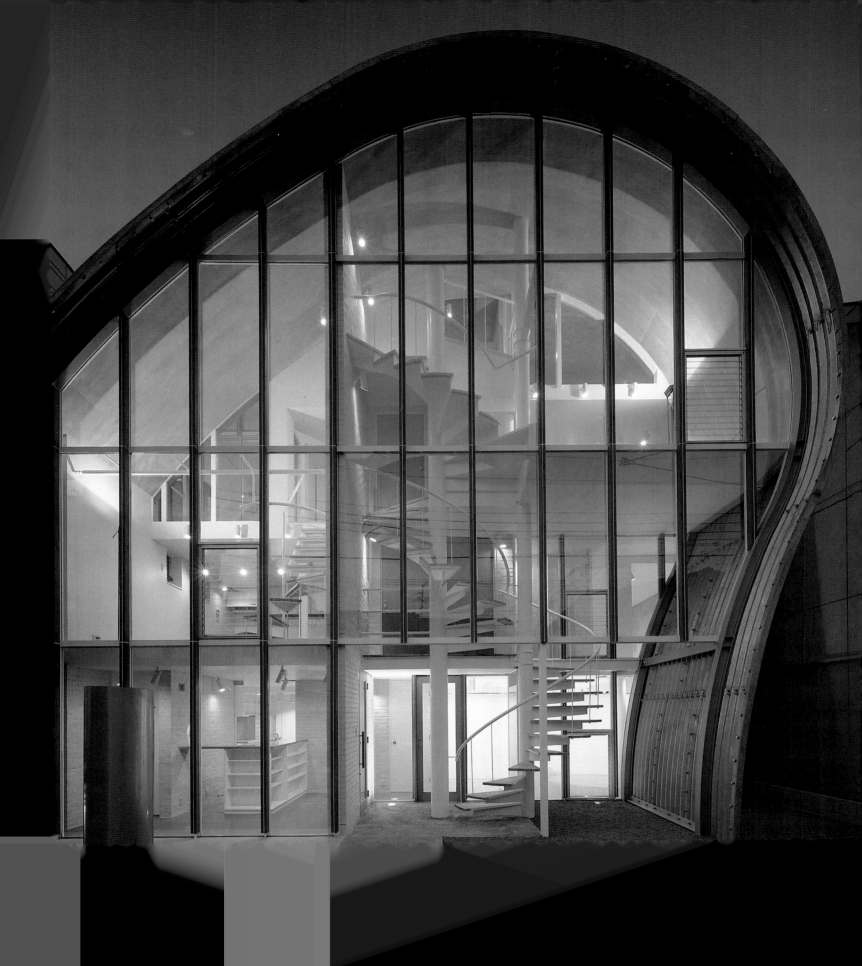

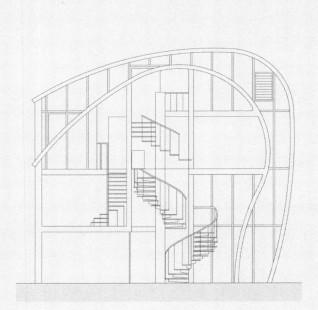

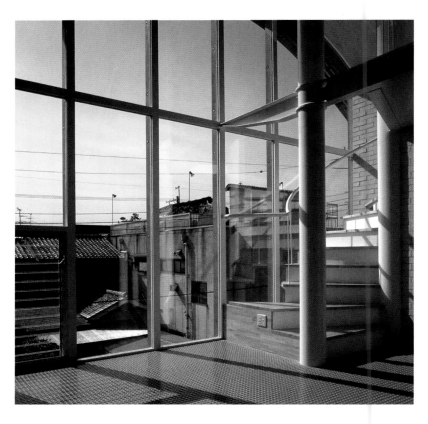

Curved steel plates, inspired by the energies of the body and intended to add dynamism to the structure, were attached to the upper part of the façade.

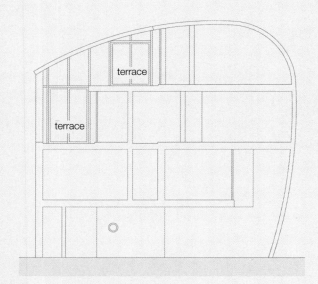

terrace

terrace

Sections

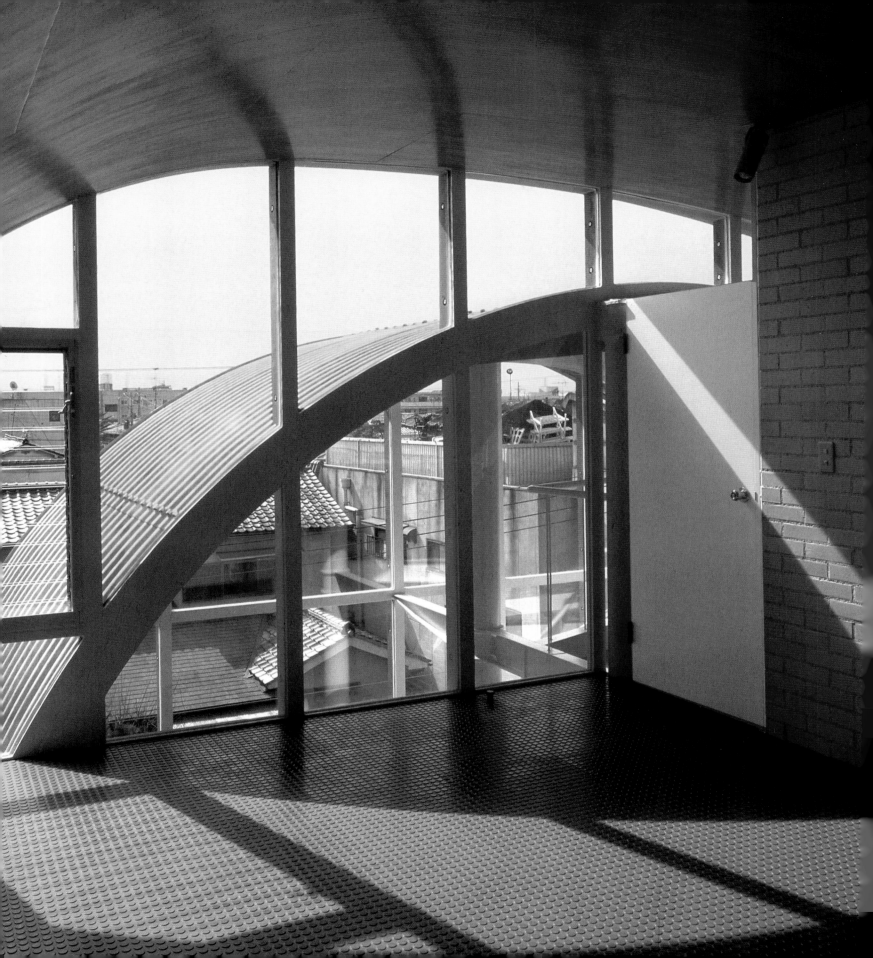

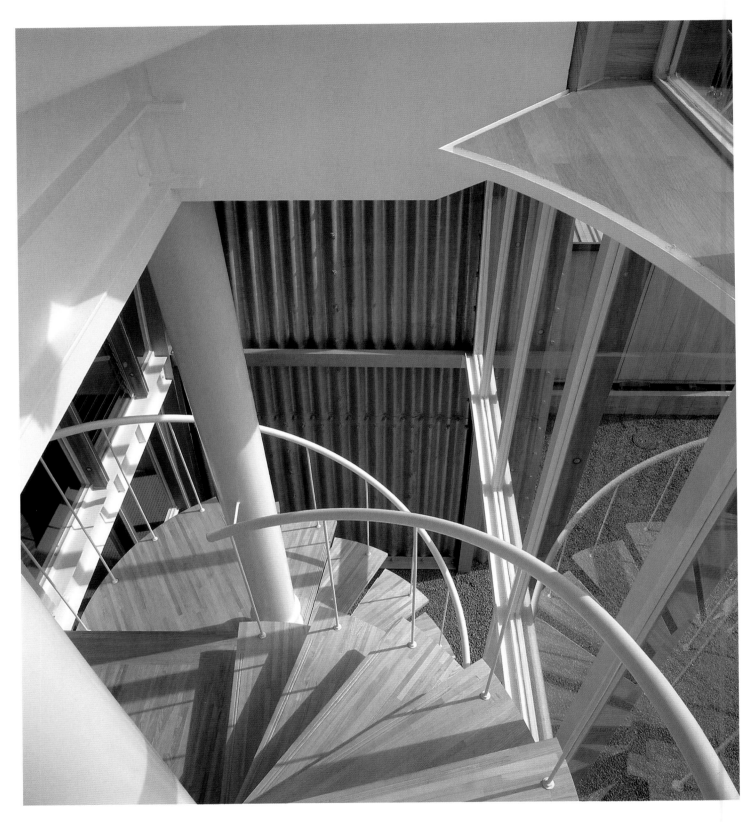

A spiral staircase extends through the different levels of the building to the gallery, which crowns the setting and functions as an interior balcony.

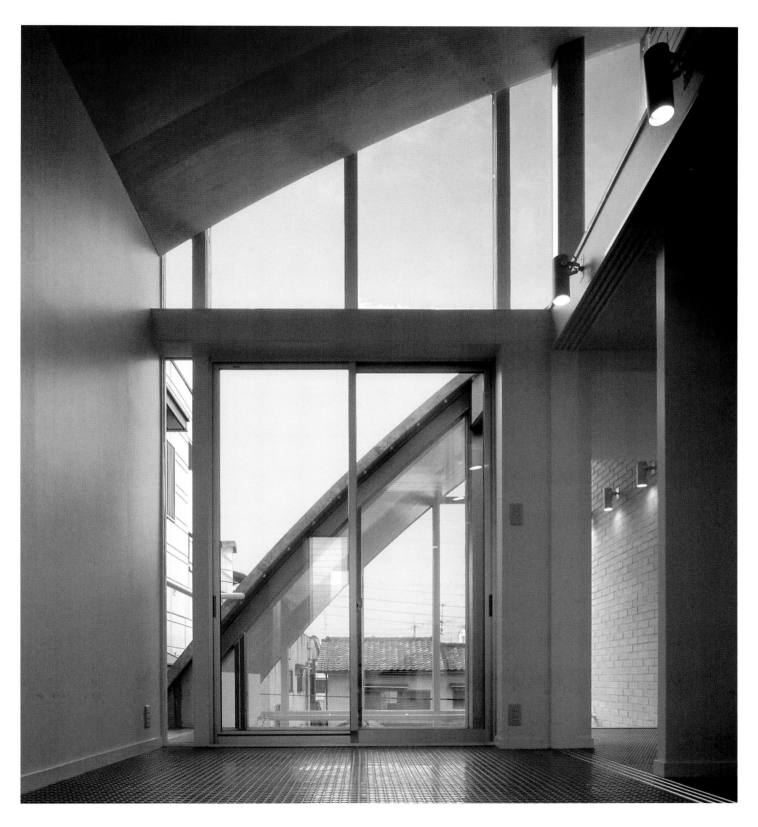

The glass deck roof, constructed with a translucent double layer, allows light to flow through the different levels, capturing the subtle movement of the exterior architecture.

K-HOUSE

As a starting point for the project, the architects designed an architectural structure to serve as ribs for the walls that support the building. The idea of creating a reinforced frame was carried out by constructing 7-inch thick walls with a single reinforced base. The architects describe the project as a "shelf structure," since this type of architecture looks like it has reorganized the different spaces up to the top of the building.

A metal staircase leads to the top "shelf," the highest one, where a bathtub is intentionally located beneath one of the main skylights. The shaft of light that falls directly on this point emphasizes its important role on the top floor of the building. A red armchair also stands out on this "shelf," adding an accent of color in an environment of neutral, relaxed color and materials. In the middle level, the architects decided to install a compact kitchen that is also used as an eating area. While the cooktop is located at one end, the rest of the surface is used as a dining table. Finally, the bottom "shelf" houses the living room, which contains a piano and a small study area. This space is located next to the home's garage.

The team of architects created a unique and incredible layout with this novel structural system, bringing with it a more rational space that has a functional and repeating traffic pattern.

ARCHITECT: **Architecture WORKSHOP**
PHOTOGRAPHER: **Daici Ano**

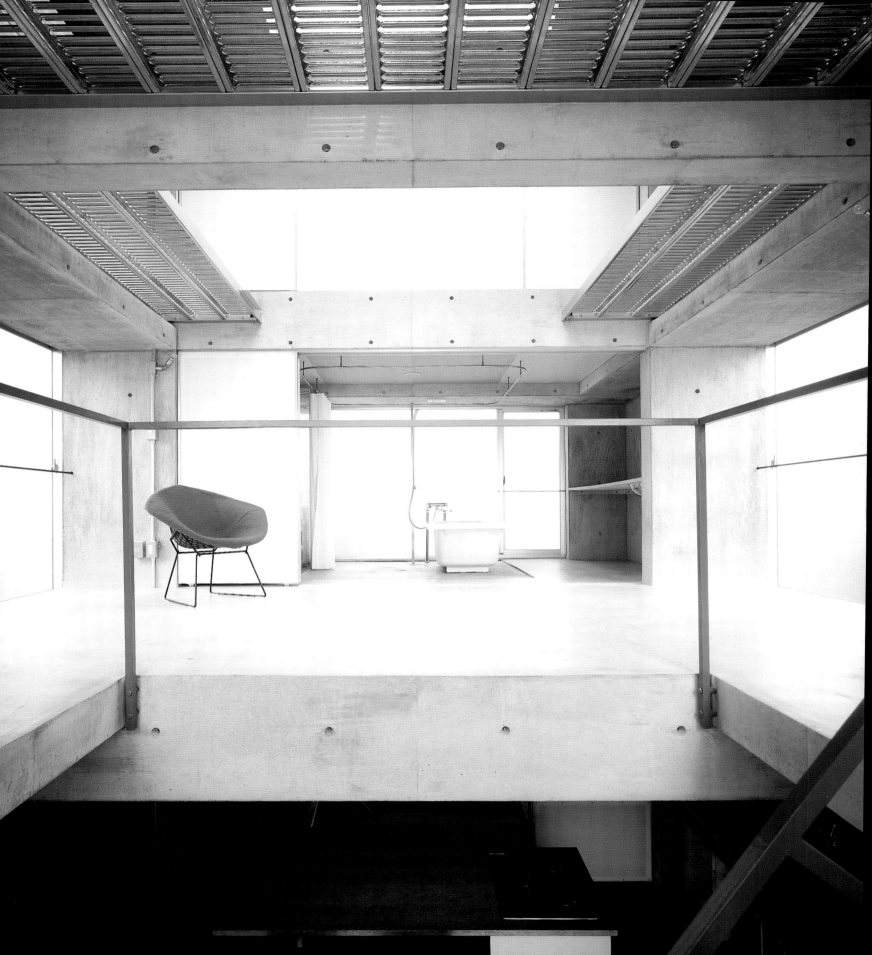

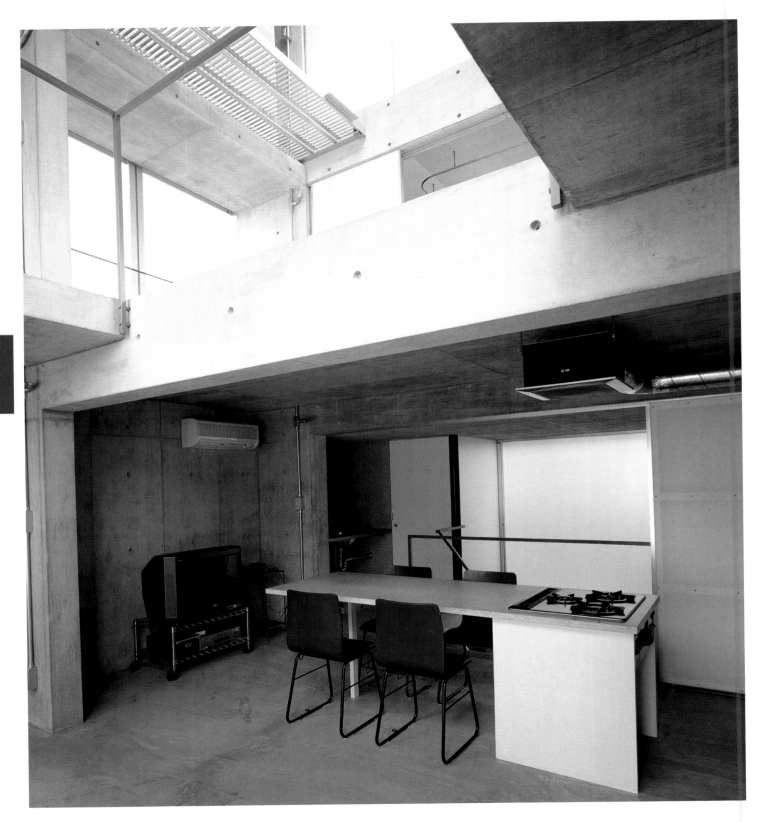

In the highest part of the building, a bathtub sits directly below a skylight, making it the focal point of the setting.

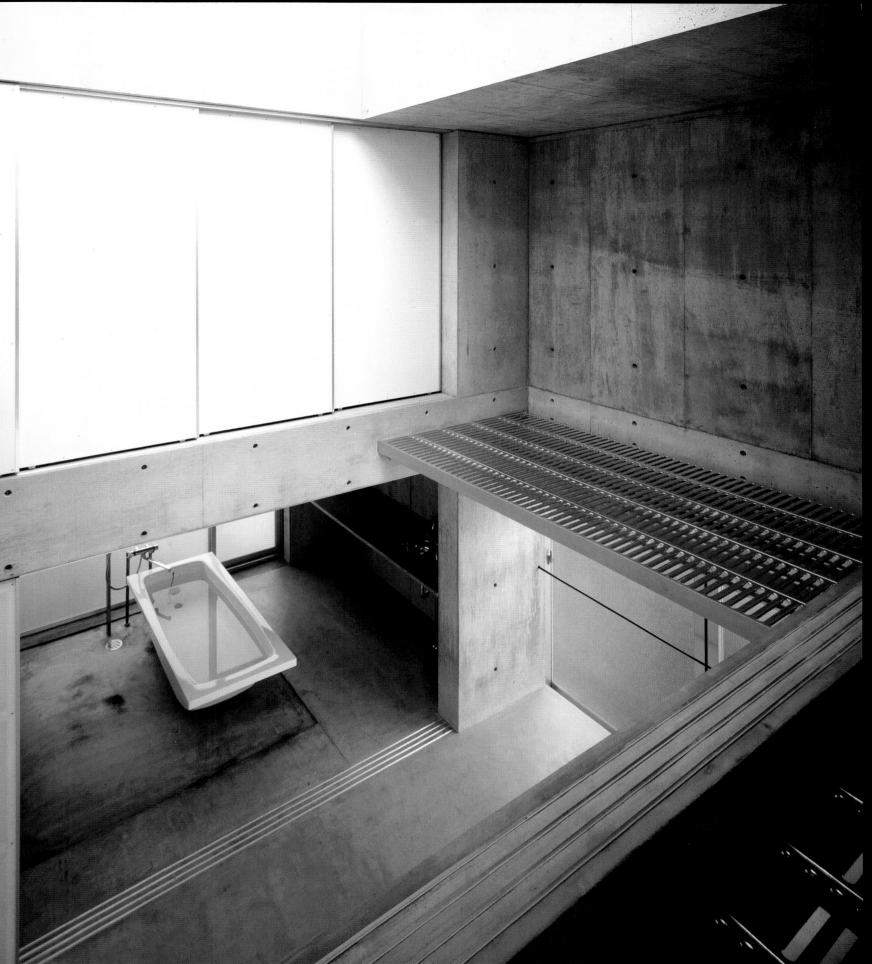

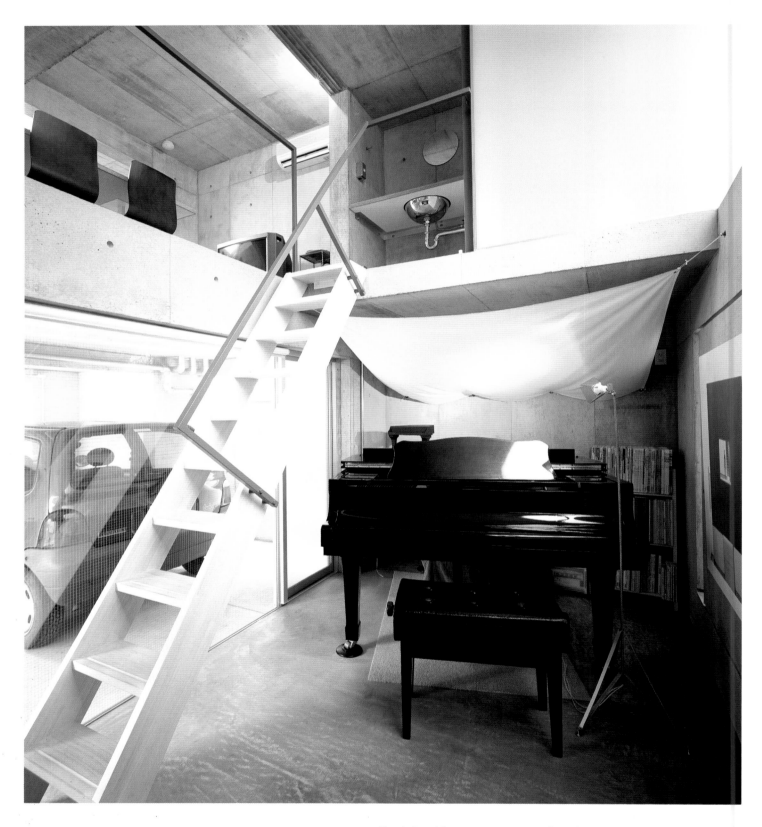

The design of the uppermost structure allows the midday sun to penetrate the interior and flood the central setting.

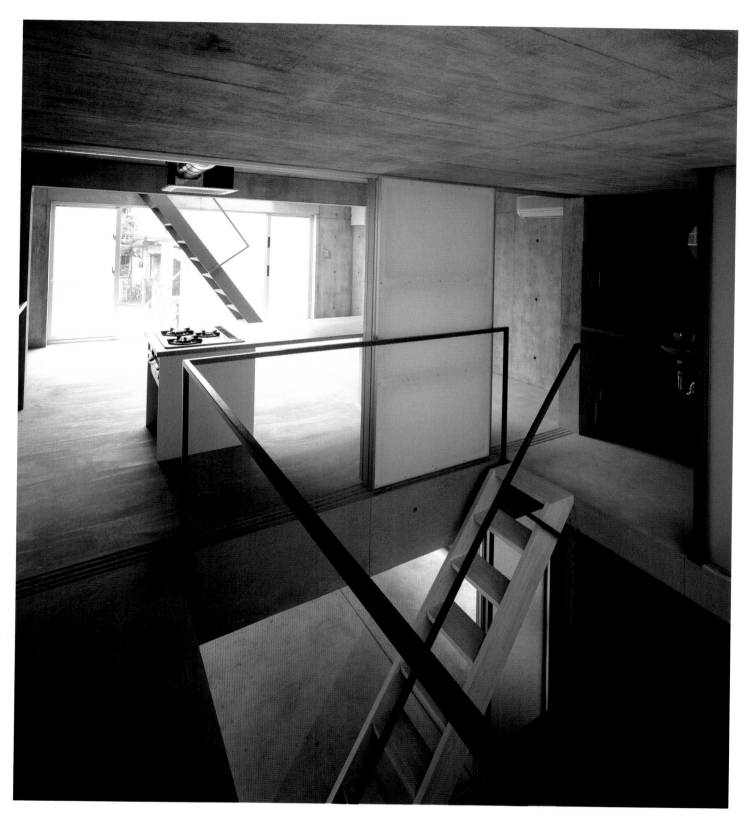

A metal stairway accesses the different levels, ending at the "shelf" that touches the roof of the building.

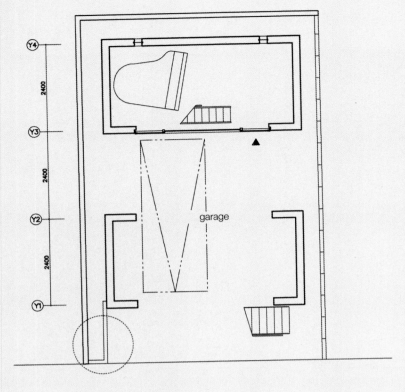

First floor

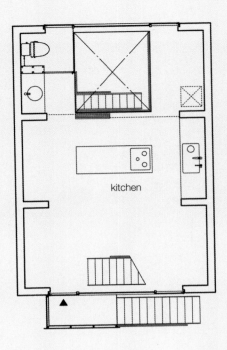

Second floor

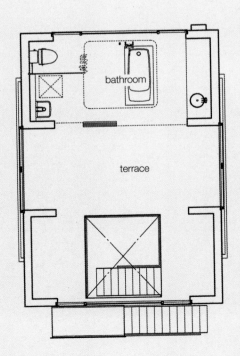

Third floor

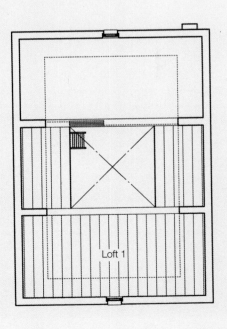

Fourth floor

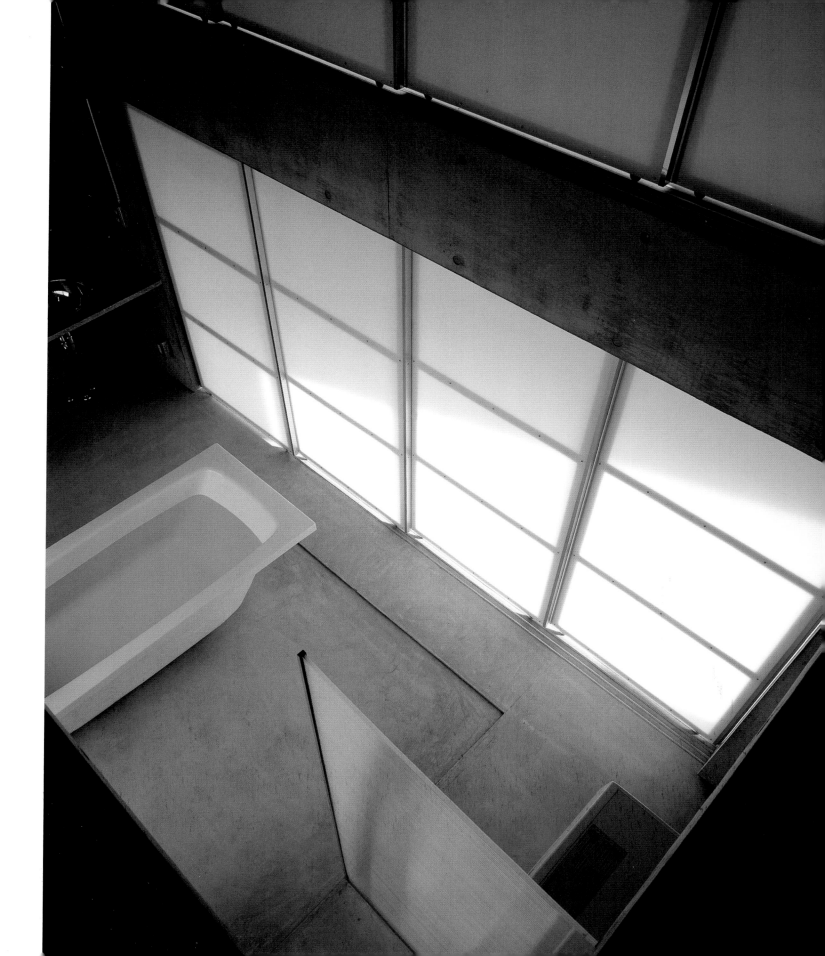

ALICE

Before designing this residence, the architect Norisada Maeda made an analysis of the original lot, since it was extremely large and rectangular. Located in one of the most commercial neighborhoods of Tokyo, Alice is the antithesis of the classic urban apartment. The client suggested the following approach for creating a personalized home: construct a pool in the upper area of the residence as a focal point, where different green spaces could be enjoyed, mitigating the chaos of the crowded city.

The intervention in the top level of the dwelling was one of the architect's main objectives. This space contains a bedroom that connects to a terrace, which provides views of the city, as well as a panorama of all the rooms of the house, including the strategically placed pool. The pool is located several meters above ground level. From above, it can be seen extending horizontally towards the exterior, floating in the middle of the concrete. A glass wall with a double function was created on the main façade as an architectural solution. On one hand, it keeps the cubic container separate from the rest of the structure, and on the other, it promotes the connection between two totally antagonistic settings.

Thanks to the pool, the architect was able to take advantage of the natural resources at his disposal. When it rains, countless drops of water splash on the surface of the pool, and the small waves caused by the wind encourage communication between the two different spaces. A rainbow, created by an effect of the water and the glass, can be observed from the breakfast table.

ARCHITECT: **N Maeda Atelier**
PHOTOGRAPHER: **Hiroshi Shinozawa**

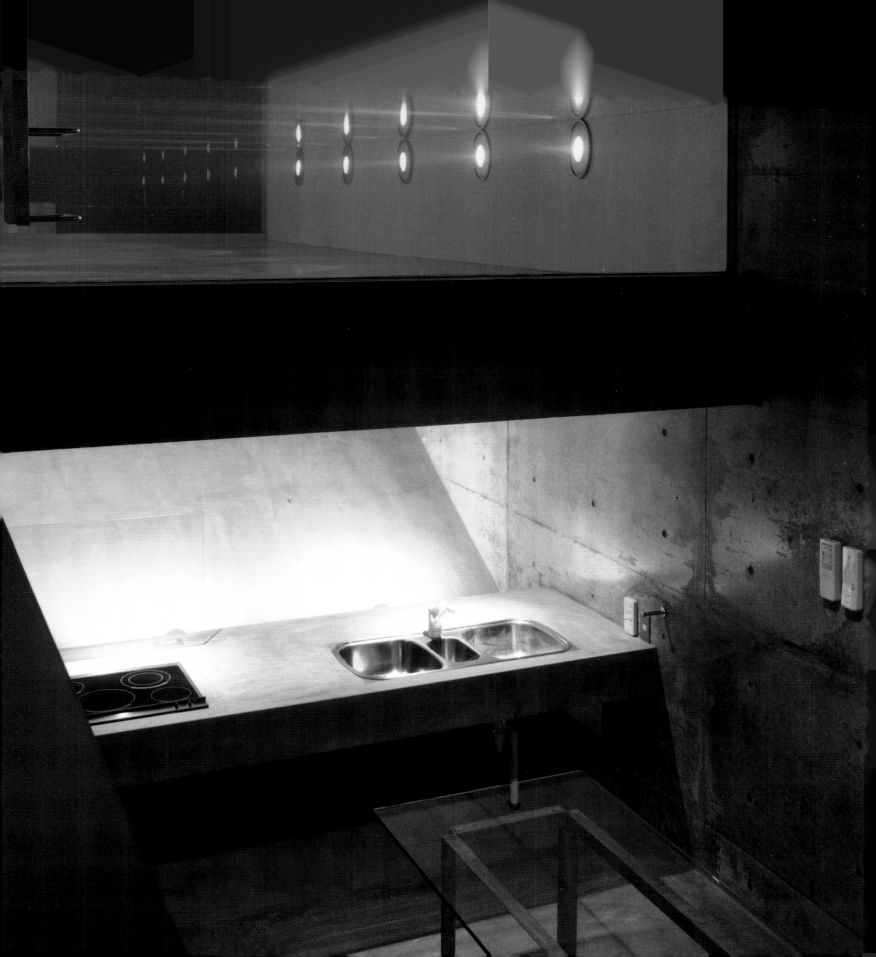

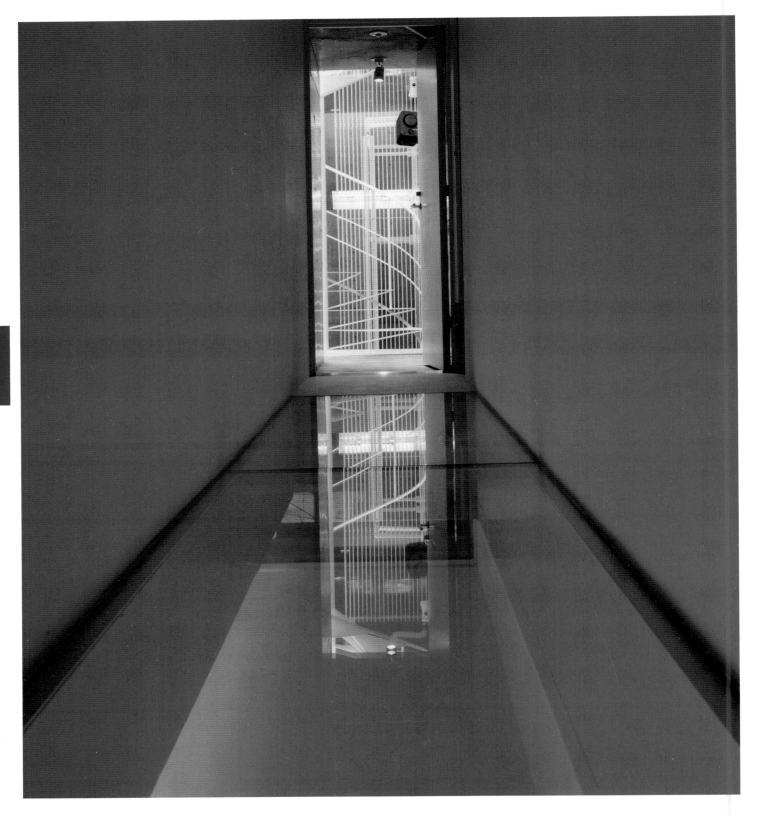

The cube-like swimming pool is located in the center of the building, catching the attention of anyone who looks towards it.

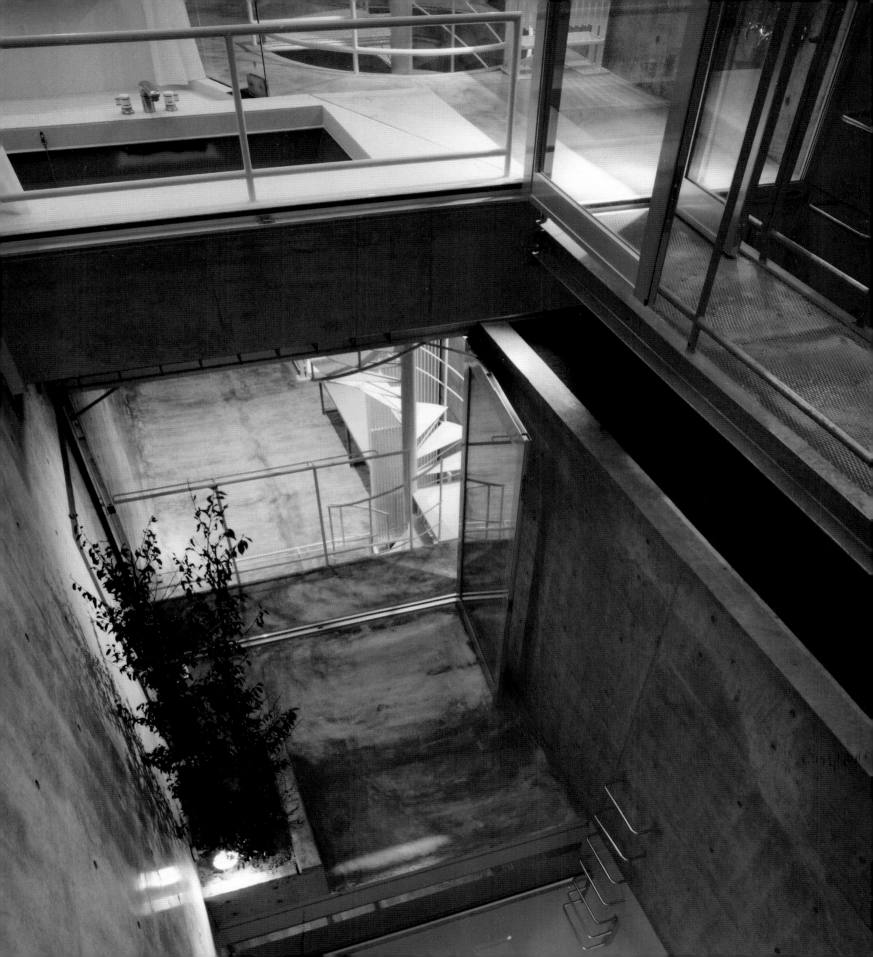

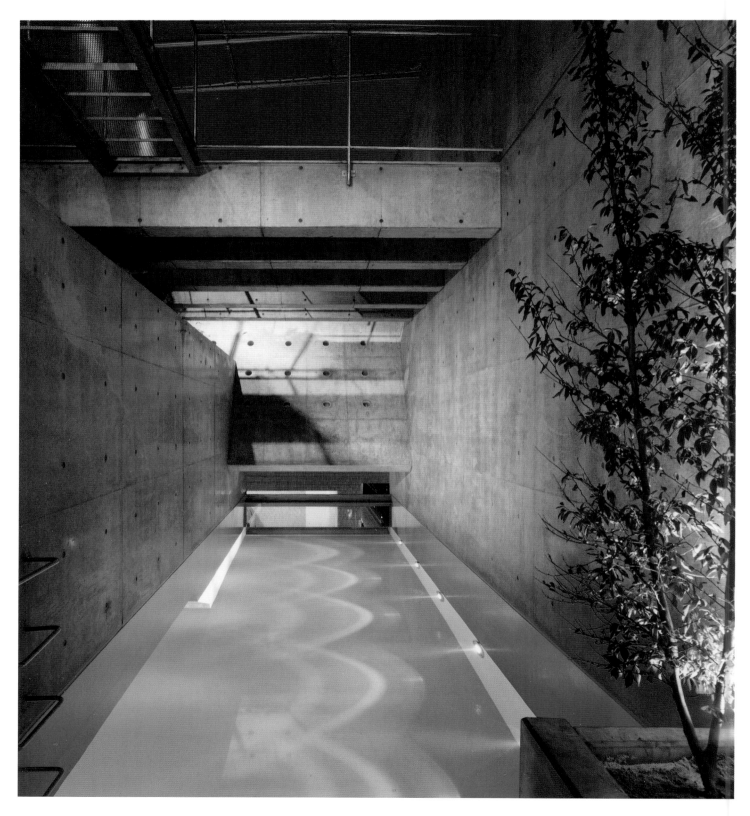

The manipulation of the perpendicular forms and height create a recurring theme in the area, establishing the green spaces requested by the client.

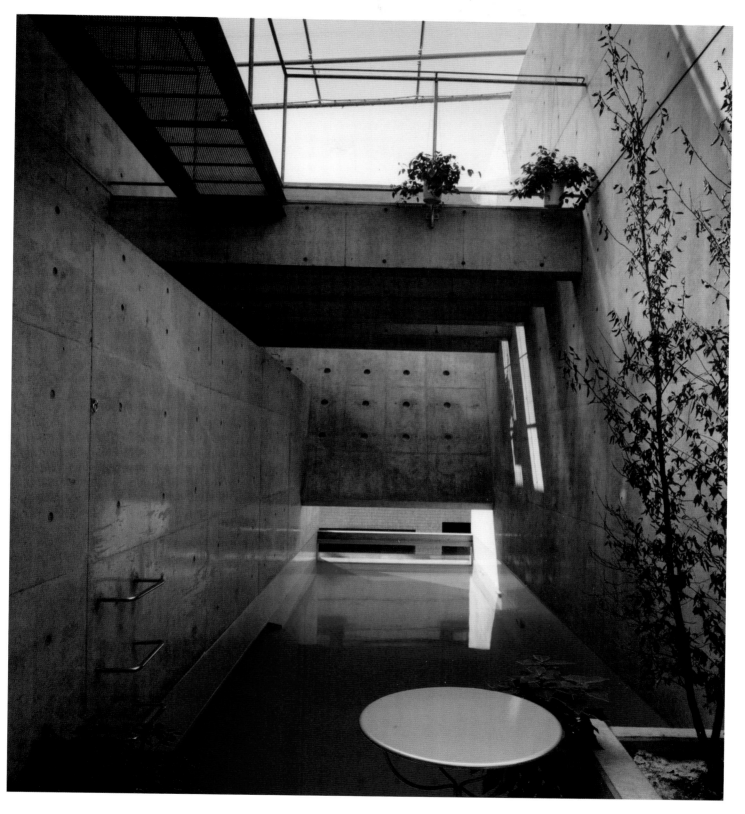

The swimming pool stretches across the middle level of the building and extends beyond the main façade. From the outside, people can be seen swimming and reaching the front of the pool as if it were the railing of a terrace.

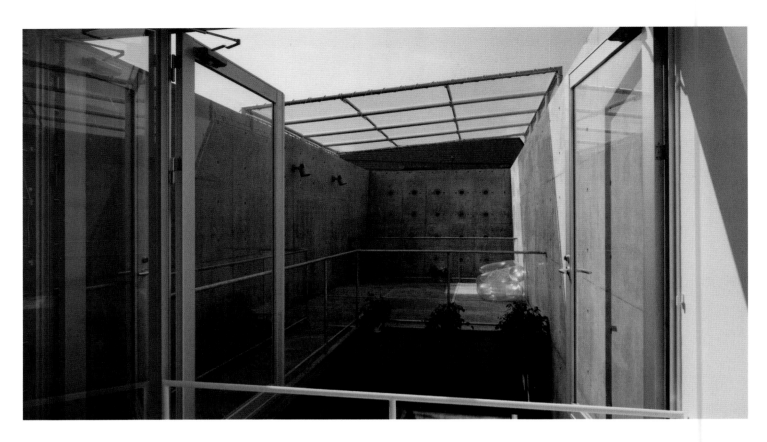

A terrace on the top floor becomes another privileged spot in the building for escaping the commotion of the city of Tokyo.

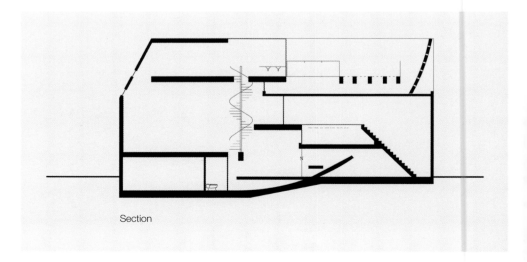

Section

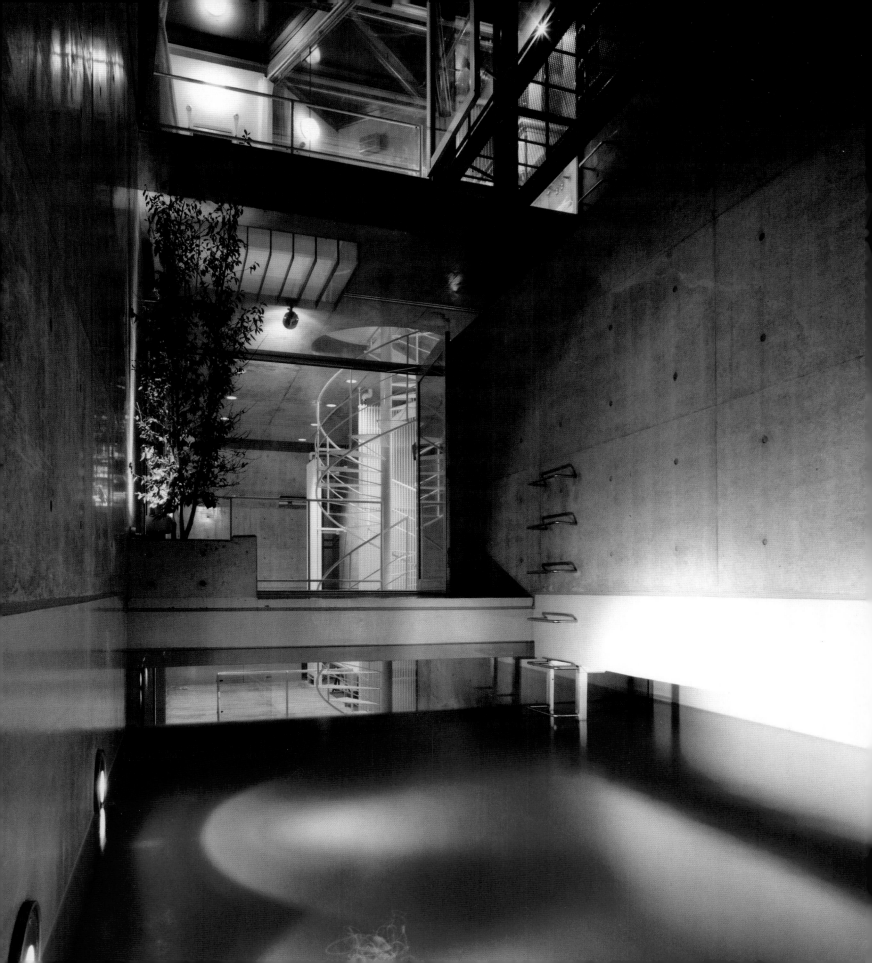

C-HOUSE

The building, located on the outskirts of Tokyo, encompasses two different urban functions: a single studio apartment and a coffeehouse, both owned by the same client. The project, approximately 645 square feet, came as a solution to a building that had to be erected at a busy intersection where two secondary streets converged. The architects not only had to keep in mind the two main architectural functions, but also had to take into account the modern Tokyo lifestyle.

The project represents a study of contemporary social life and what the microurban world is like inside a building. The structure of the coffeehouse is completely transparent, both its floor and the upper part. The transparent glass structure of the coffeehouse above surrounds the residential unit as if it were an extension of the outside world. The see-through design of the shell blurs the boundaries between the outside and inside. From the exterior, the activity that takes place in the coffeehouse on the upper level is completely visible. However, the lower level, which contains the residence, looks like an opaque and floating volume, and people on the outside of the building are unable to see into it. One of the notable features of this design is that each unit, the residential as well as the commercial, has separate access from the street.

The residential or studio environment is rendered as a minimalist and functional space where there are no superfluous elements. The house facilitates a positive and extreme compromise with the city's public property, and suggests an analysis of the traditional view of a residence as an enclosed cosmos for individual life.

ARCHITECT: **Toshimitsu Kuno + Nobuyuki Nomura + Tele-Design**
PHOTOGRAPHER: **Tatsuya Naoki/Tamotsu Matsumoto**

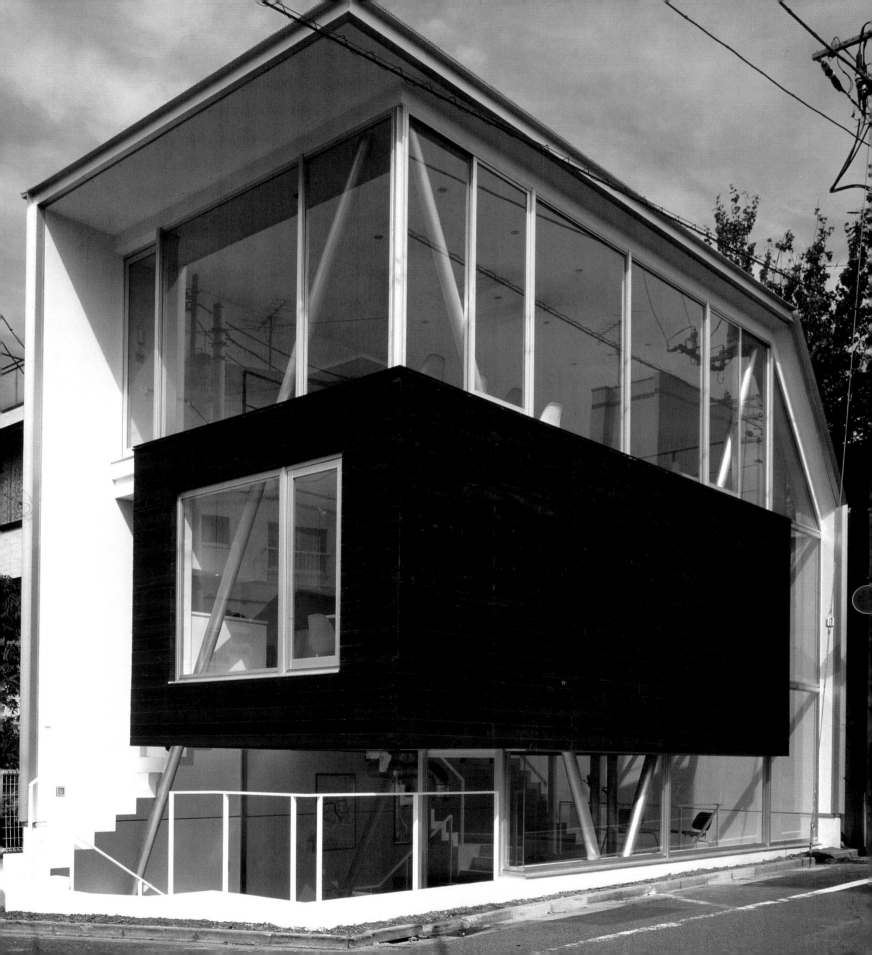

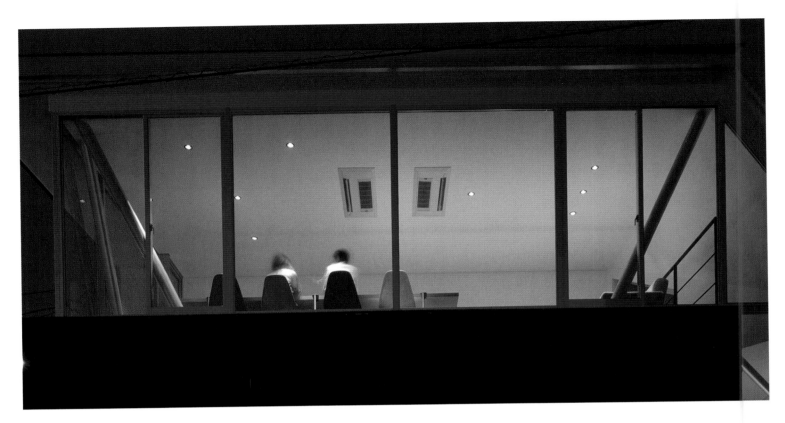

The coffeehouse, located on top of the building, can be seen from the outside, extending around the opaque box of the residential unit as if floating above it.

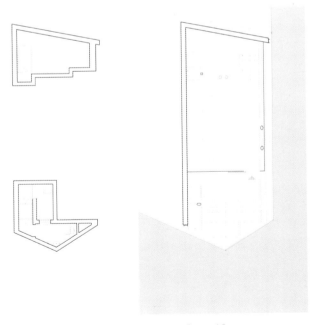

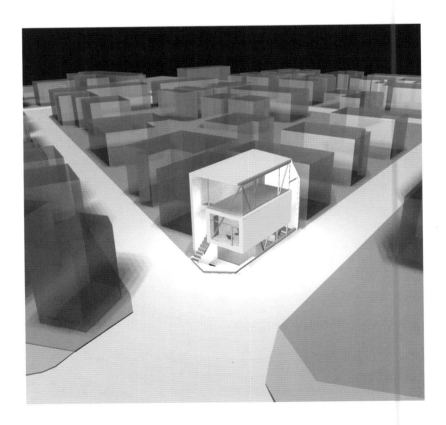

First floor

Second floor

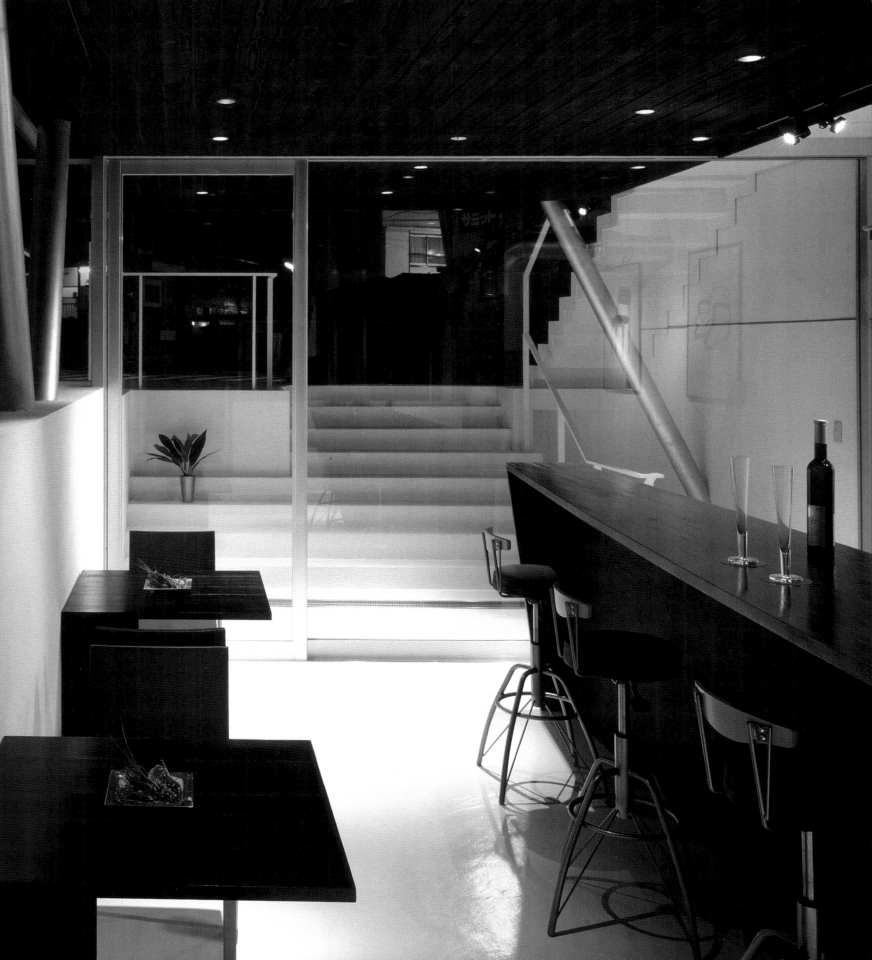

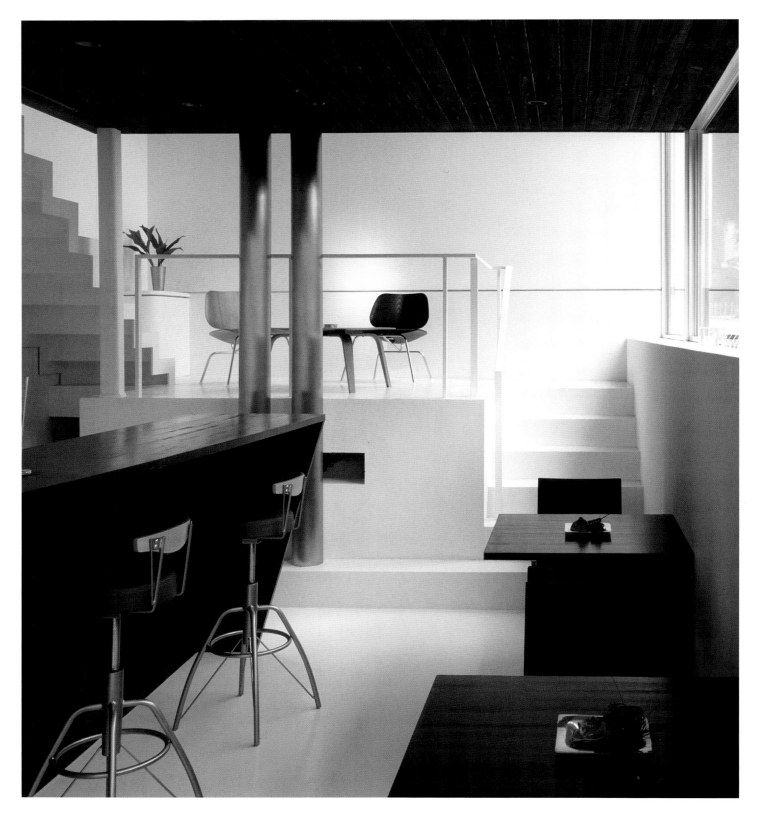

The residential box is kept closed and inaccessible to prying eyes, a reflection of the intimacy of the space.

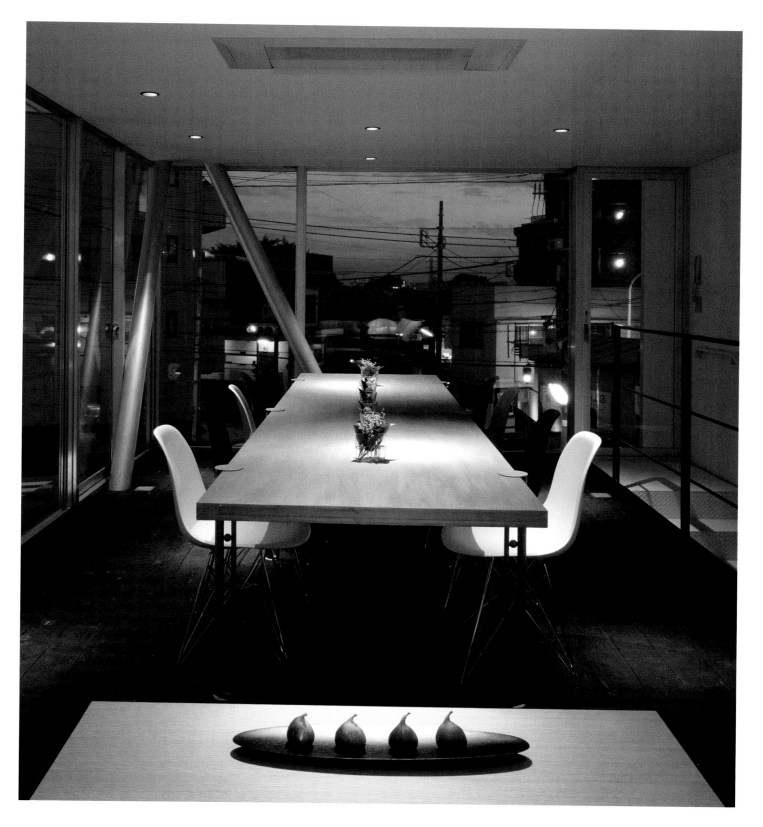

The glassed-in and transparent structure of the coffeehouse is like an observatory, allowing the surroundings to be appreciated.

WEB

The architect used a very simple plan to design this residence. Instead of employing the usual method of erecting a structure following a predetermined rectangular floor plan, he used this base to create an atypical puzzle. It consists of five elevated volumes that are arranged like floating elements up to the ceiling. When looking up, this arrangement appears to be a web of glass boxes.

The significance of this recurrent design is that the occupants of this building can choose the most appropriate module according to their daily activity: top, middle, bottom, or in between the various boxes, according to the "rules of insertion" as defined by the architect. To create living spaces between the boxes, a clear, glass floor was installed between the elevated volumes that form the modular puzzle. This architectural structure, which has only walls to vertically divide the space along with the three horizontal levels of the building, configures the entire living space.

From the outside, the architecture appears to have too many levels, but the concept behind the style of the house is that of living in a dynamic space, full of elements that combine and interact with each other. This system allows the residence to be enjoyed if one keeps in mind the ephemeral and versatile choices that are available at any time of day.

ARCHITECT: **N Maeda Atelier**
PHOTOGRAPHER: **Nacása & Partners Inc.**

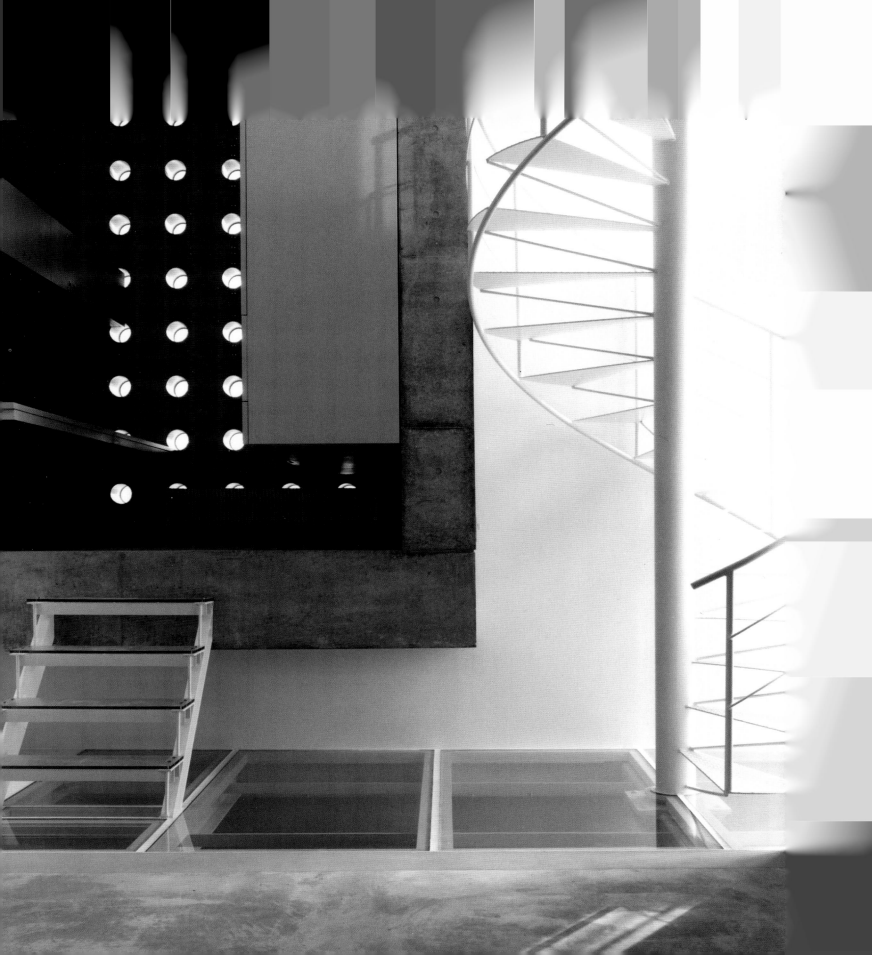

From the outside, the façade reflects the combination of interior spaces, revealing the relationships between the volumes.

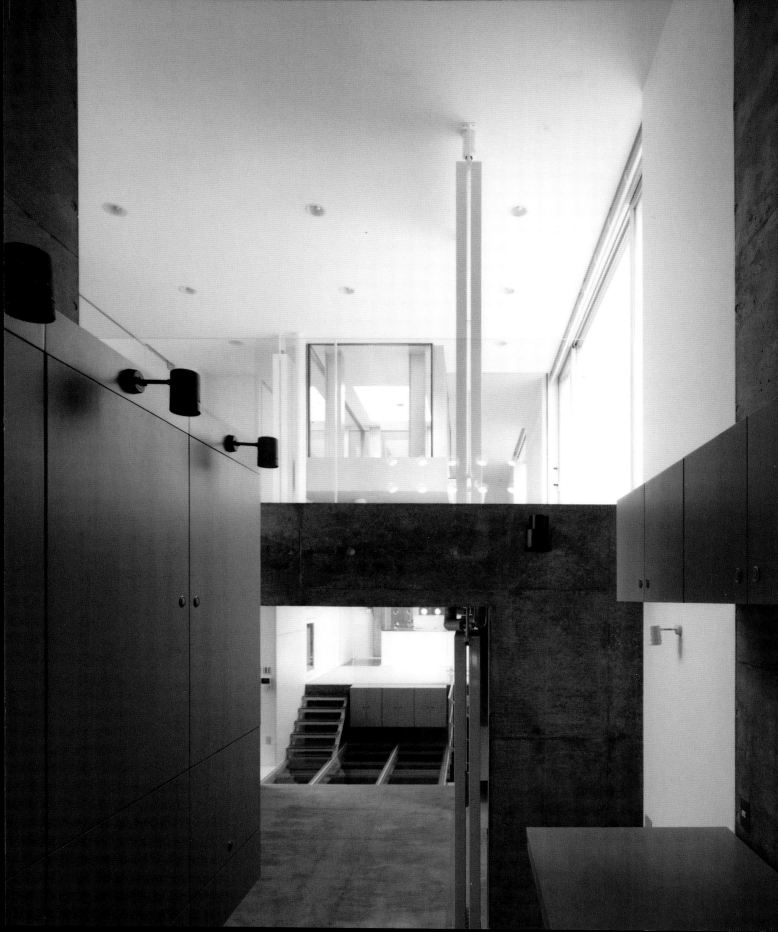

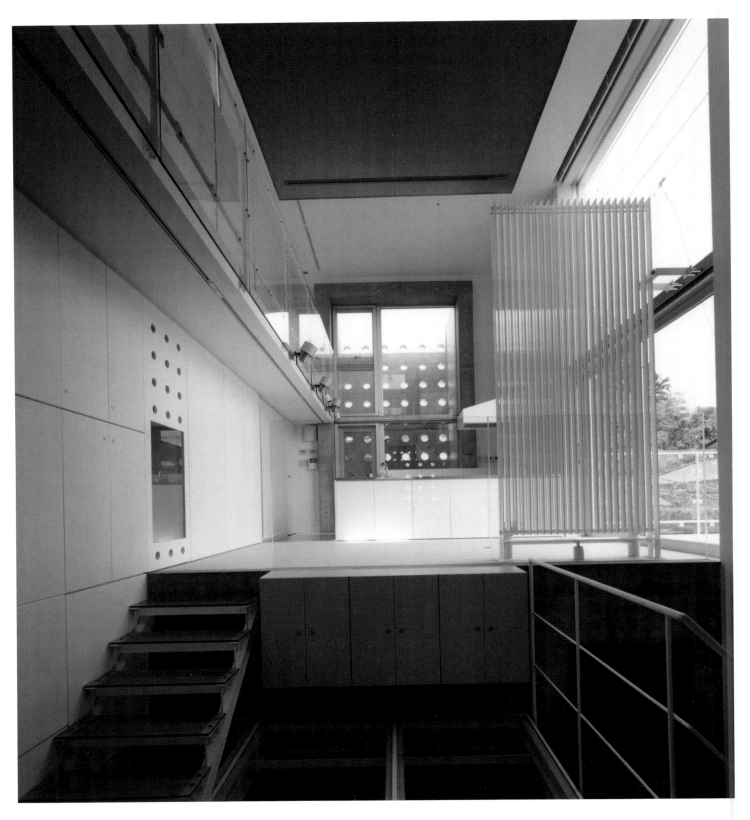

Looking upwards from the inside, one can see an atypical puzzle consisting of five volumes, which house the rooms, arranged like floating elements at the top of the building.

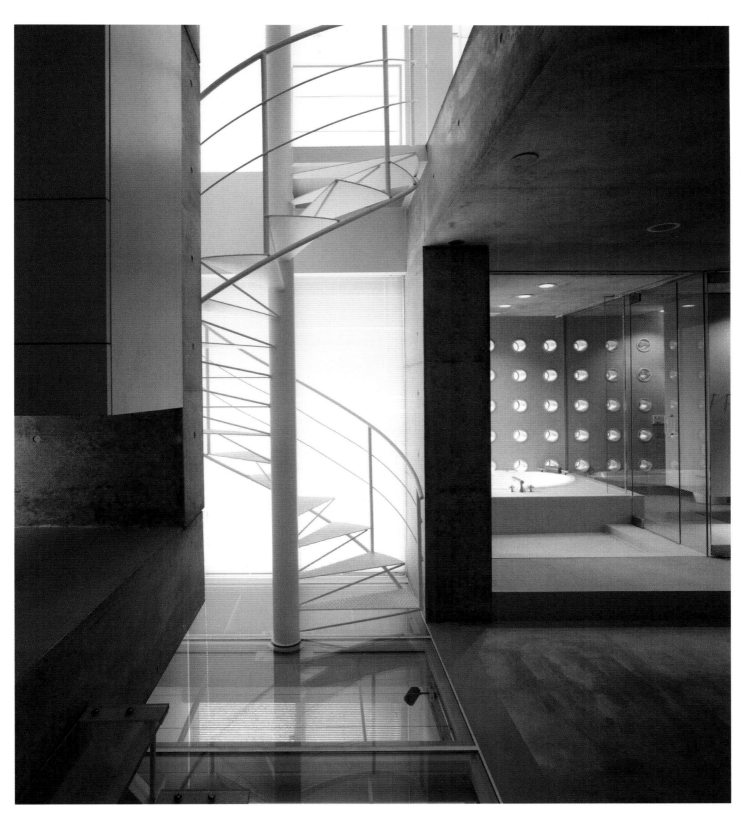

Between the boxes are clear glass floors, which are meant to create additional living spaces.

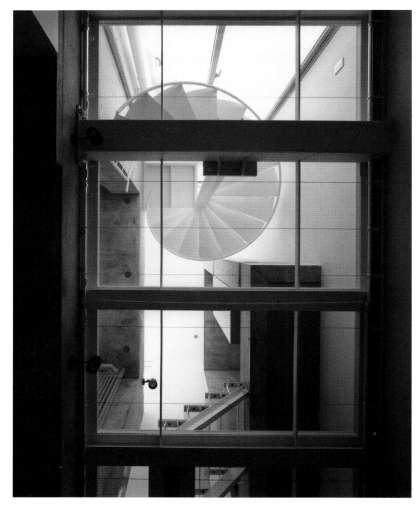

The occupant can choose the most appropriate room for the needs of the moment. Upstairs, downstairs, middle, or between the boxes, the interior becomes a subjective and versatile dwelling.

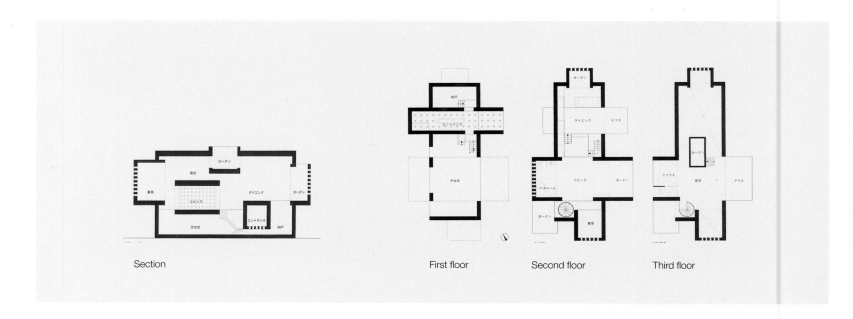

Section

First floor

Second floor

Third floor

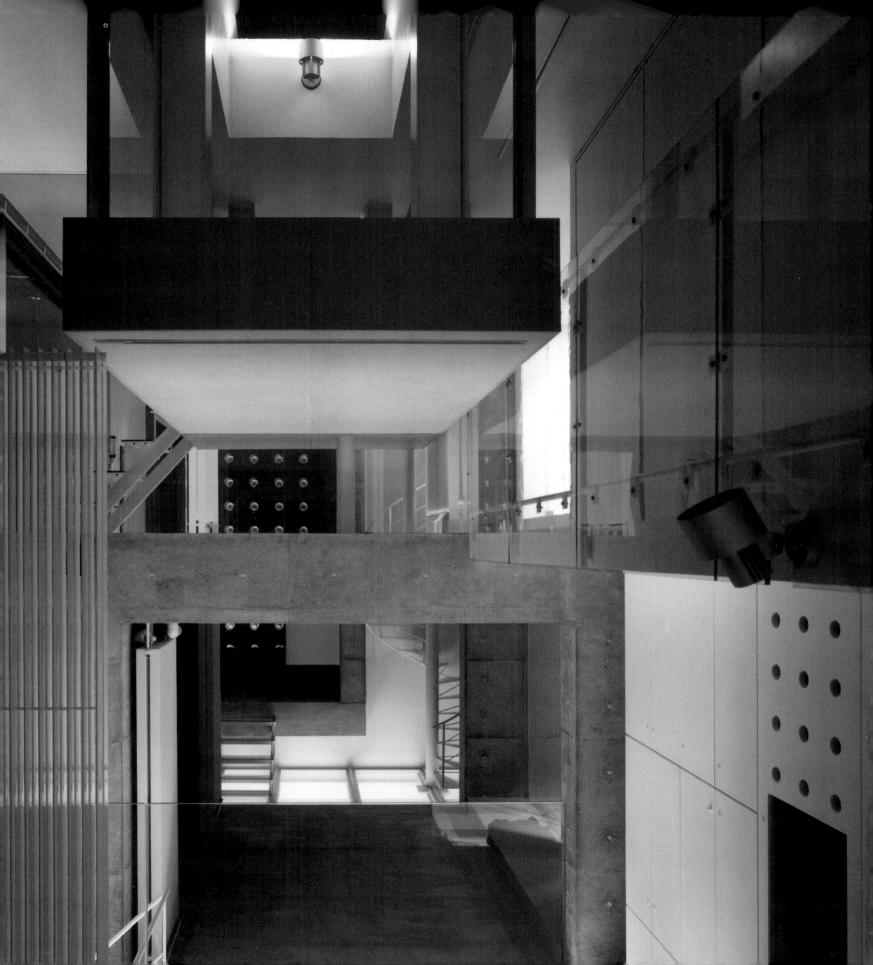

HAUS 23

Built during the 1930s, this residence was first remodeled in 1966, when the floor plan was changed to create three different apartments. Unlike the old building, this interior is well lit, taking advantage of its orientation toward the sun to capture all the light in each room. In the most recent remodeling, the architect departed from the original structure, covering the interiors with different materials and surfaces that create interesting relationships between the volumes that would have been unimaginable in the initial structure. The wood ceiling on the top floor of the residence slopes to create areas that are protected from direct sunlight. The structure has an open feeling, and elements that are usually located in closed spaces, like the bathroom or the kitchen, can be seen in an intermediate and undefined space, half protected by the roof.

The spatial ambiguity of the various interior environments is emphasized, because at the top they are open to the exterior, and the light floods into them to blur their boundaries and blend with them. The interwoven shadows in the interior are proof of this, resulting from the light that shines through the side windows of the structure and that filters through the skylights placed in the ceiling by the architect.

Two of the apartments can be entered directly from the street. One of them is on the ground floor; the other is located on the top floor and has some marvelous views of the surroundings. The middle level was divided between both families, with the possibility of removing a bedroom to gain more space.

ARCHITECT: **Michael Strobl**
PHOTOGRAPHER: **Pez Hejduk**

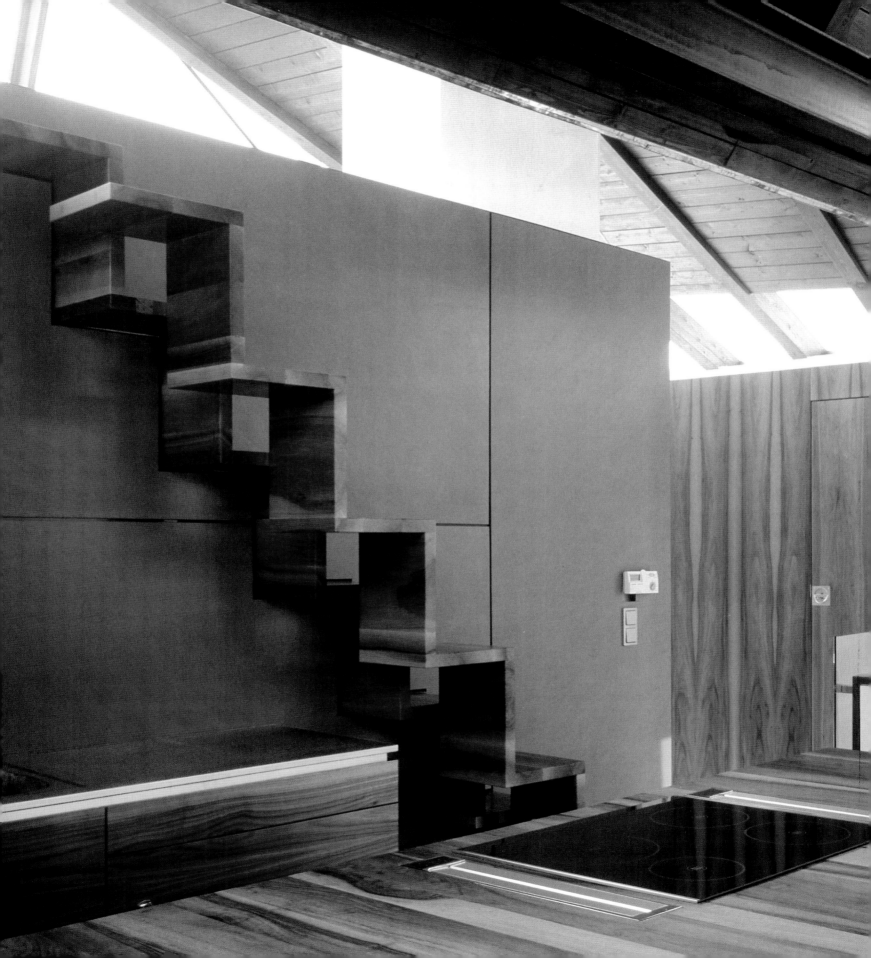

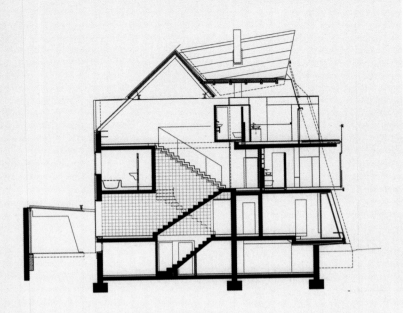

Longitudinal section

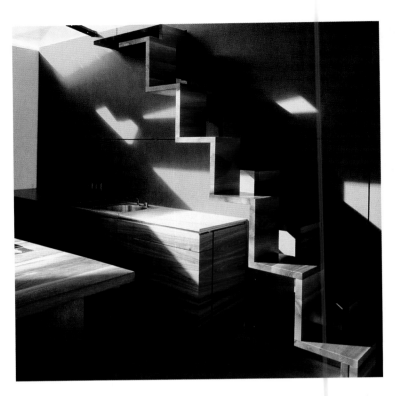

The design takes advantage of the fact that the rooms face the sun to create an interplay of light and shadows, which harmonizes with the liveliness of the interior surfaces.

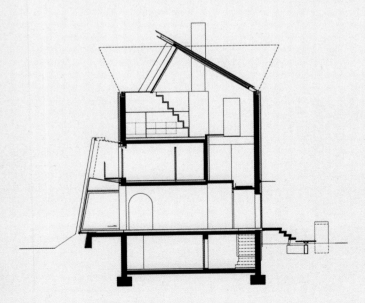

Cross section

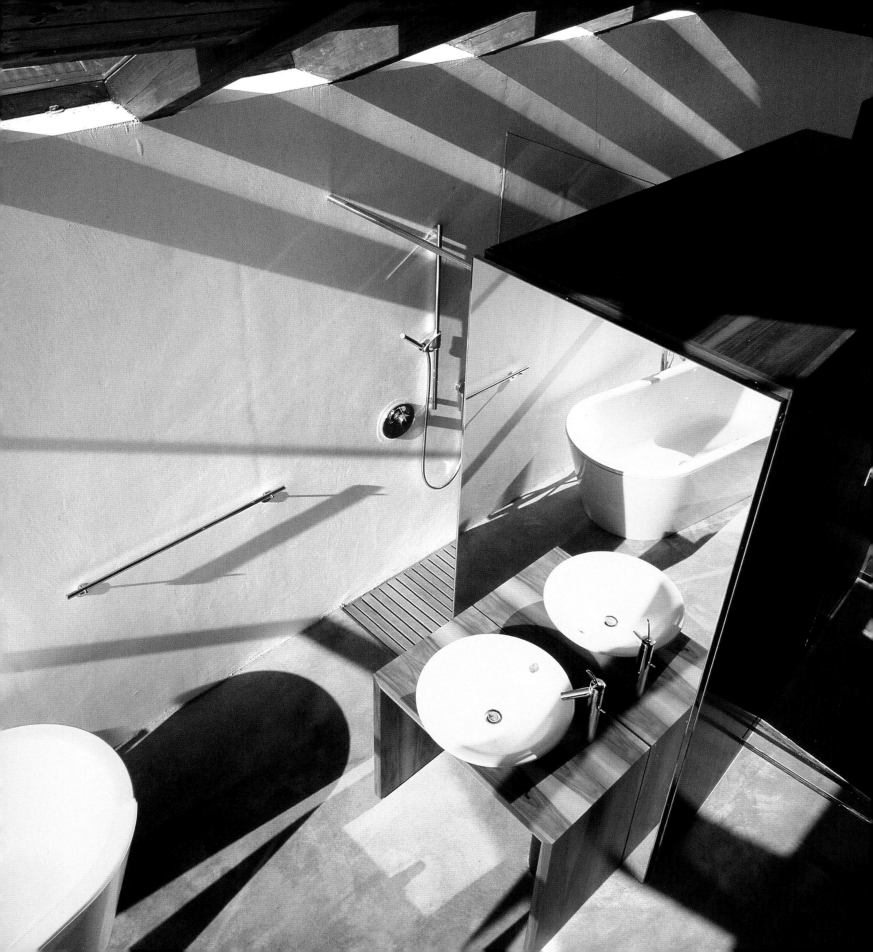

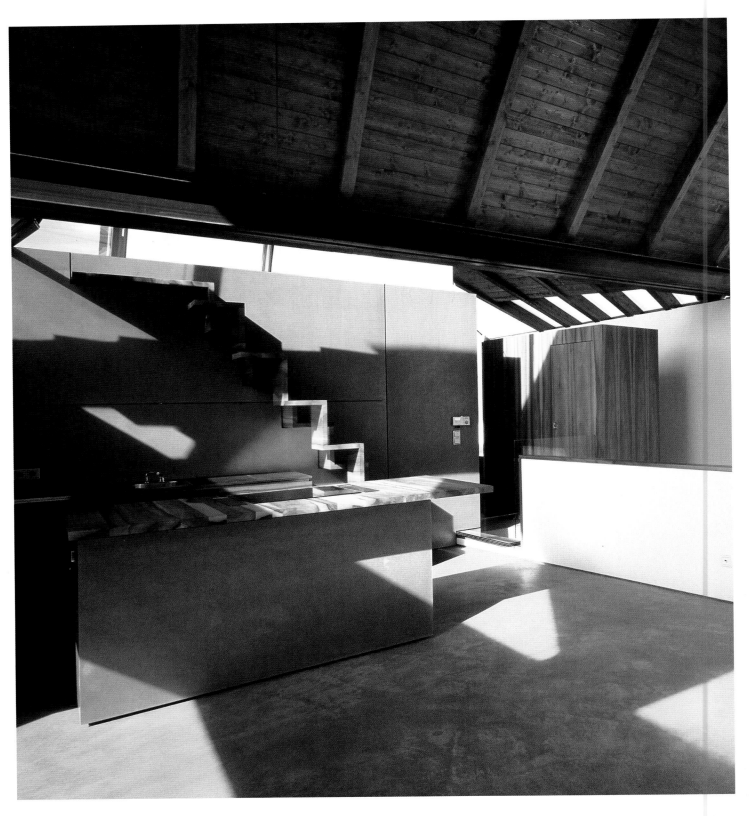

On the top floor of the apartment, the interior is sheltered under the roof, which slopes downward, while light filters through the sides.

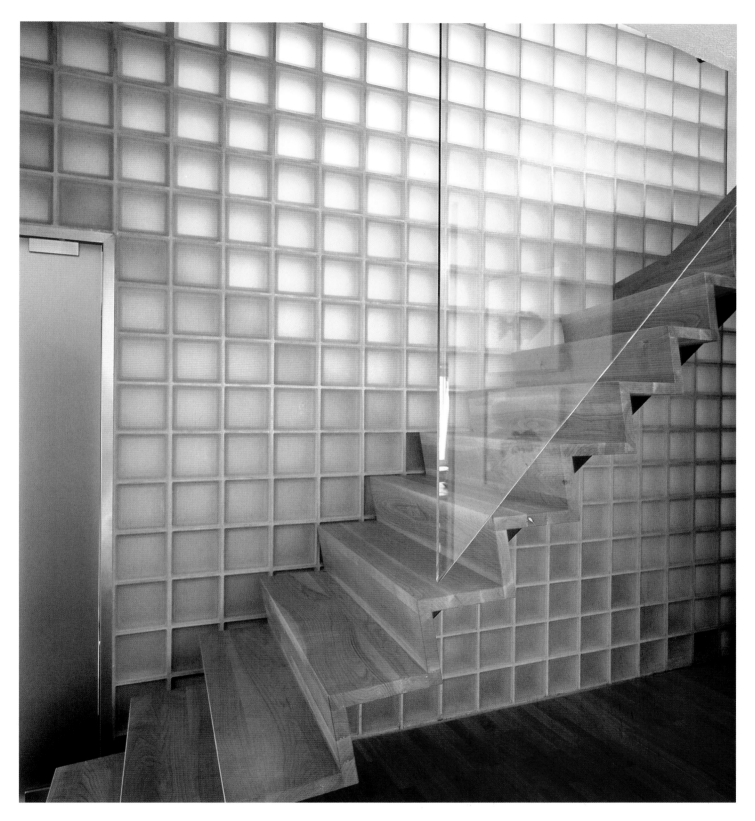

The staircase, with wood steps and an almost invisible transparent railing, leads to the top floor of the residence, which has some incredible views of the surrounding area.

TANGO

Starting with the concept of generating communication between private space and public space, the architect designed a system of five circles randomly placed in the walls of the structure. Each one of the circles contains a private room that can be used as a bedroom or a child's playroom. At the same time, the space that is behind the circles is reserved for use as part of the daytime area, like the bathroom or the living room. This arrangement allows the activities of the occupants to freely flow through the inside and outside of each circle.

If one looks up at the vaulted ceiling, the space seems complex. However, the circles are like separate stages that look as if they are suddenly emerging from each space and opening in the ceiling, capturing the essence of the setting on the top floor. Defining the private area naturally creates the public space. The resulting design would never have been possible with normal communications between the rooms.

A glasslike material was used on some of the walls for transparency and to light the interior, so that the circles installed on different levels would seem to be part of the same whole.

ARCHITECT: **N Maeda Atelier**
PHOTOGRAPHER: **Nacása & Partners Inc.**

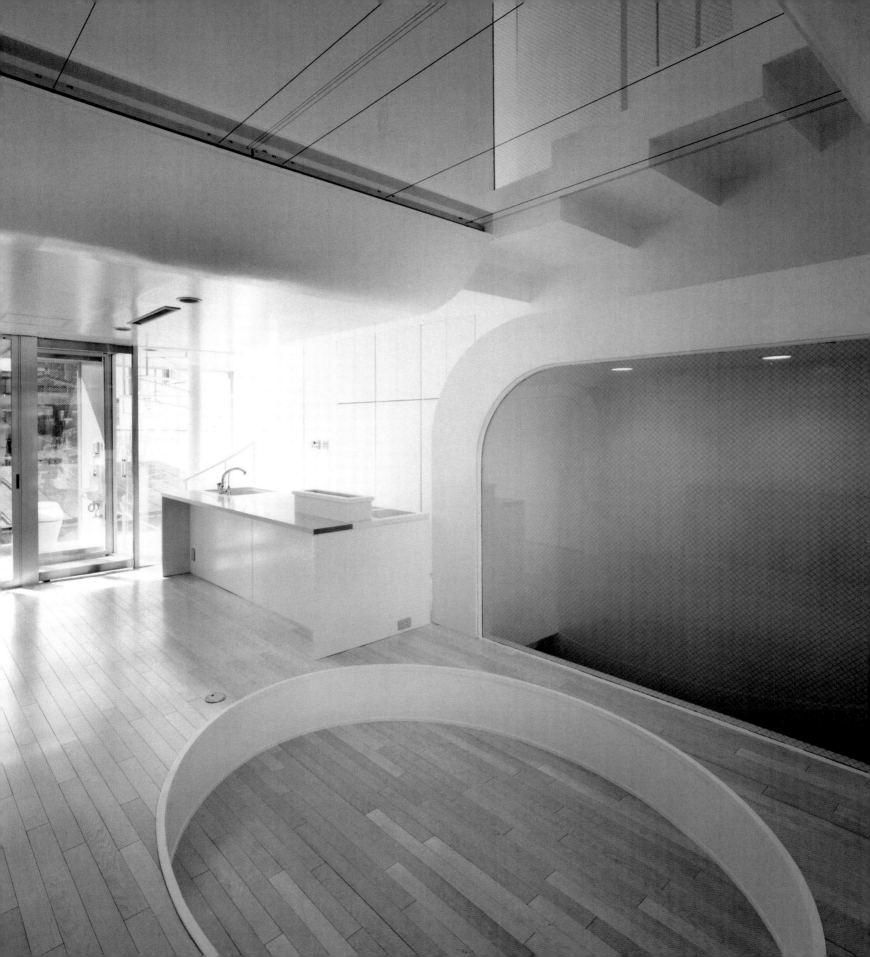

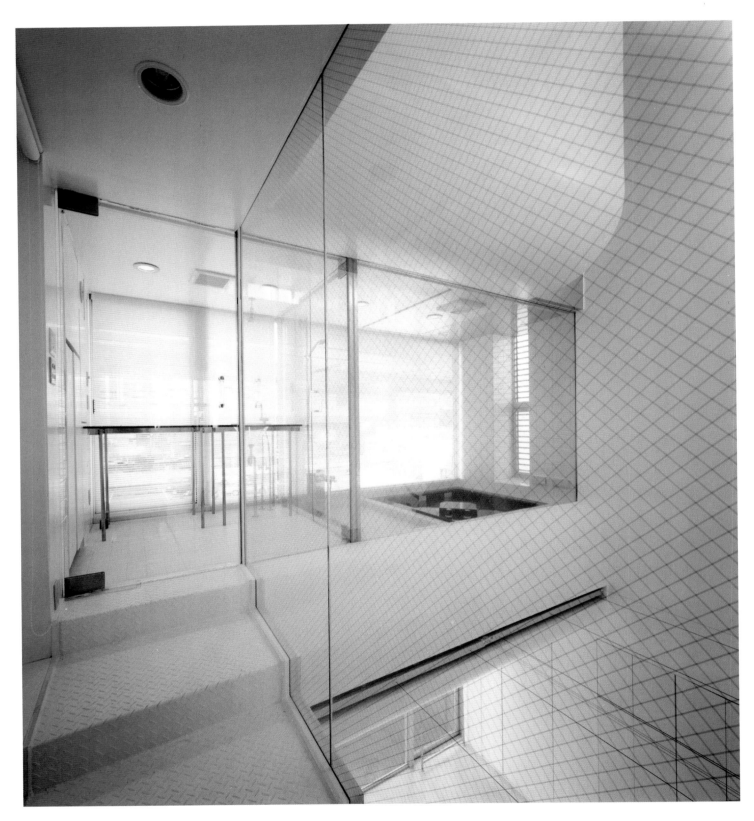

From the center of the space, the five circles, randomly installed in the walls, stand out.
The private areas are located inside of them.

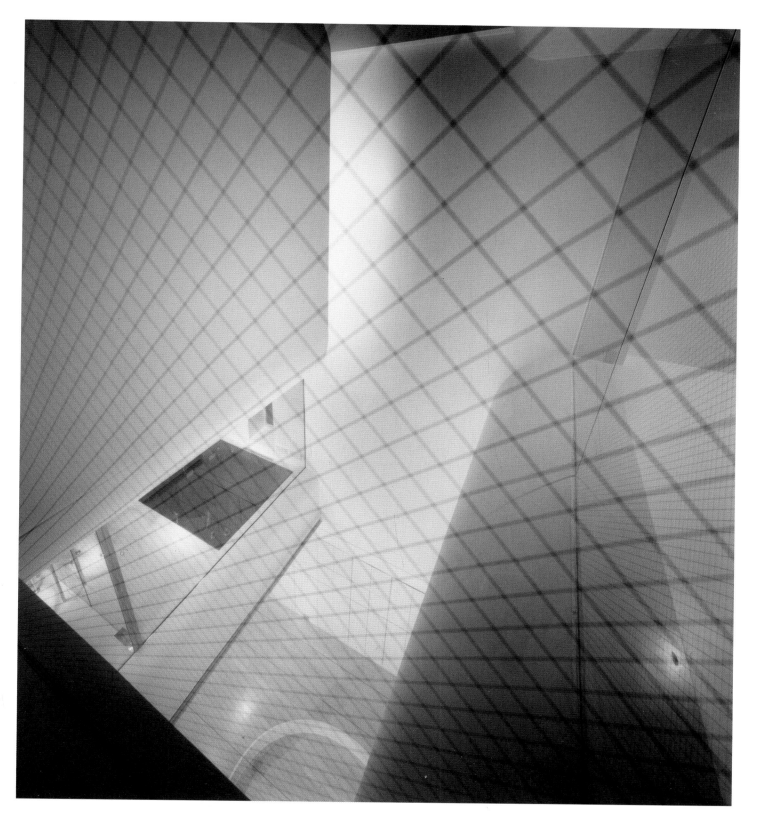

The activities of the occupants flow freely in the space outside of these circles, which is
basically designated as the daytime area.

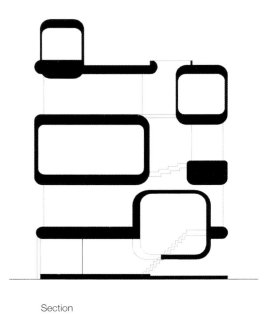

Section

A normal distribution of the circles would never have been able to
create the interplay of spaces that takes place in this interior.

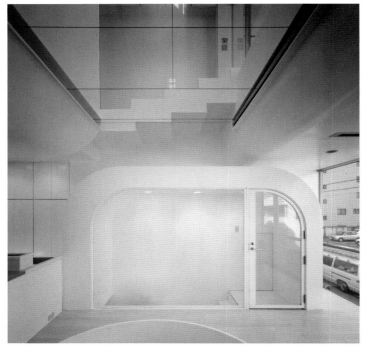

The circles are designed to contain private areas like
bedrooms, or complementary spaces like the playroom.

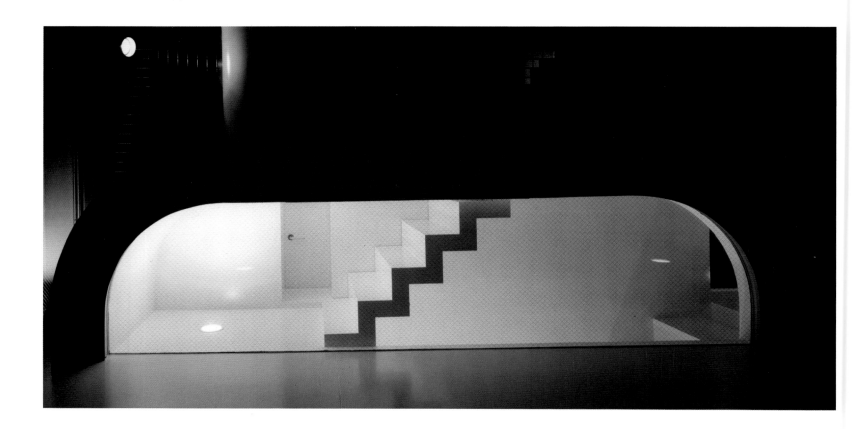

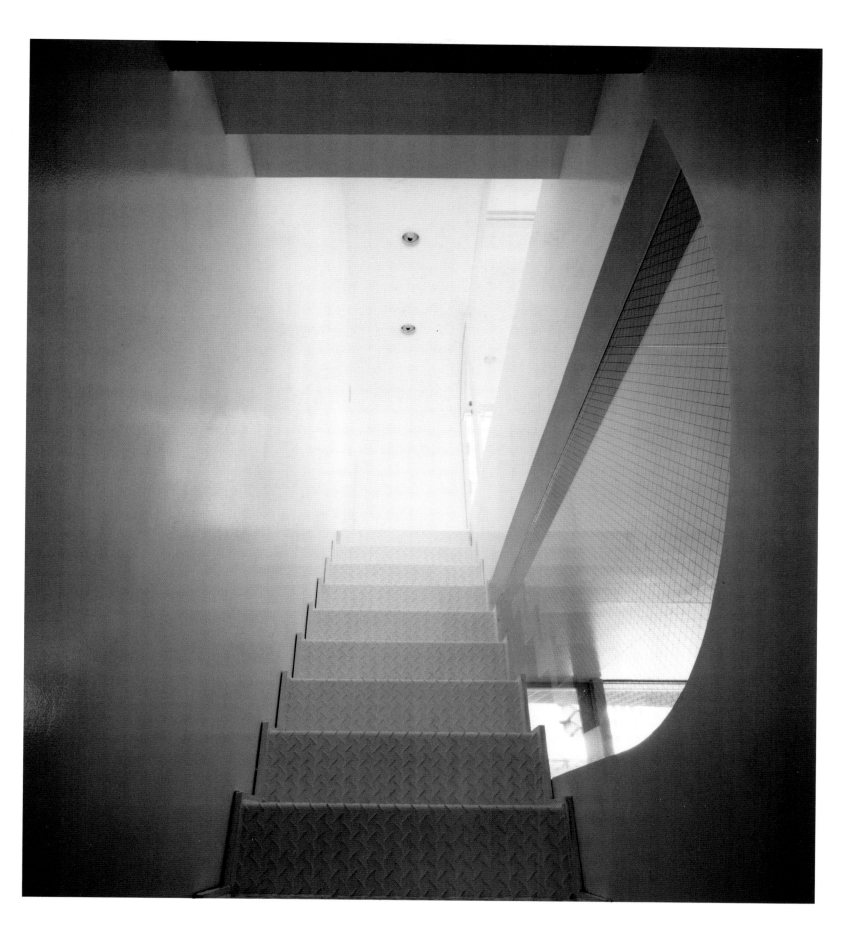

SPS HOUSE

After analyzing the site and the architectural challenges offered by the location, Querkraft designed this residence for the owners, a family with two children. The main objective was to situate the house in its surroundings so that none of the nearby buildings could interfere with the magnificent view of the city of Vienna, which can be seen from the top floor. To create an open space that fulfills these requirements, the architects came up with unusual elements placed on top of the structure that were reminiscent of individual lofts. They stand out above the house like huge lookouts, especially designed to enhance enjoyment of the surroundings.

The adults' bedroom, along with a second living area, was added on one side of the top floor. However, to enjoy the magnificent views even more, the architects exploited the structure of the building's roof and put in a terrace that extends over the rest of the rooms.

During construction, after analyzing the possibilities of the terrain, the decision was made to create a subterranean wine cellar, so that 895 square feet of surface area were obtained instead of 538 square feet. As a means of isolating the residence from the capital city, the family suggested a garden area connecting the interior through the porch below the terrace, turning that space into a transitional channel that blurs the boundary between indoors and outdoors.

ARCHITECT: **Querkraft**
PHOTOGRAPHER: **Hertha Hurnaus**

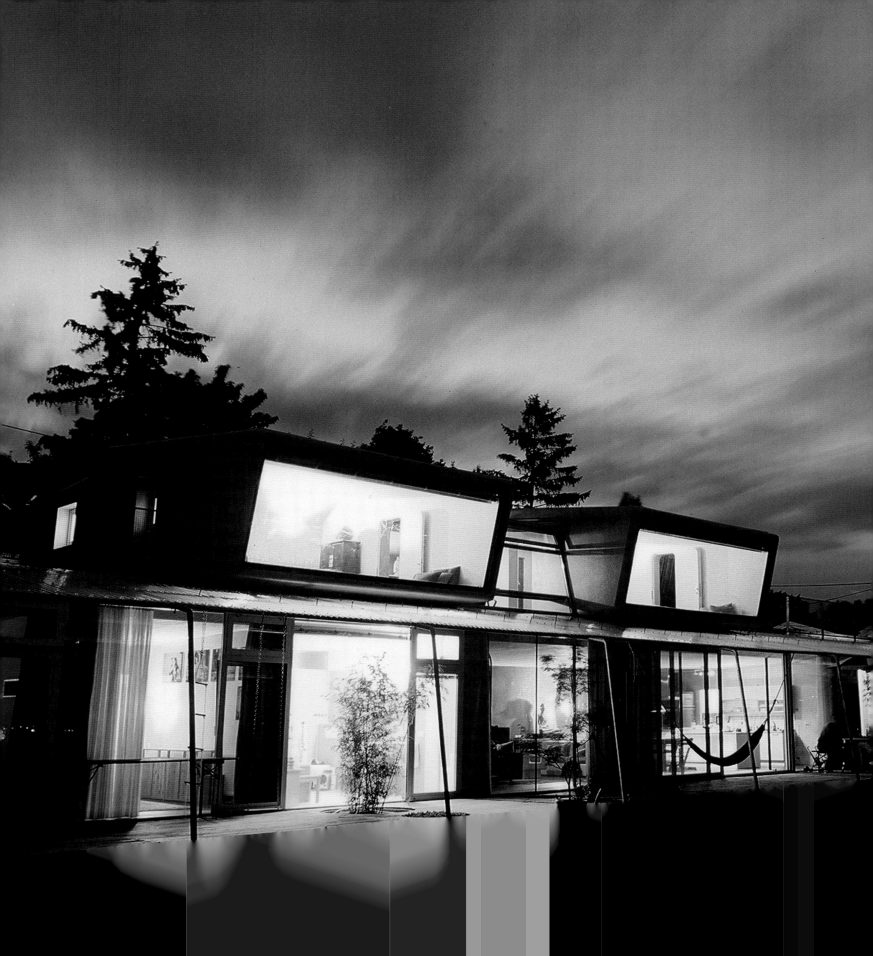

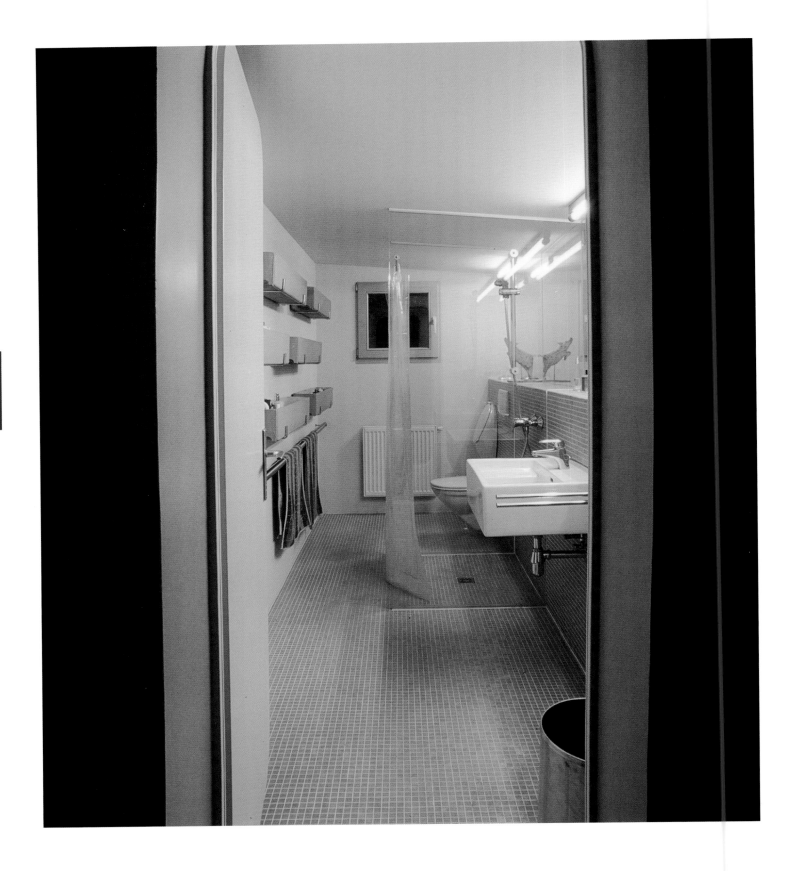

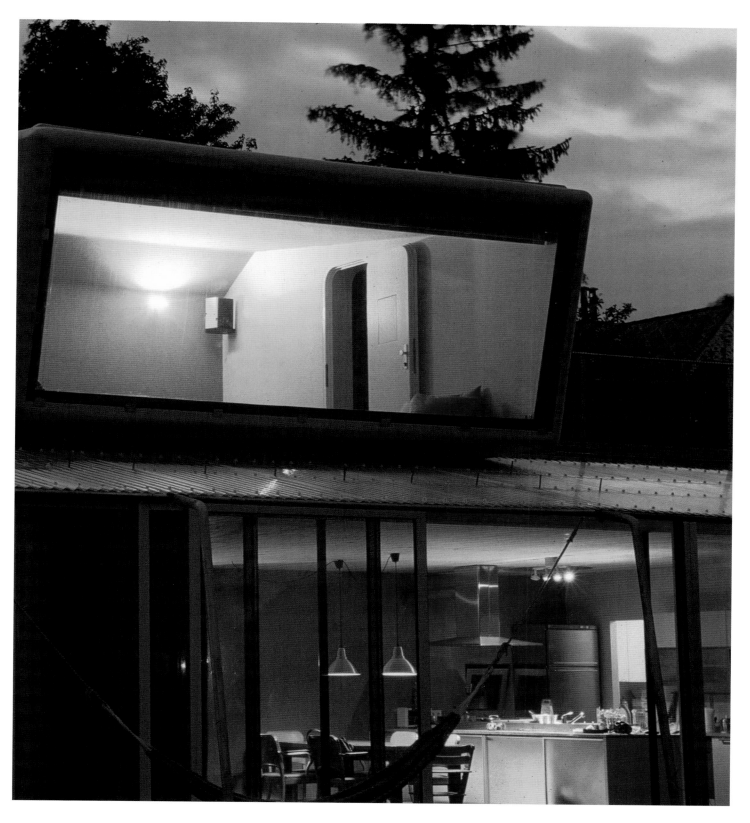

Individual lofts were constructed on top to increase the height of the building.

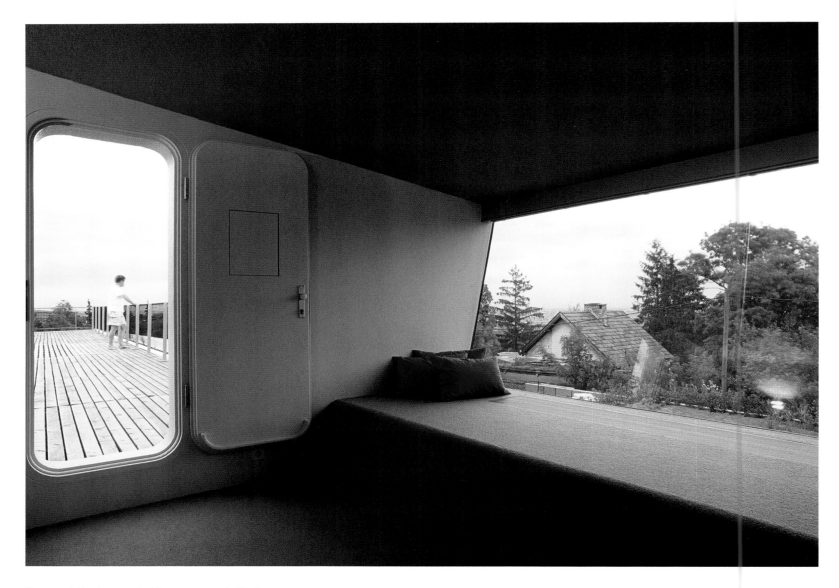

The parents' bedroom and a living area connected to the
outside terrace are located on top of the residence.

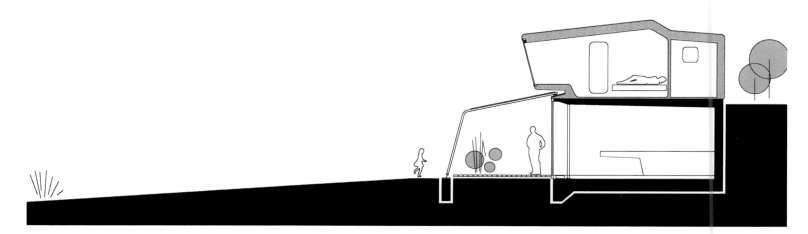

Section

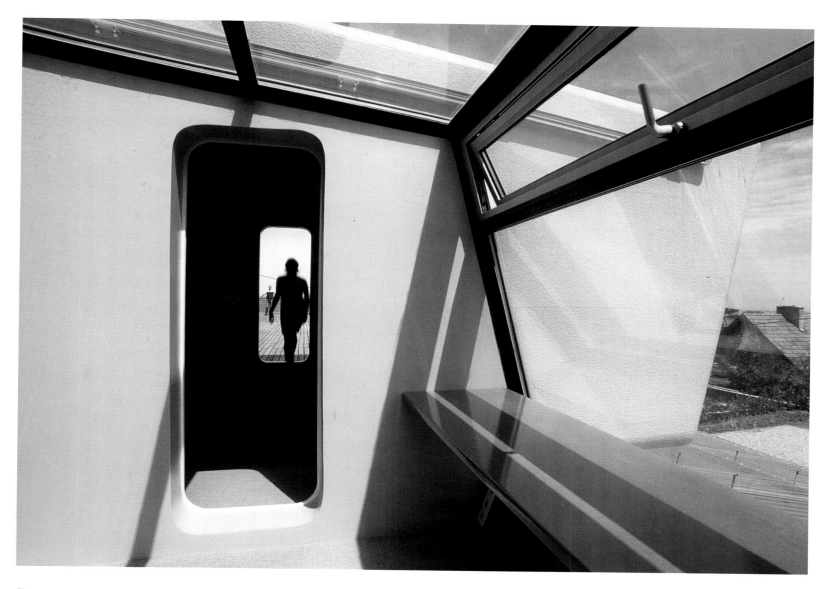

The terrace extends over the residence, and its exceptional location encourages interaction with the surroundings.

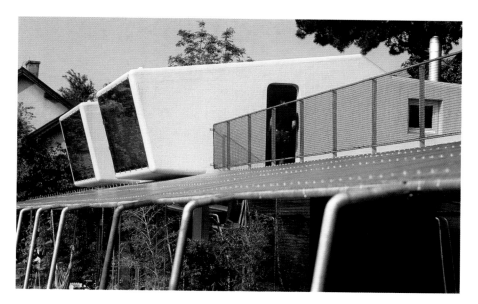

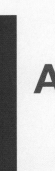

STINGEL APARTMENT AND ROOFTOP PAVILION

This apartment is located on the top floor of an old townhouse in the revitalized East Village neighborhood in New York City. Converted into the second home of an artist, it enjoys magnificent views of St. Mark's Church and its surroundings.

In a space measuring just 700 square feet, the architects designed an open interior connecting to the exterior, a design that would adapt to the nomadic lifestyle of the owner. To fulfill the initial premise, the project was approached from a functional standpoint to ensure that the interior elements did not pose any obstacles to the sought-after serenity and spirituality.

The architects utilized the 345-square-foot terrace to create the Rooftop Pavilion, a fitting temple for rest and relaxation and for contemplating the spectacular views of Manhattan. Similar in appearance to Chinese gardens, whose structures are a complex fusion of manmade creations and their interrelation with the surroundings, the terrace becomes a natural refuge in the middle of the Big Apple. Its structure consists of thin wood panels that discreetly conceal the view of the skyline of New York and moderate, from above, the light that floods the terrace.

ARCHITECT: **Cha & Innerhofer Architecture & Design**
PHOTOGRAPHER: **Dao Lou Zha**

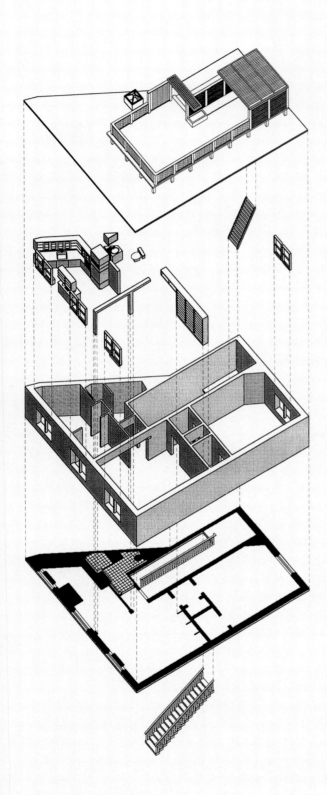

Perspective

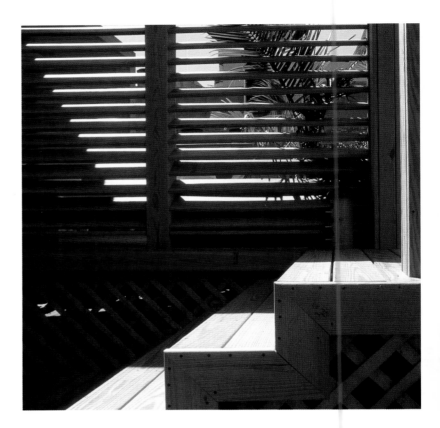

The structure on the terrace is made of narrow wood boards, which filter the direct light that falls on this area.

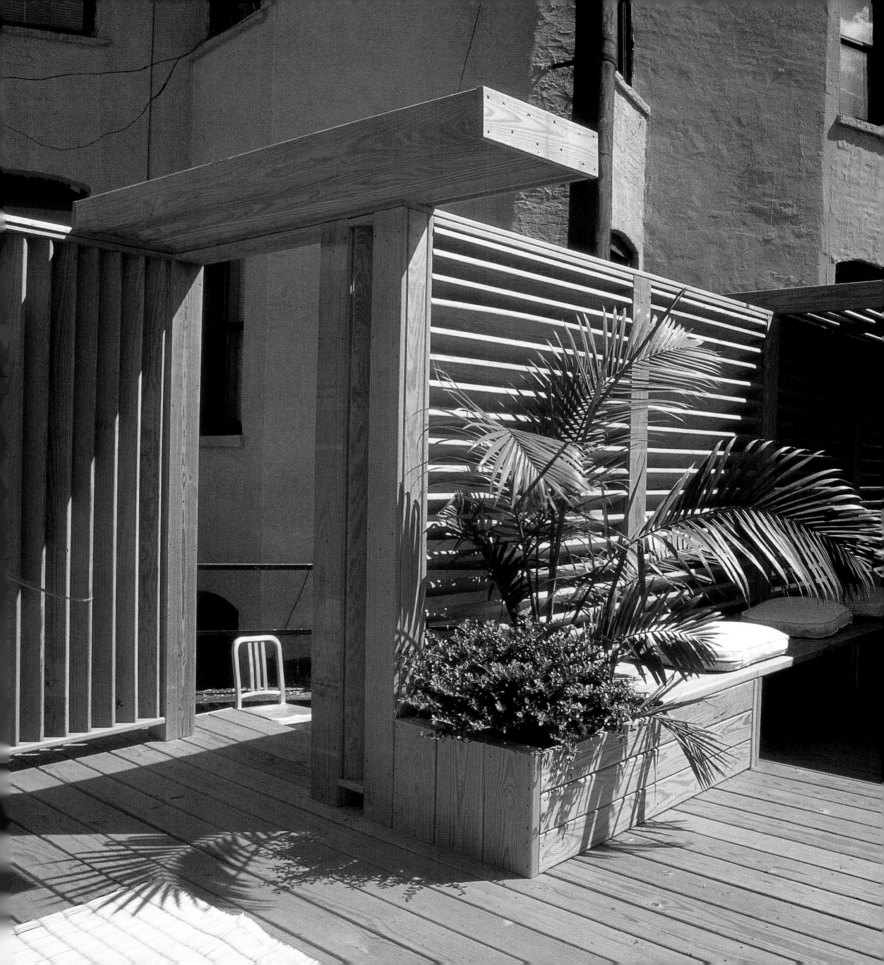

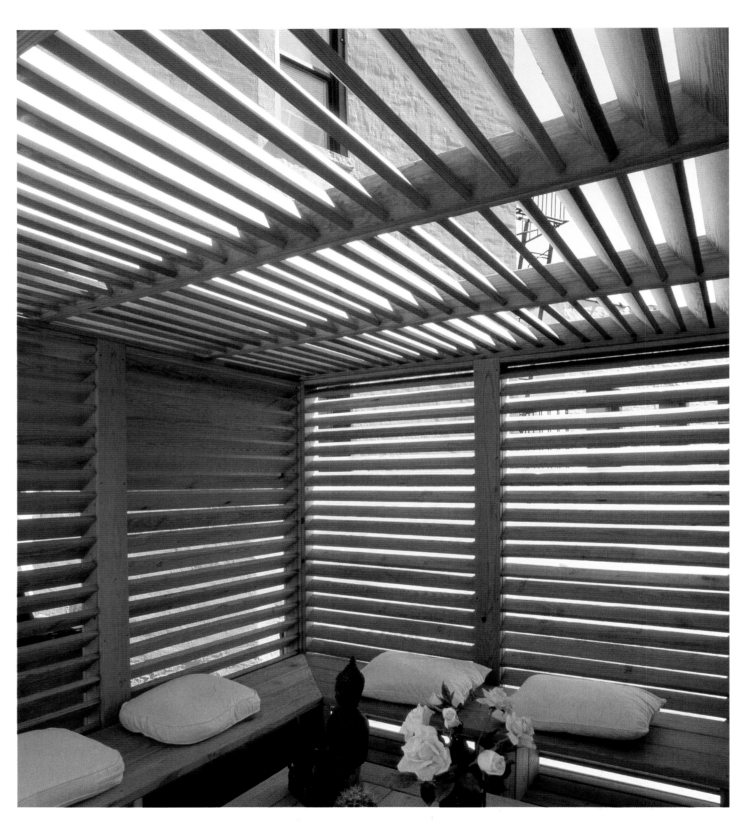

Some spots have a spiritual feeling, and they become small havens designed especially for resting.

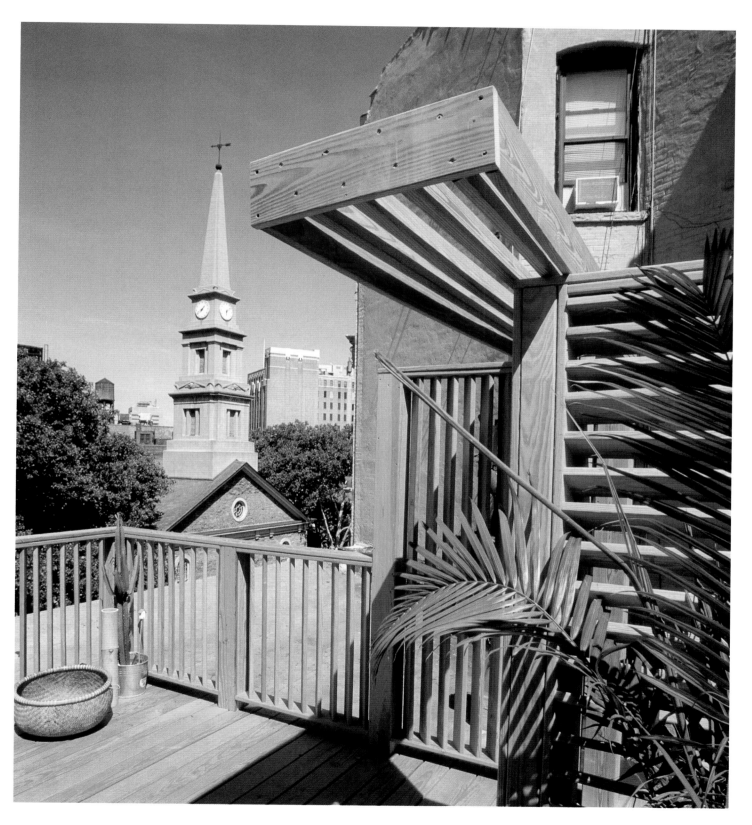

The casual style of the exterior makes it a natural refuge at the top of the building, from which the spirit of the city can be experienced.

EAST VILLAGE PENTHOUSE

This project is located on the fourth floor of an old building on the Lower East Side of Manhattan. It was adapted to the different levels of the original structure, creating areas that were naturally integrated into the usable spaces. The renovation of the top floor incorporated a small terrace in the penthouse, to be used as the main entrance, living area, and dining room. The creation of an open and uncluttered outdoor area allows direct light to flood the interior of the residence, at the same time creating a connection with the outside world. As an extension of the main dining room, this space becomes a gathering place, while the rest of the private quarters are arranged around it.

The stair-step design of the basic floor plan led the architects to consider the idea of defining the various areas inside the apartment. Different environments were created, arranged in an ascending pattern from the bottom to the top, conforming to the features of the ceiling. Therefore, the fourth floor of the residence houses the bedrooms and the bathrooms, with the adults and the children separated in different wings. On a lower level, the dining room and living room receive natural light through their connection to the outside terrace.

The arrangement of the volumes of the interior was made possible by the height of the ceiling. The different levels can be seen from the center of the main floor, projecting from the top level down to the main floor, generating a range of geometric forms and volumes that define the concept of the space.

ARCHITECT: **Rogers Marvel Architects, PLLC**
PHOTOGRAPHER: **Paul Warchol Photography**

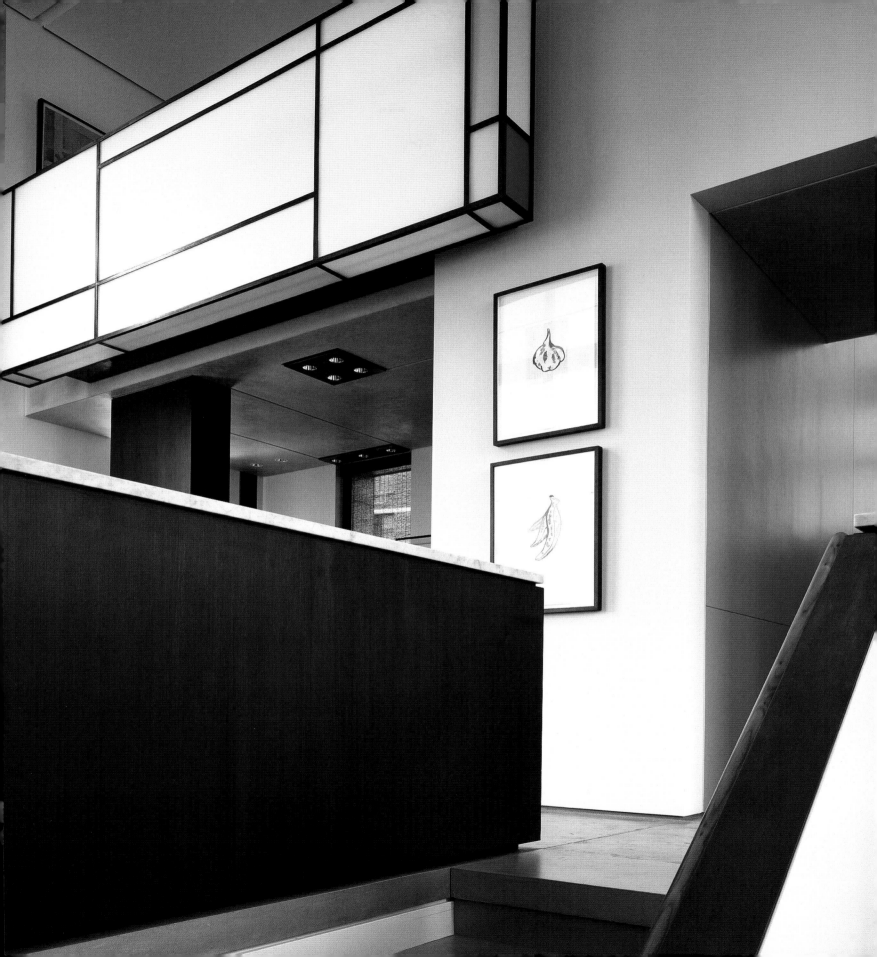

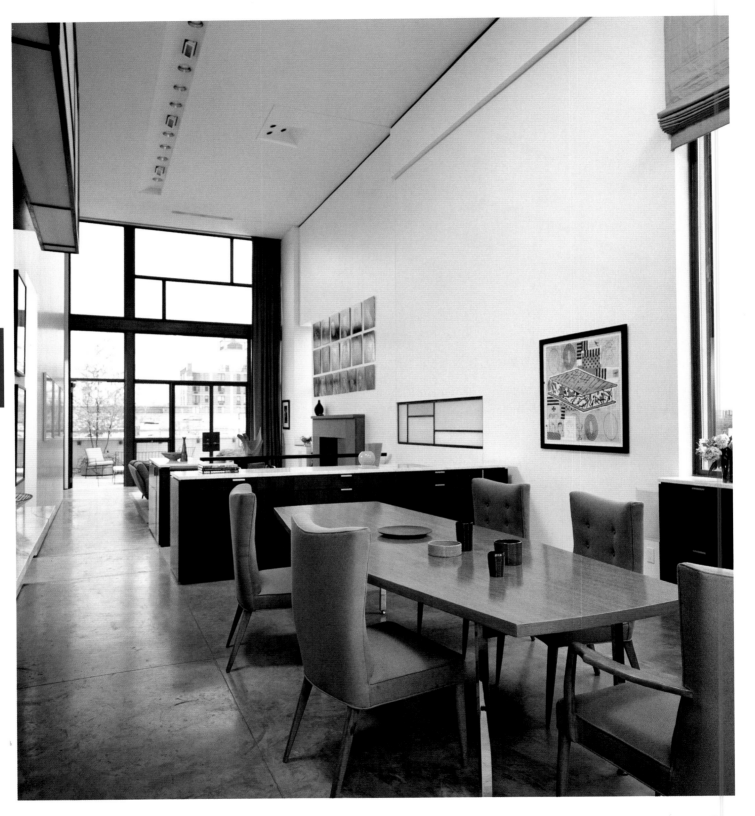

The dining and the living areas share a continuous space in a setting with remarkably high ceilings.

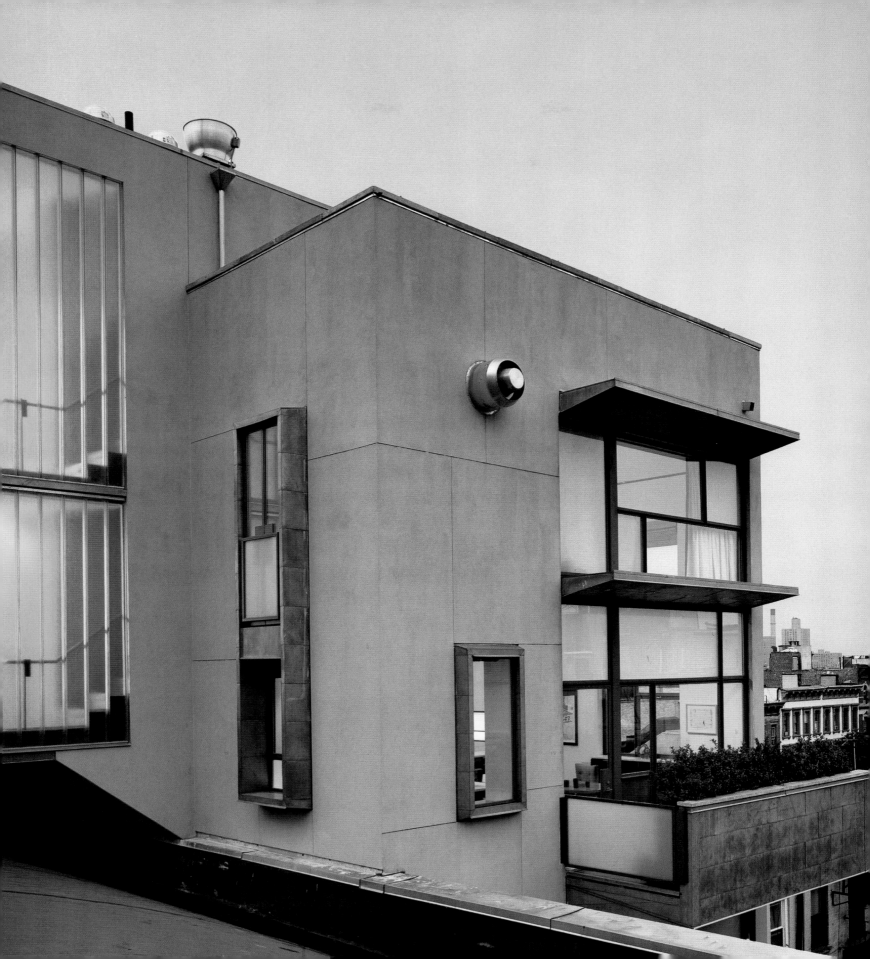

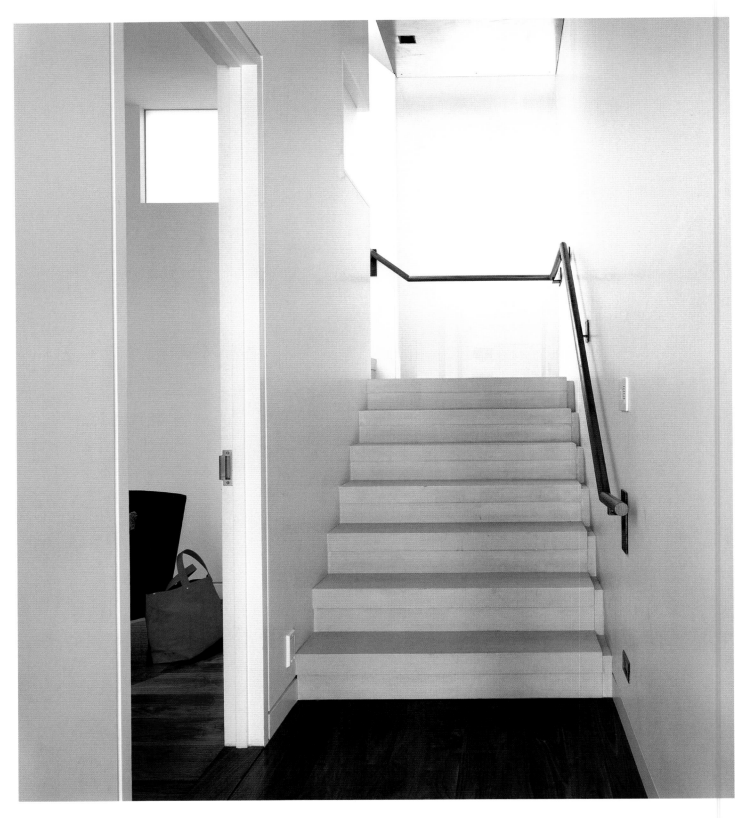

The stair-stepped layout allows the interior spaces to be arranged separately, conforming to the differences in ceiling height.

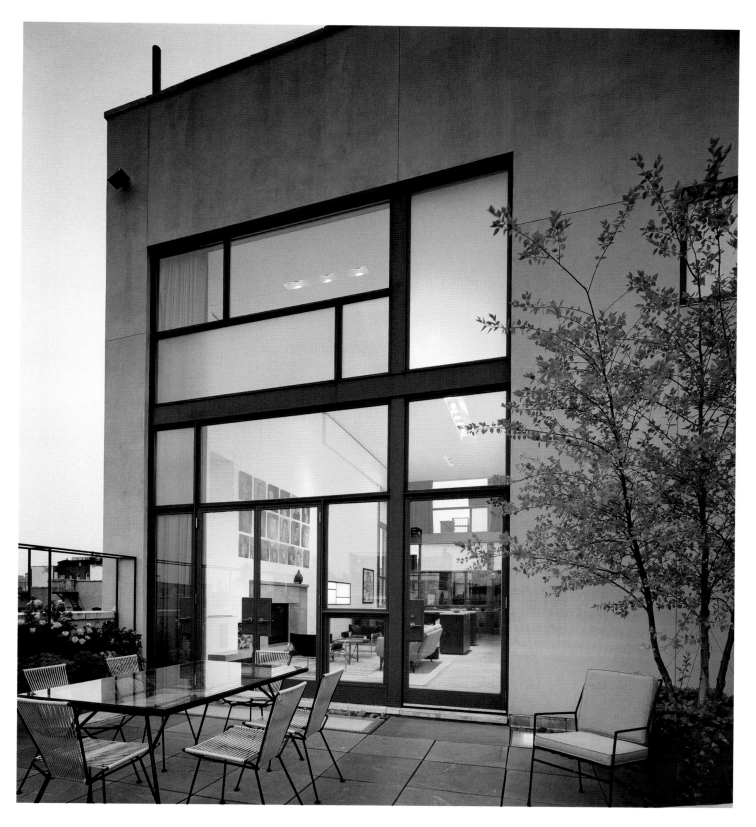

The remodeling of the home included taking advantage of the adjacent terrace, incorporating the outdoor space to complement the interior living area.

The large window in the living area lets light flood the interior. The fourth floor was remodeled to house the private rooms in different wings.

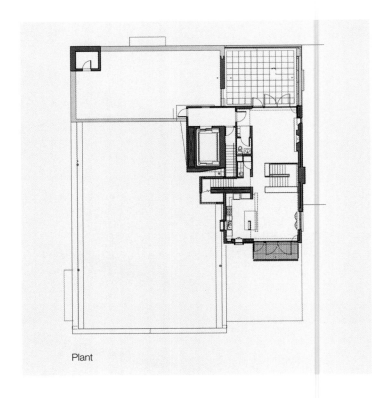

Plant

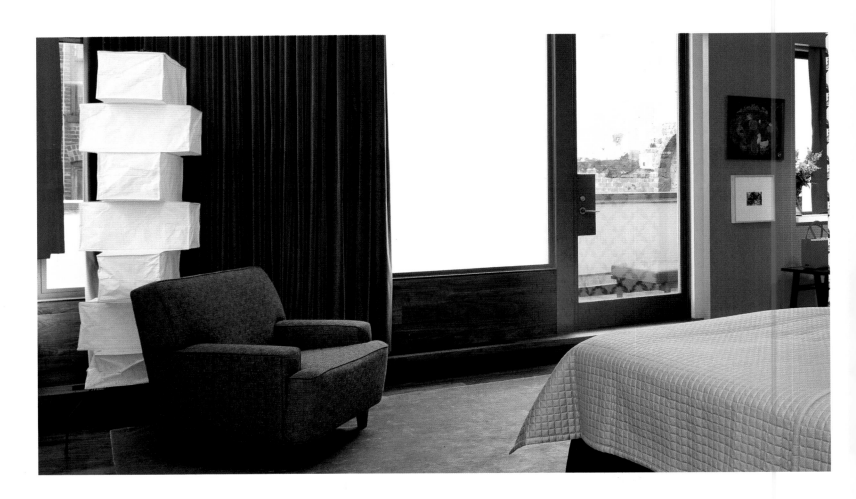

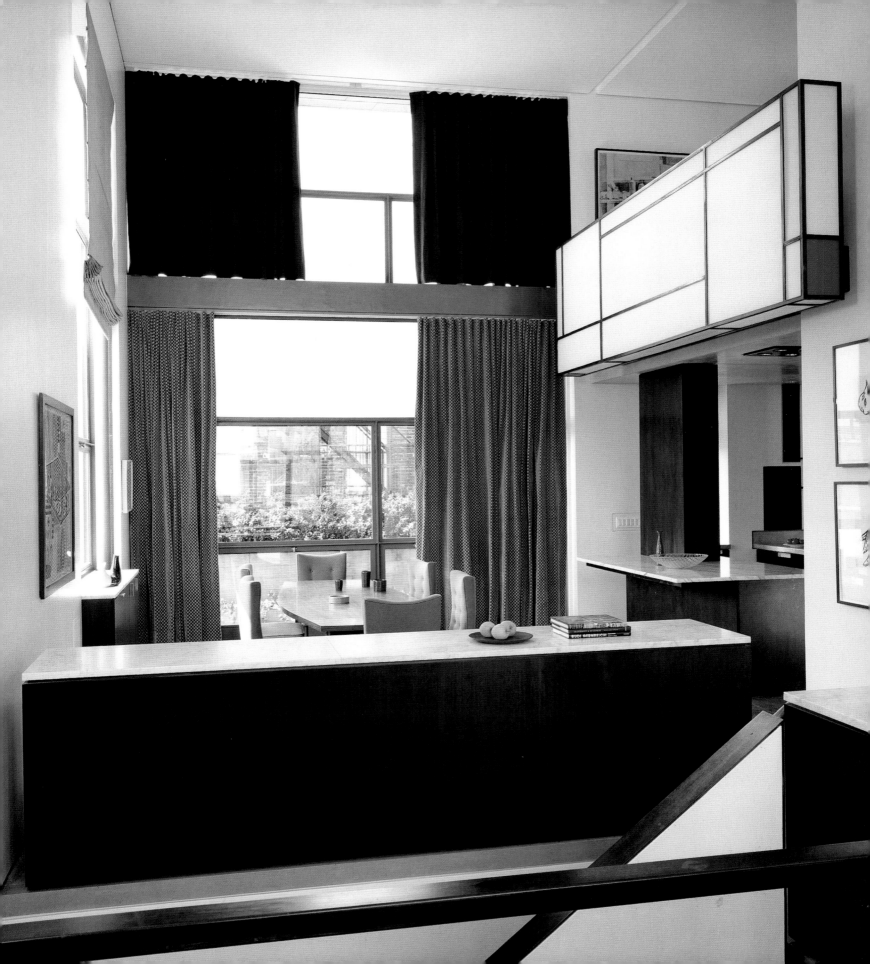

SGL HOUSE

Located west of the outskirts of Vienna, the SGL House is part of a project that includes two neighboring single-family homes with similar layouts and structures. In designing this home, the architects found that they faced fewer restrictions than they had with the first house, because city zoning laws were more lenient and permitted a larger building lot.

A steel stairway leads to the bedroom, located on the top and most important level of the residence. The sloped roof defines the height of the structure, while the rooms inside adapt to the irregularities of the architecture, which defies the challenging terrain. The favorable placement of the bedroom windows permits bright light to enter during the sunniest hours of the day.

On the lower floor, which extends to the west and opens to the kitchen and dining area, the level of the entrance is architecturally determined by the height differences of the sloping terrain. The south side is defined by a glass façade which keeps the space open and oriented toward a small courtyard to a swimming pool that is visible from the living room.

ARCHITECT: **Propeller Z**
PHOTOGRAPHER: **Margherita Spiluttini**

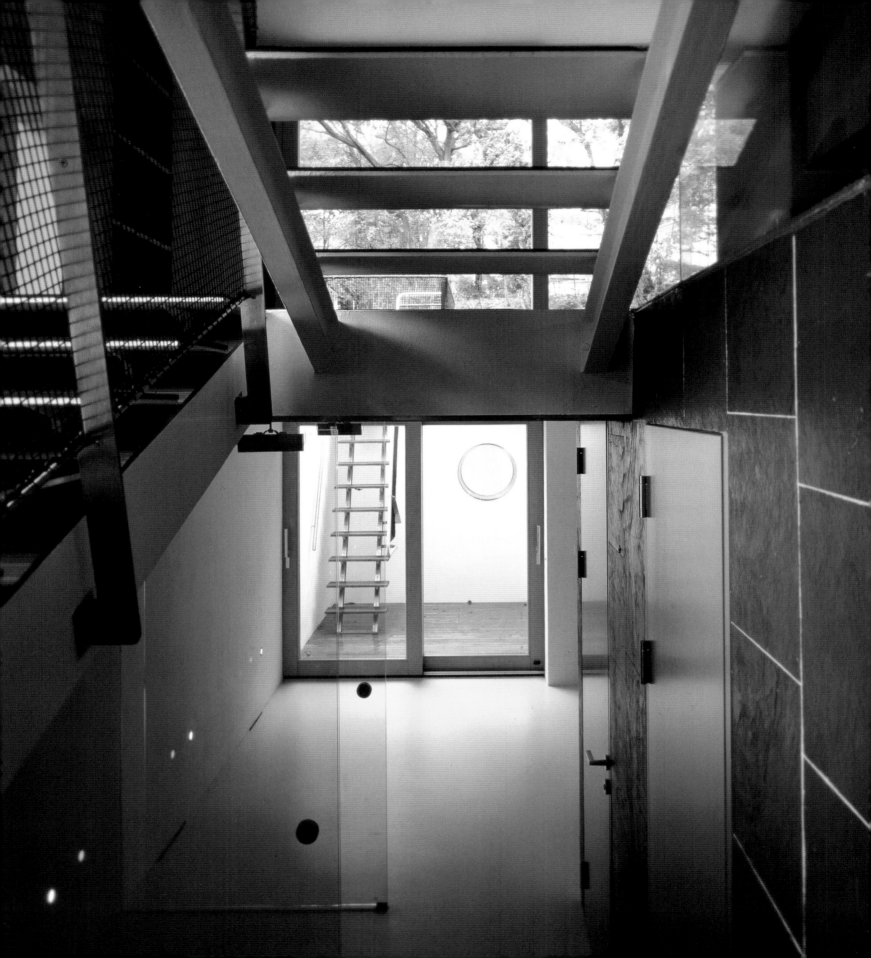

A metal stairway leads to the private rooms, located on the top floor. Wonderful views of the surrounding areas can be enjoyed from this space.

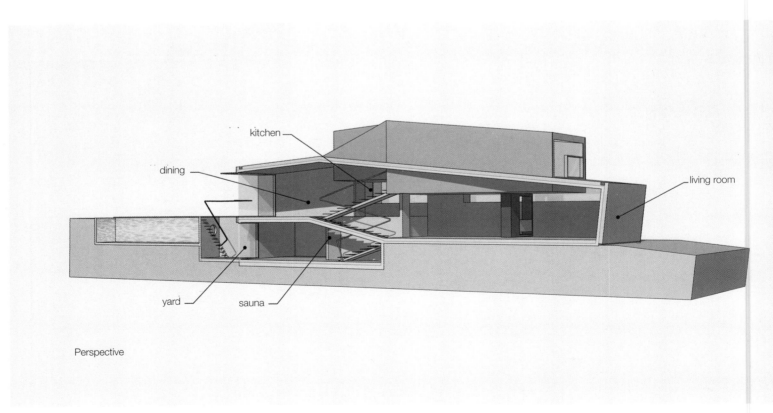

kitchen

dining

living room

yard

sauna

Perspective

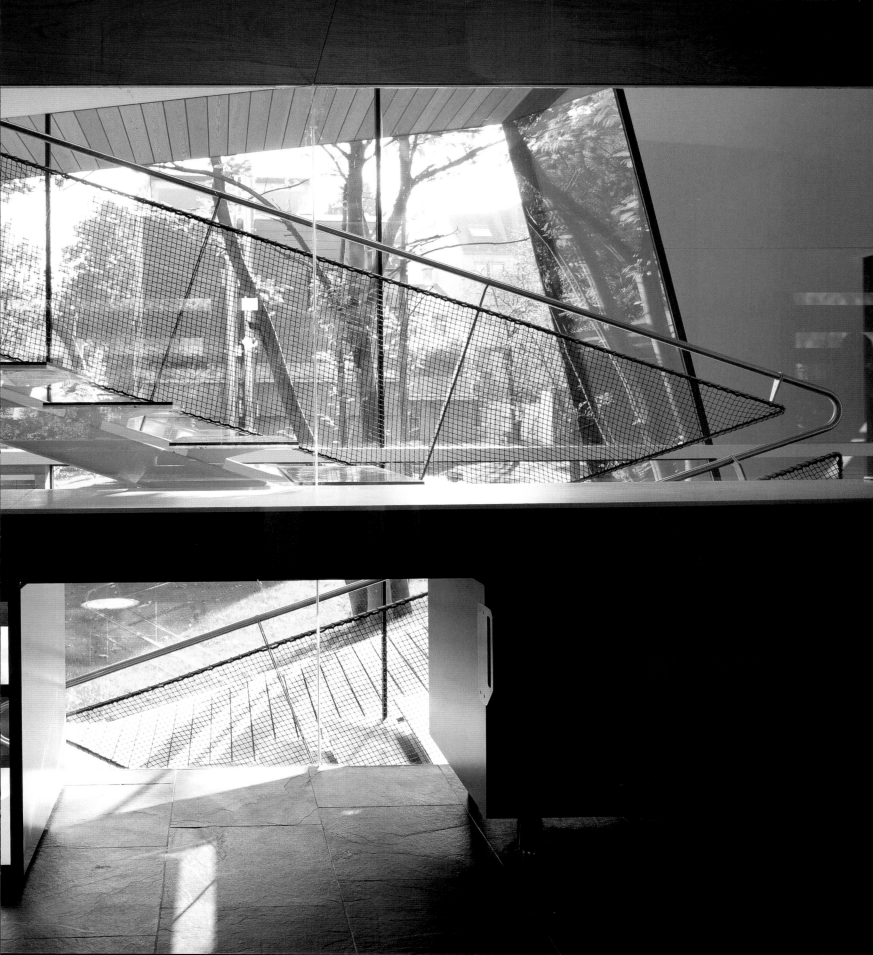

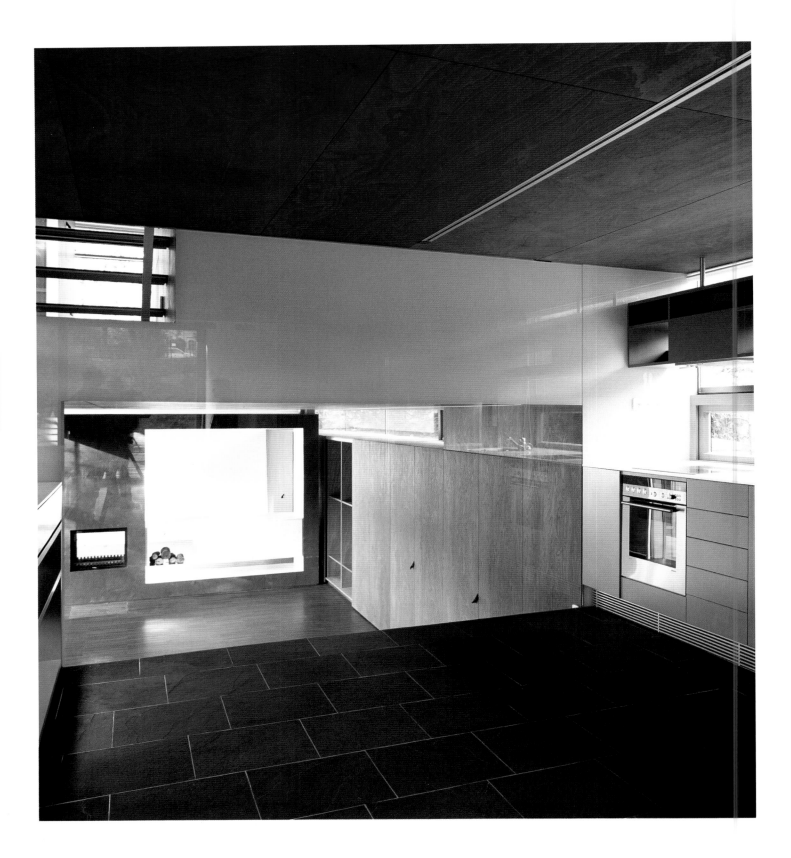

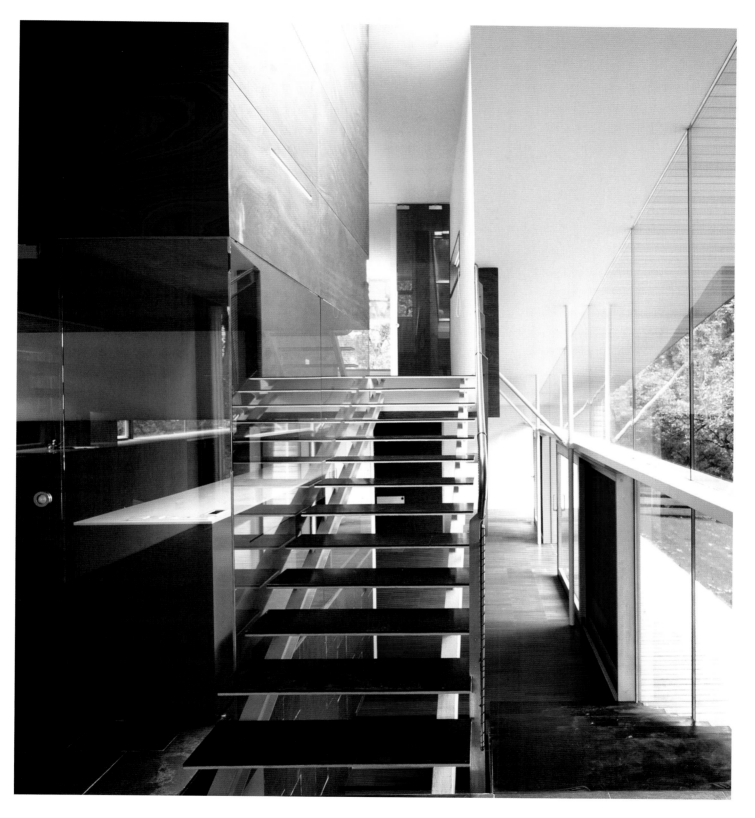

The placement of windows on the front façade allows light to filter through during the day.

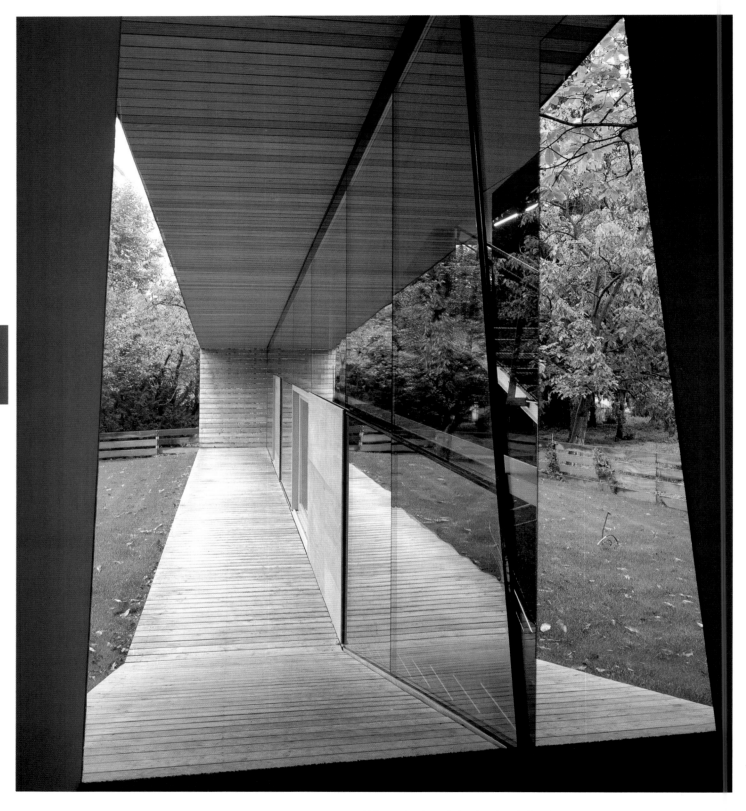

Light coming through the glass façade floods the interior, creating shadows that interact with the empty space.

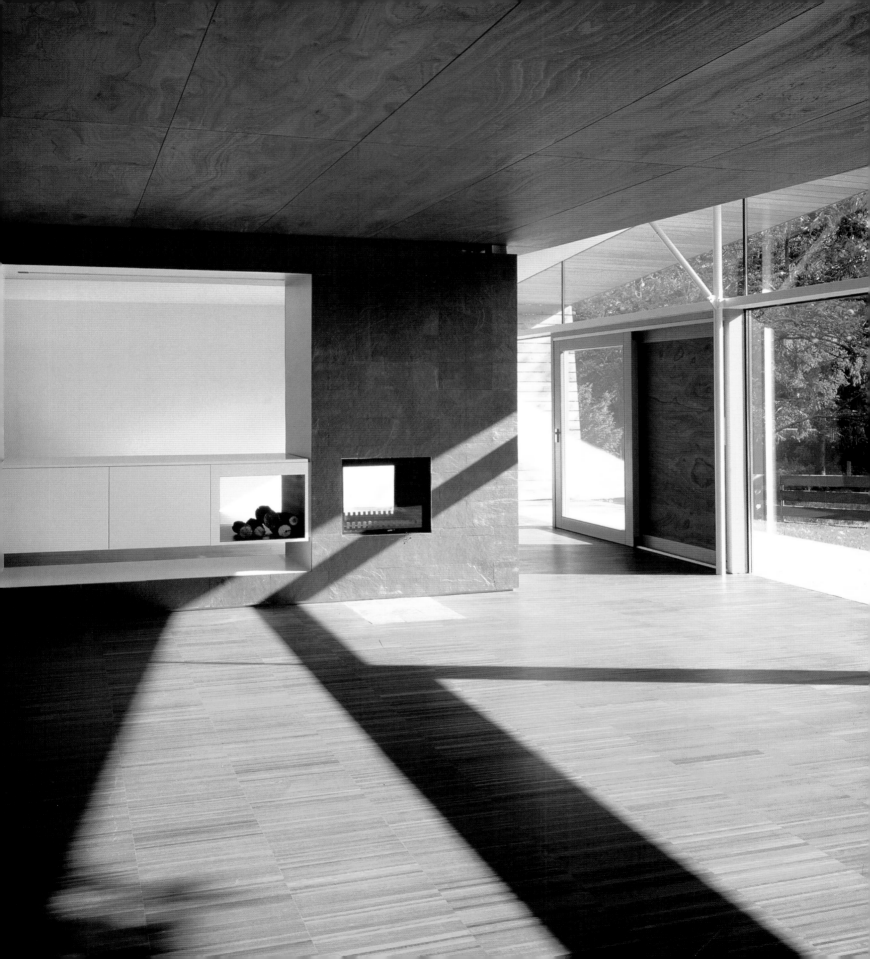

BORNEO 56

This design project, located in the eastern section of the port of Amsterdam, grew from the idea of creating a group of three single-family homes and three apartments built one behind the other. To prevent a street full of parked vehicles from hindering the views of the harbor, a plan was devised that included an interior street that passed through the structure, with several garages. The patios are suspended over the parking areas, allowing enjoyment of the sun and magnificent views to the north side of the houses.

The very long and inevitable tunnel structure was a response to the dimensions of the dwelling, which dictated the interior expanse. However, the architects opted to alter that exterior line so that additional living space was gained, including ample balconies designed with glass verandas of different colors. Thanks to this plan, the resulting interior spaces are larger and at the same time a departure from the monotonous galleylike design, making the final project much more coherent.

The interior spaces are free of superfluous elements and feature contemporary furnishings and simple lines. On sunny days, the magnificent views of the water seem to flood into the homes.

ARCHITECT: **De Architectengroep Rijnboutt Ruijssenaars**
Hendriks Van Gameren Mastenbroek BV / SeARCH
PHOTOGRAPHER: **Nicholas Kane**

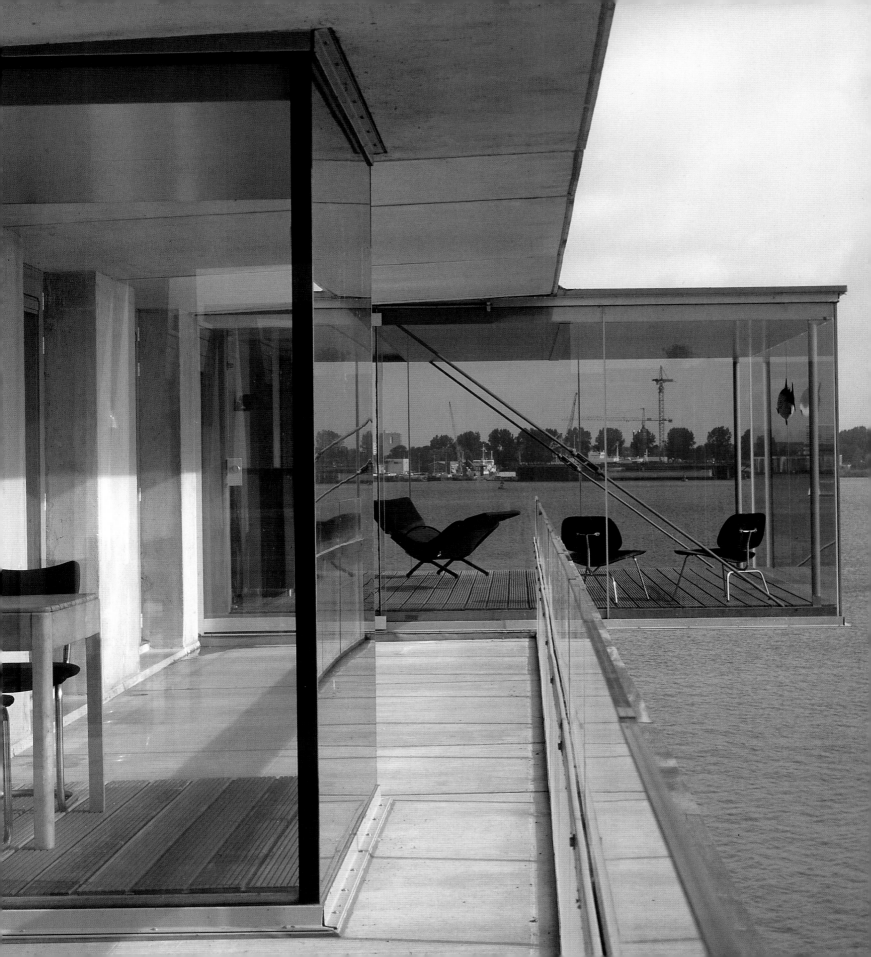

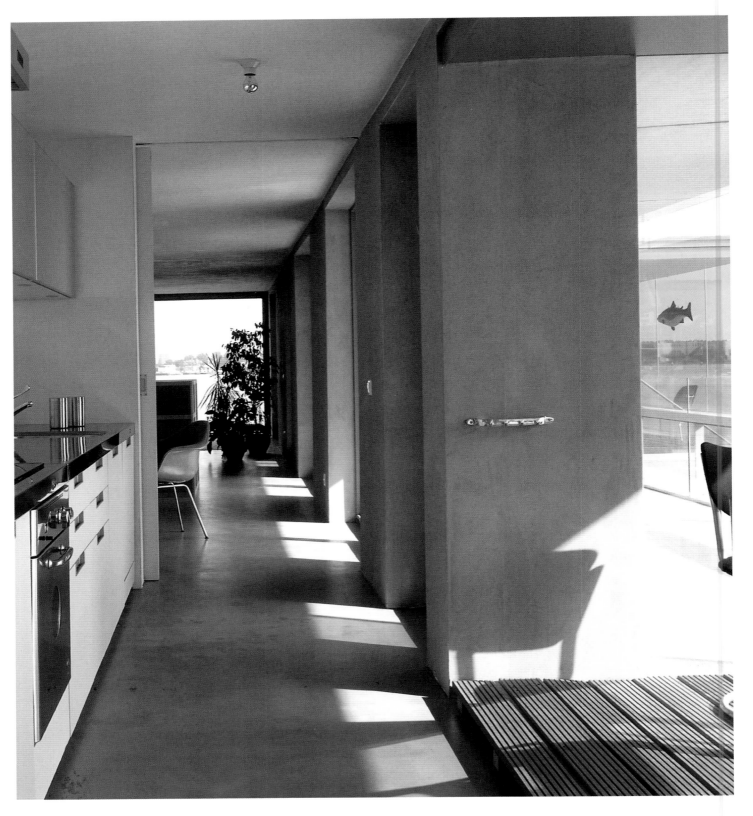

The interior spaces are open and connected to the harbor outside, which can be seen throughout the residence.

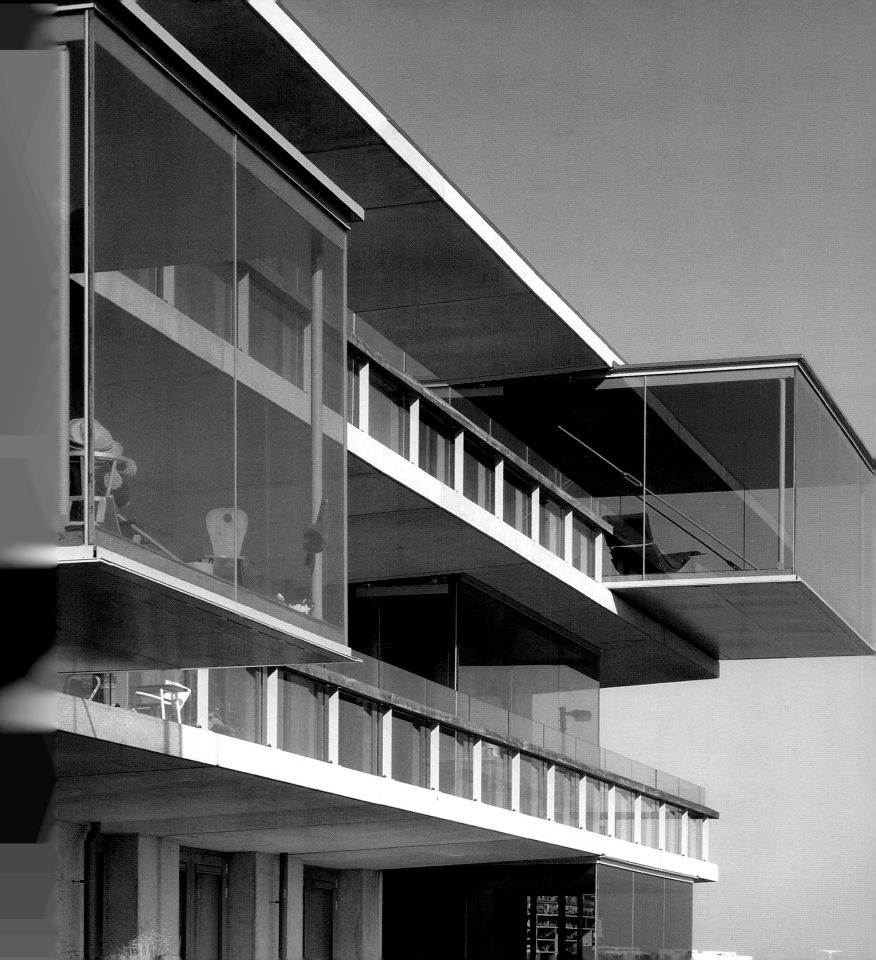

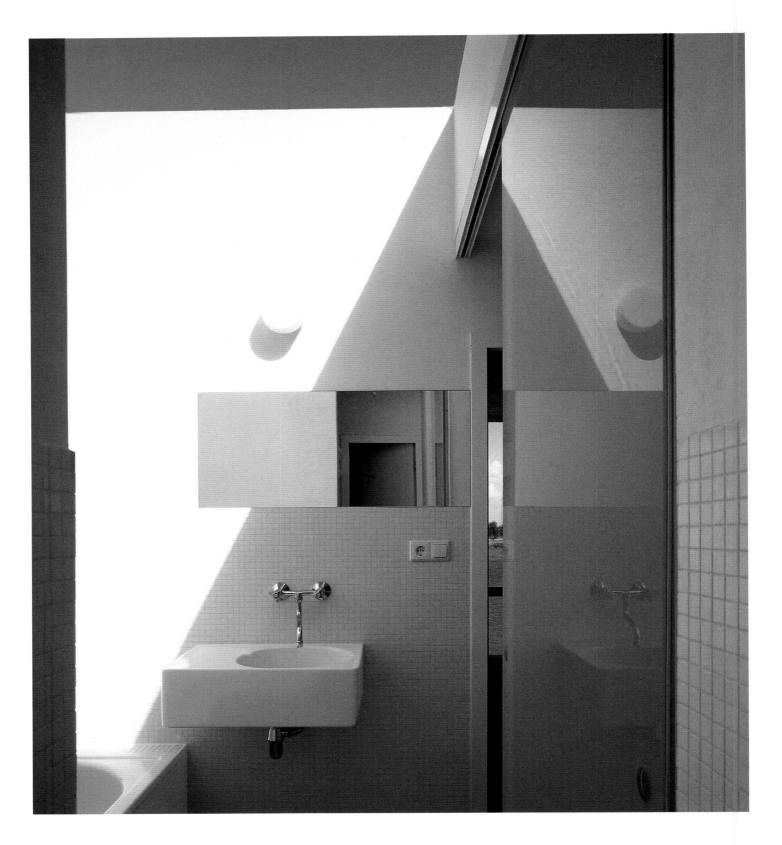

Some rooms in the house are outdoors and have fantastic views.

The furniture gives the space a feeling of luminosity, which harmonizes perfectly with the home's spiritual and relaxed interior.

BARGE
& MURPHY LOFT

The architecture firm of Buschow Henley Ltd took full advantage of the opportunity to remodel the original structure of a Victorian building in London, turning the top floor into a loft. After evaluating the parameters of the 2,150-square-foot space, the architects changed the floor plan and converted it into a loft extending over two parallel blocks. The most important undertaking in remodeling this loft was the creation of the roof. After analyzing the condition of the original roof, the architects decided to make it the focal point of the plan and to develop the rest of the project around it.

The architects decided to replace the original skylight and they explored ways of designing several independent skylights in the roof. Their initial plan presented an ironic group of structures in the form of a slope, fences, a lawn, and a garden with a kitchen, as if each new skylight had to contain a separate residence with its own garden. However, their final solution was to cover the structure with sensible materials like zinc. This way, the seven skylights on the east wing opened to the south with side views to the east and west. Conversely, the three semi-independent skylights on the west wing opened to the sky and to the west. The group of pavilions was connected directly to the apartments just below them, exactly where the Barge & Murphy loft was located. Inside each one is a crystal clear, transparent roof that allows light to filter through into the center of each plane.

ARCHITECT: **Buschow Henley Ltd**
PHOTOGRAPHER: **Nicholas Kane**

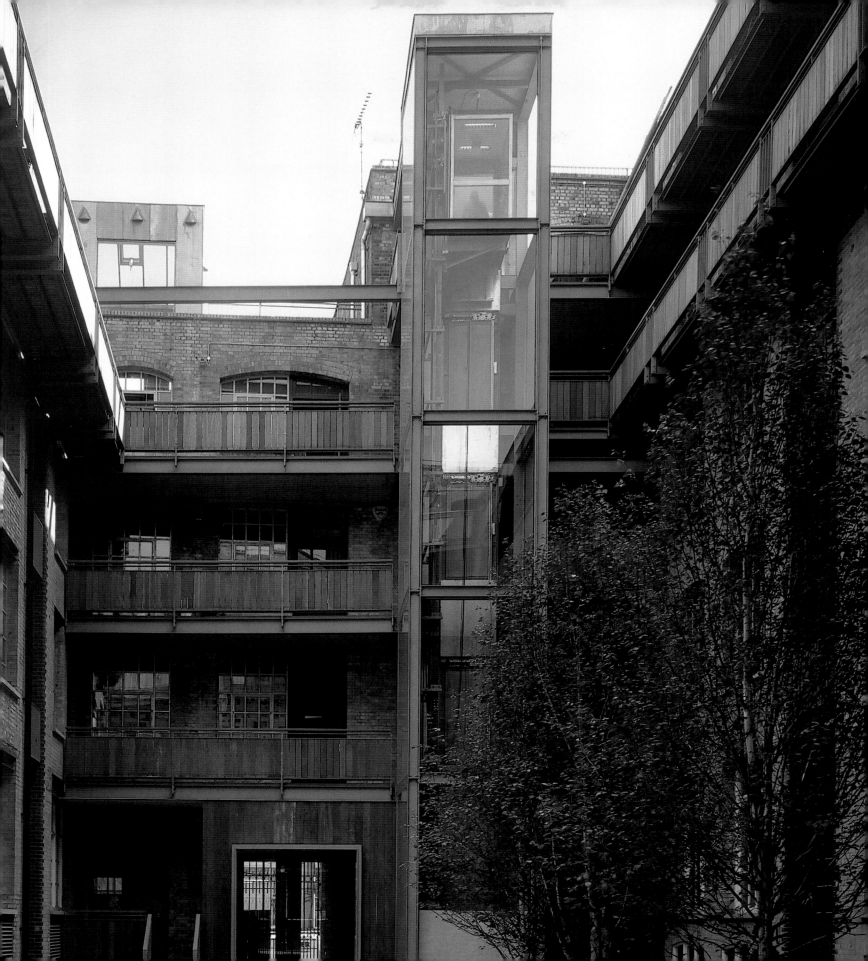

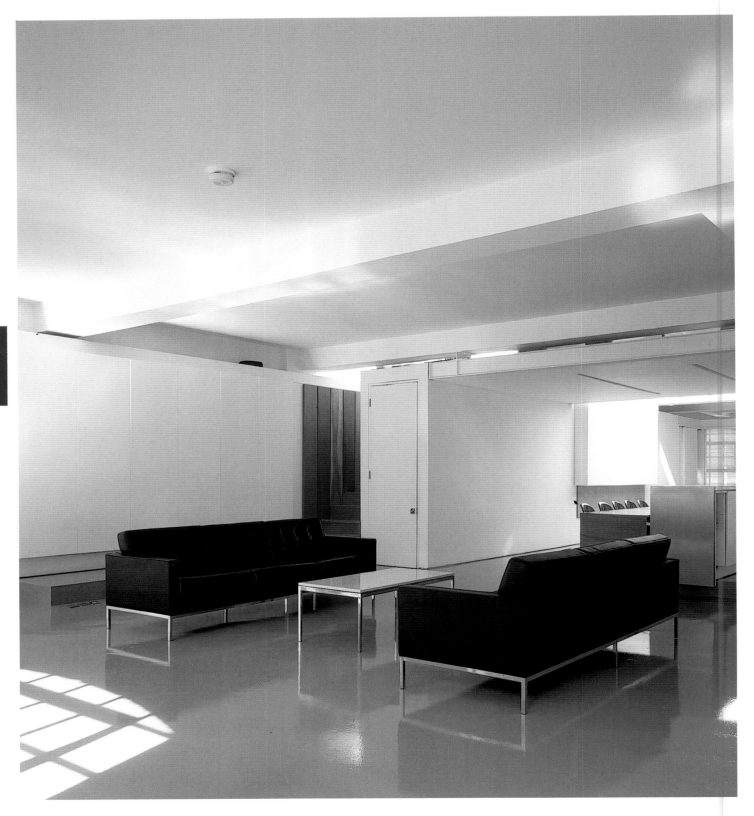

The 2,150-square-foot floor of the old attic was converted into a balanced, brightly lit loft that combines the elegance of the original building with a certain amount of modern design.

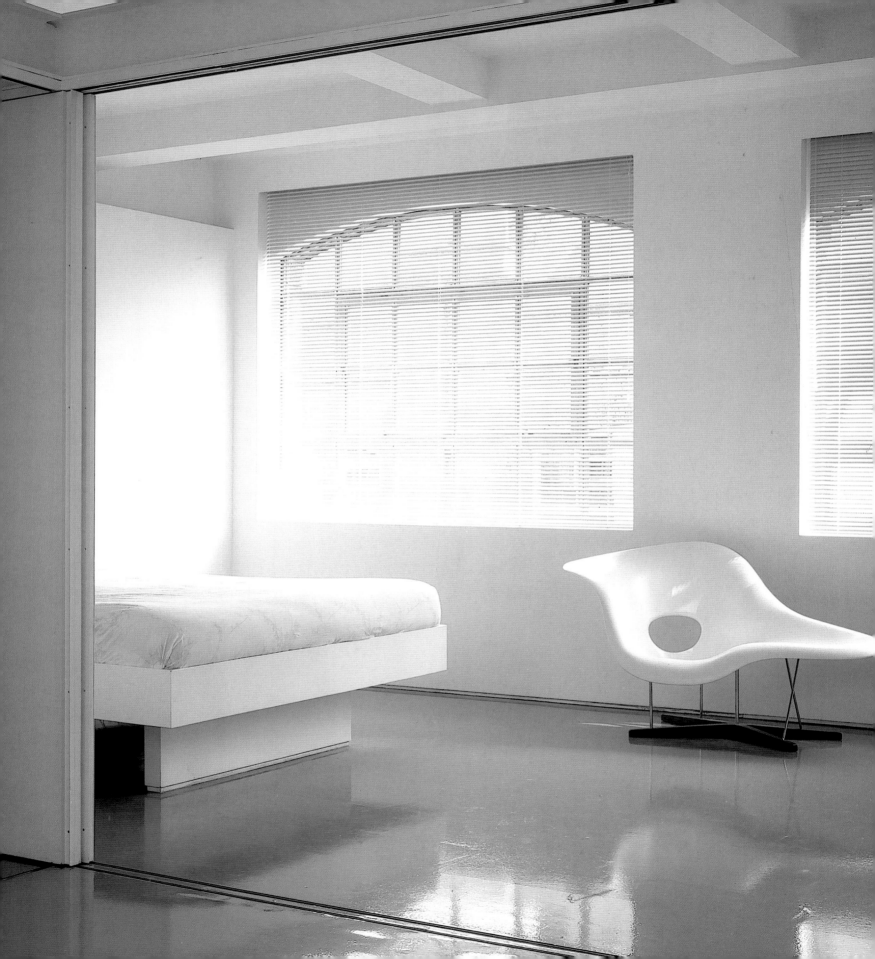

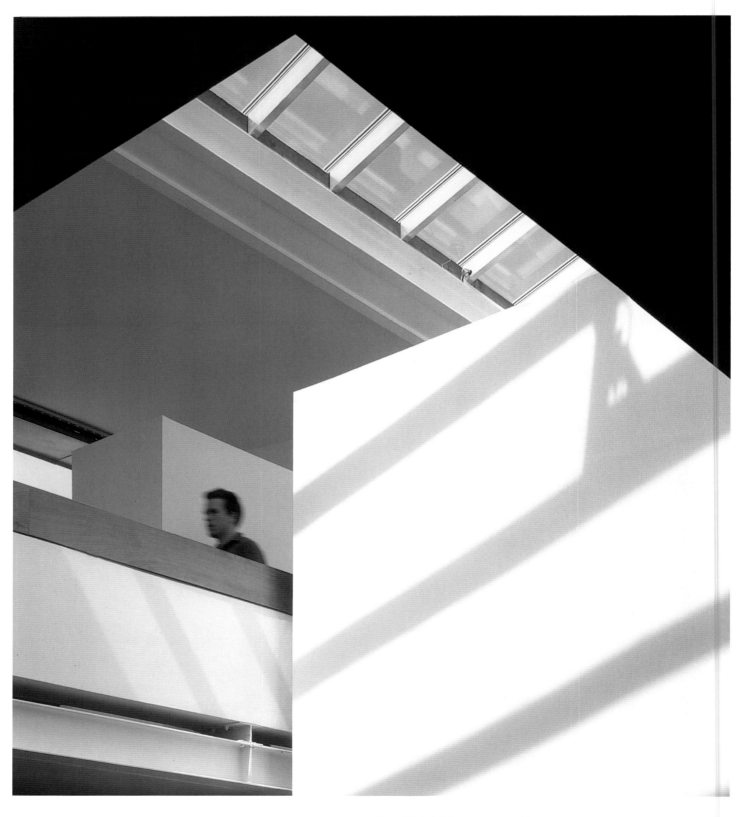

The original skylight was converted into seven individual skylights, which are directly connected to the apartments located immediately below.

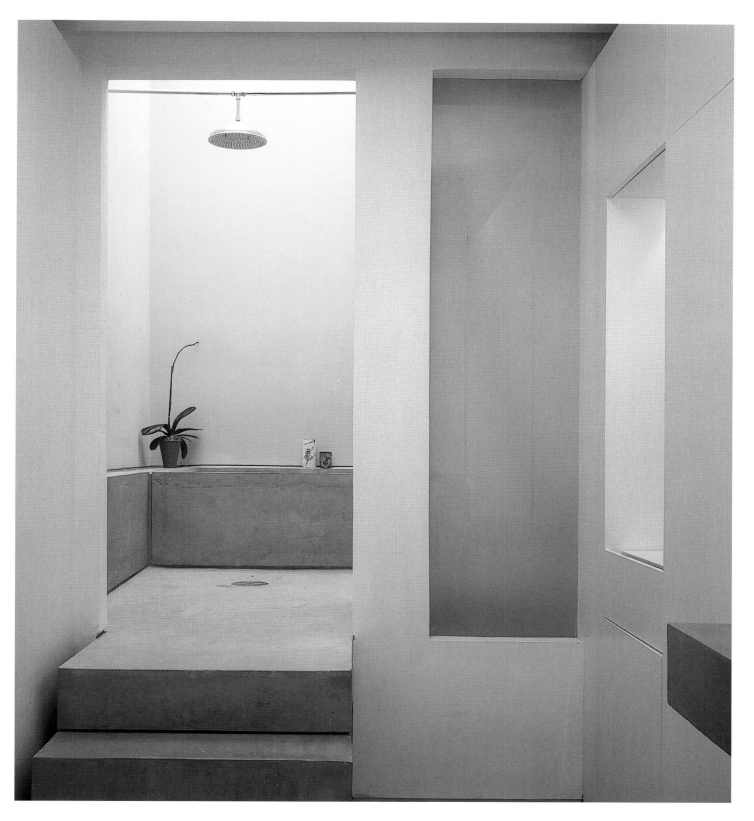

163

The structure steers clear of closed architecture. The roof is open to the exterior through the skylights, which add meaning to the space.

The exterior terrace, with its exceptional location on top of the building, is a refuge for relaxing in the light on sunny days.

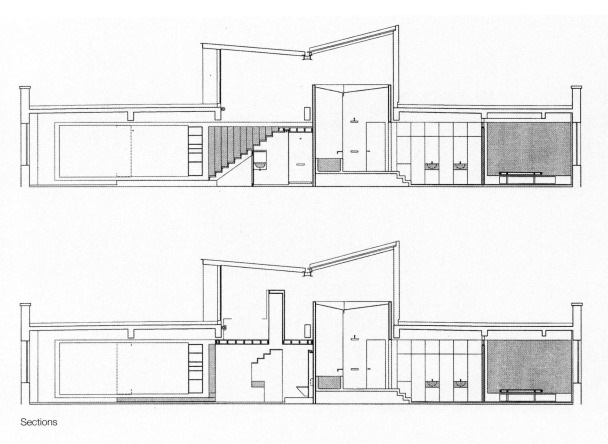

Sections

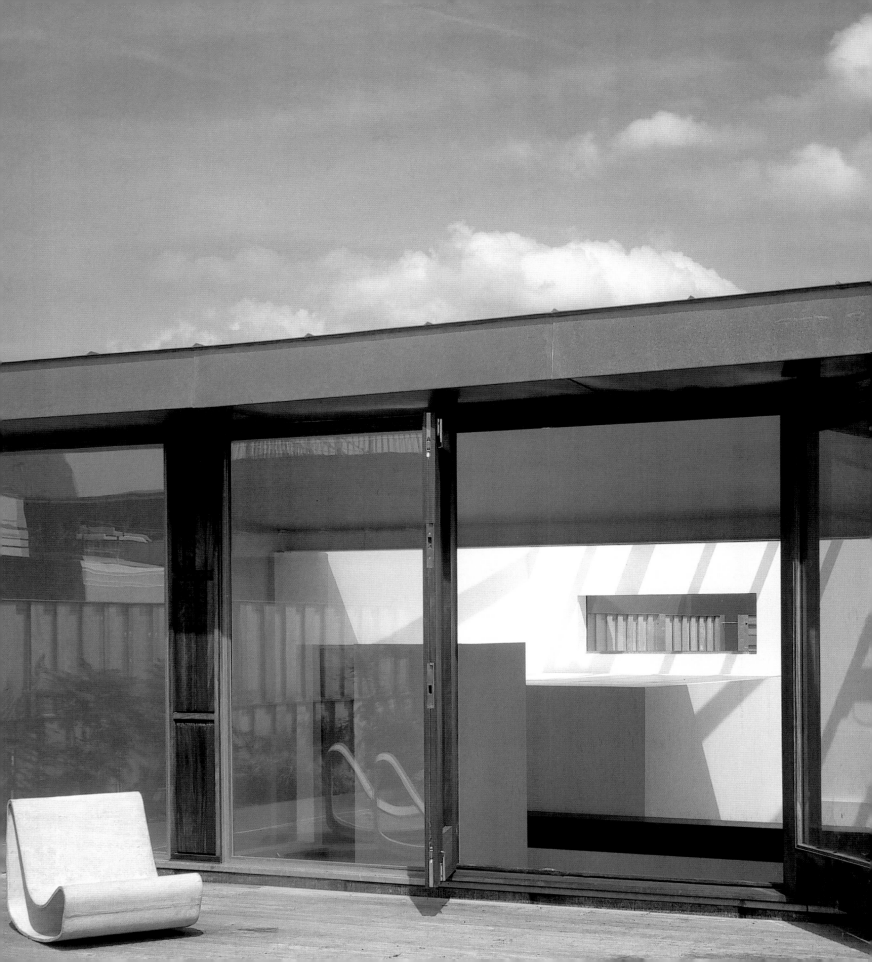

PERKINS RESIDENCE

The original structure of this loft, located in the SoHo neighborhood of New York City, allowed it to be converted into a two-level residence. The main objective of the project was accomplished by connecting both levels with a white staircase with outlined steps that climbs to the loft on the top floor. The client suggested connecting the two levels to improve the interior lighting, since the light comes in through the top floor and falls indirectly into the living space, which also captures the natural light that enters through the windows on this level.

The height of the ceiling and the amount of space within the peripheral walls on the first level permitted a free and calculated arrangement of the living room, the dining room, and the kitchen in the single space. This space trilogy is rationally distributed in the very vertical interior. The white walls increase the feeling of luminosity, and the wide range of materials used blends perfectly with the furniture and its predominantly dark colors. The contrast imparts transparency to the setting, where the most imposing details stand out from the least recurrent ones.

ARCHITECT: **A + I Design Corporation**
PHOTOGRAPHER: **Lily Wang Photography**

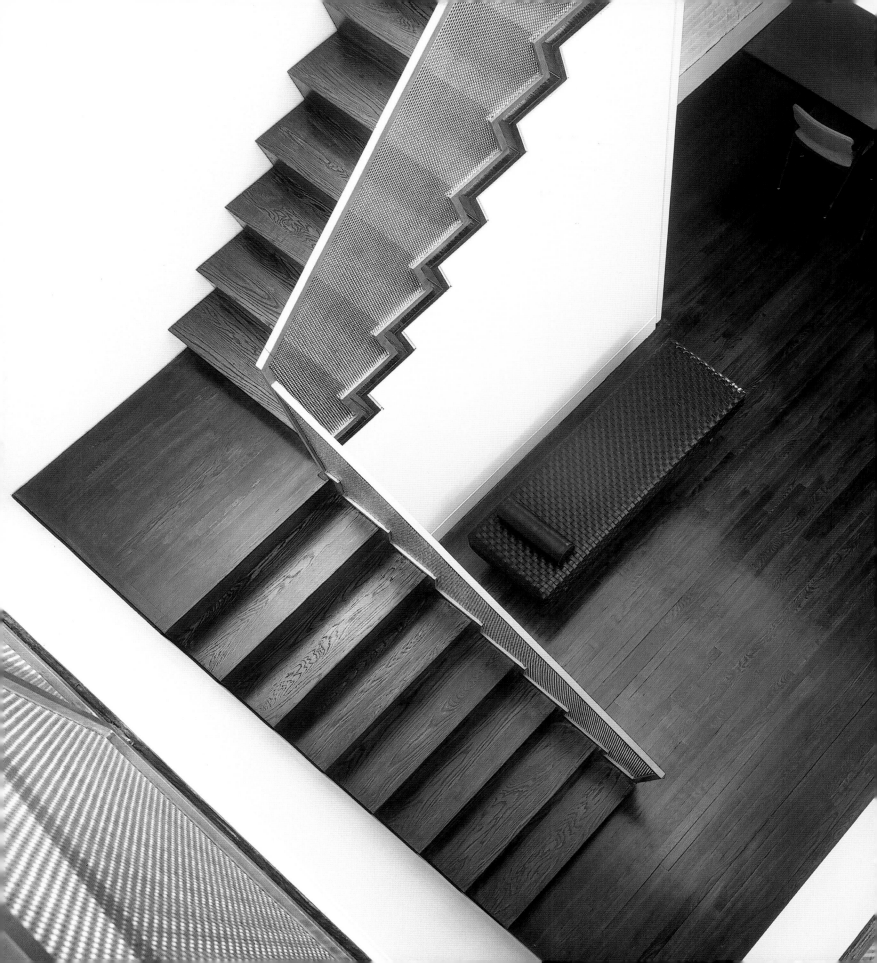

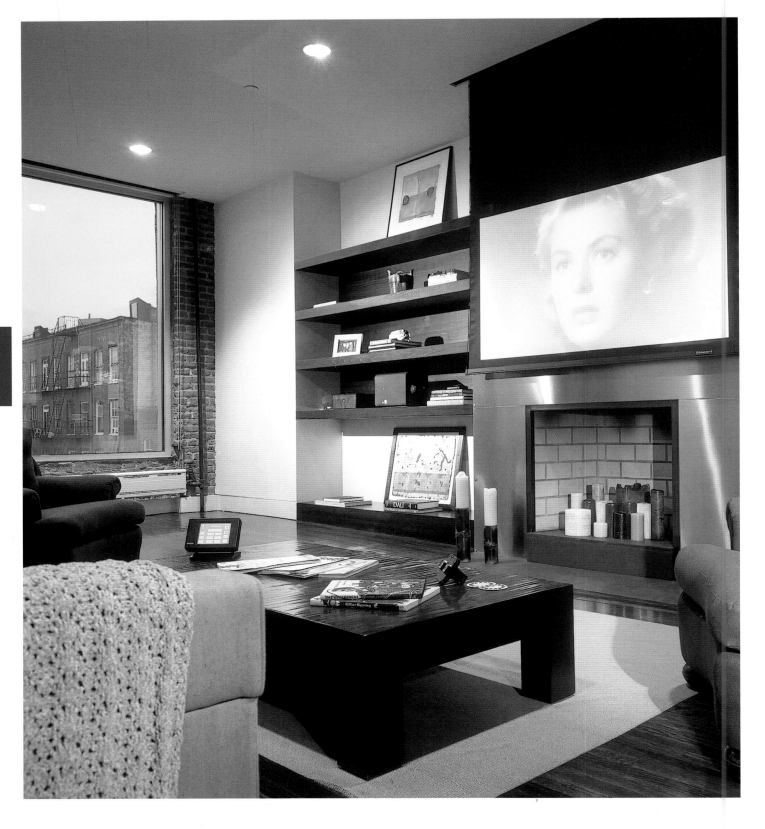

A white staircase with an outline of each step climbs to the second level of the loft.

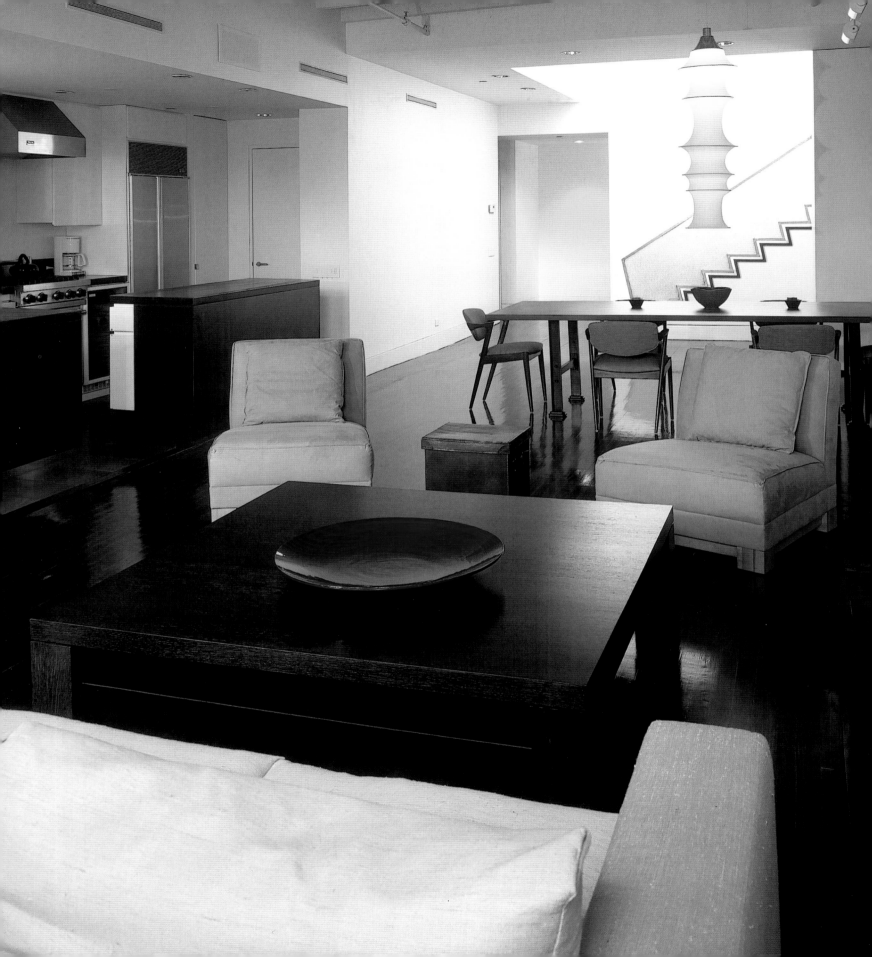

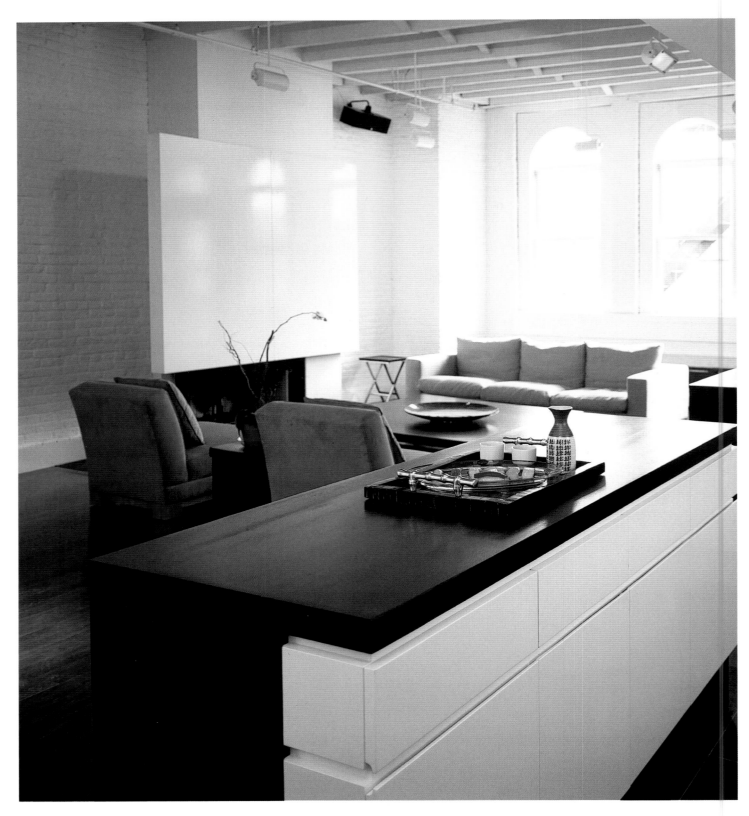

On the top floor, the design and distribution of the rooms is planned to allow light to enter and add richness to the spaces.

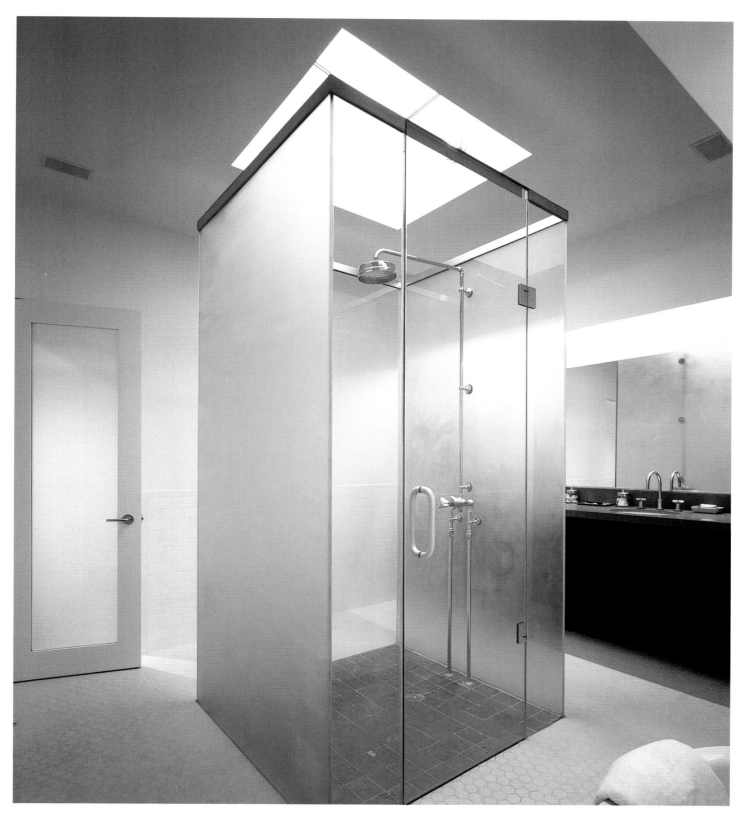

A glass screen surrounds the shower and extends to the skylight above, which channels the light flowing downward.

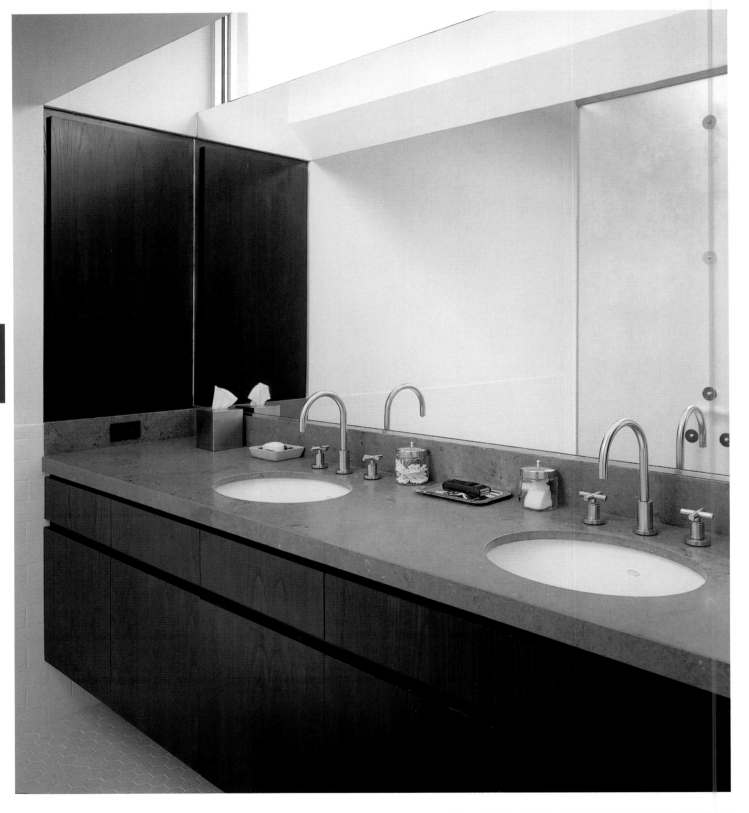

A few details, like the play of lines on the entrance wall, accentuate the vertical feeling of the apartment.

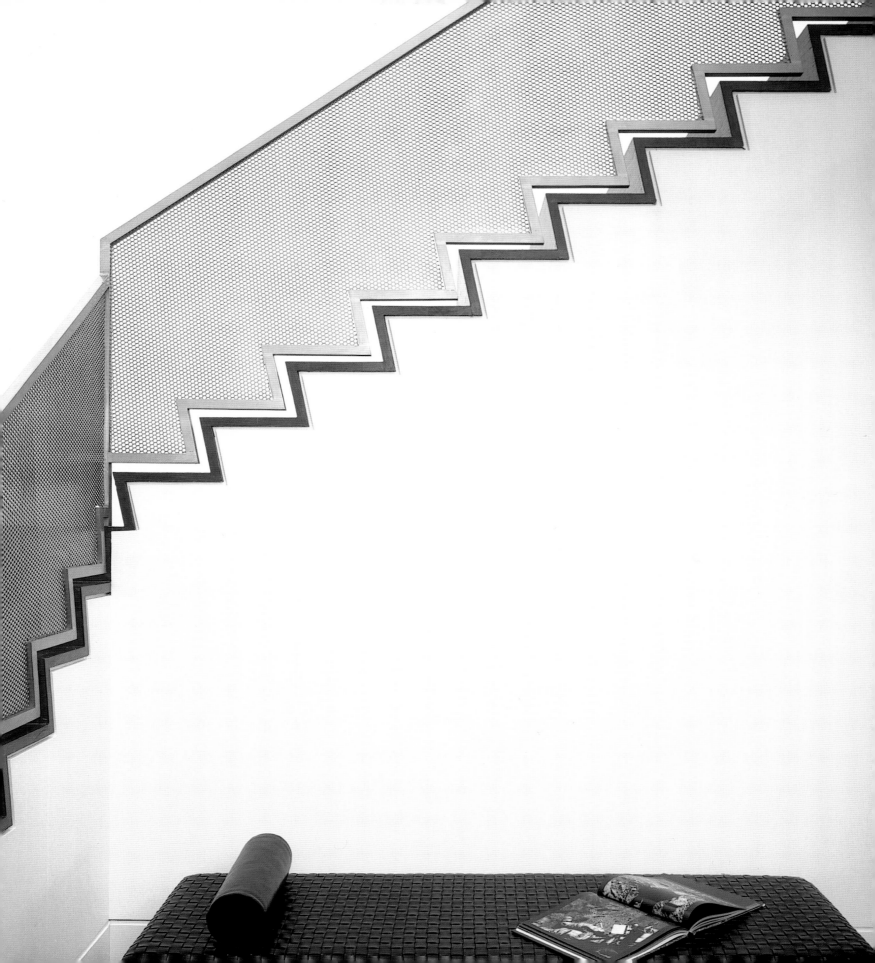

directory

A + I Design Corporation
125 Fifth Avenue
New York, NY 10003, US
Phone: +1 212 460 8920
Fax: +1 212 460 5951
dag@aplusi.com

AIA Albert Salazar/Joan Carles Navarro
Pl. Sant Pere, 3, bajos
08003 Barcelona, Spain
Phone: +34 93 412 05 14
Fax: +34 93 317 41 81
www.arquitectoniques.com
iabcn@arquitectoniques.com

Architecture WORKSHOP
2-14-21 bf, moto-azabu
Minato-ku, Tokyo
106-0046, Japan
Phone:+81 3 5449 8337
Fax:+81 3 5449 4822
www.archws.com
hasama@archws.com

Buschow Henley Ltd
27 Wilkes Street
London E1 6QF, UK
Phone: +44 (0) 20 7377 58 58
Fax: +44 (0) 20 7377 12 12
www.buschowhenley.co.uk
studio@buschowhenley.co.uk

CASA Akira Sakamoto Architect & Associates
1-14-5, Minamihorie
Nishi-ku, Osaka
550-0015, Japan
Phone: +81 06 6537 1145
Fax: +81 06 6537 1146
www4.ocn.ne.jp/~sa-akira
sa-akira@oregano.ocn.ne.jp

Cha & Innerhofer Architecture & Design
611 Broadway, suite 540
New York, NY 10012, US
Phone: +1 212 477 6957
Fax: +1 212 353 3286
www.cha-innerhofer.com
mail@cha-innerhofer.com

De Architectengroep/SeARCH
Hamerstraat 3
1021 JT Amsterdam, The Netherlands
Phone: +31 (20) 7889900
Fax: +31 (20) 7889900
www.searcharchitects.nl
search@bjarnemastenbroek.nl

Endo Shuhei Architect Institute
Domus AOI 5F 5-15-11 Nishitenma
Kita-ku Osaka, Japan
Zip 530-0047
Phone: +81 (0) 6 6312 7455
Fax: +81 (0) 6 6312 7456
www.paramodern.com
endo@tk.airnet.ne.jp

FOB Architecture
34-3 Tanaka Todo Uji-shi
Kyoto 611-0013, Japan
Phone: +81 774 20 0787
Fax: +81 774 20 9888
www.fob-web.co.jp
info@fob-web.co.jp

Graftworks
1123 Broadway, suite 715
New York, NY 10010, US
Phone: +1 212 366-9675
Fax: +1 212 366 9075
www.graftworks.net
info@graftworks.net

Guillermo Arias
Cra. 11 n° 84-42
Bogotá, Colombia
Phone: +57 1 2579501
Fax: +57 1 5312810
www.octubre.com.co
garias@octubre.com.co

IN Creació d'Espais Interiors, S.L.
Avda, Pi i Mragall, 81
08140 Caldes de Montbui
Barcelona, Spain
Phone: +34 93 865 50 69

Littow Architectes
96, rue Boileau
75016 Paris, France
Phone: +33 1 45 27 02 20
Fax: + 33 1 45 27 02 25
www.littowarchitectes.com
pekkalittow@littowarchitectes.com
sophiecabanes@littowarchitectes.com

Michael Strobl. Architect
Rottmayrgrasse 23
5020 Salzburg, Austria
Phone: +43 662 872108
Fax: +43 662 872366
www.michaelstrobl.at
office@michaelstrobl.at

N Maeda Atelier
Glass House 1F, 1-9-5 Izumi-Honcho
Komae-shi, Tokyo
201-0003, Japan
Phone: +81 3 3480 0064
Fax: +81 3 5438 8363
www5a.biglobe.ne.jp/~norisada
norisada@sepia.ocn.ne.jp

Propeller Z
Mariahilferstrasse 101/3/55
1060 Vienna, Austria
Phone: +43-1 595 2727 0
Fax: +43-1 595 2727-27
www.propellerz.at
mail@propellerz.at

Querkraft
Mariahilfer Strasse 51
1060 Vienna, Austria
Phone: +43 1 548 77 11
Fax: +43 1 548 77 11-44
www.querkraft.at
office@querkraft.at

Rogers Marvel Architects PLLC
145 Hudson Street Tirad Floor
New York, NY 10013, US
Phone: +1 212 941 6718
Fax: +1 212 941 7573
www.rogersmarvel.com

Studio Aisslinger
Oranienplatz 4
10999 Berlin, Germany
Phone: +49 0 30 315 05 400
Fax: +49 0 30 315 05 401
www.aisslinger.de
werner@aisslinger.de

Tele-Design.Collaboration Network
Open Studio NOPE
2-12-5 Mita Minato-ku
Tokyo 108-0073, Japan
Phone: +81 3 3769 0833
Fax: +81 3 3769 9893
www.tele-design.net
tele-web@tele-design.net
tajima@tele-design.net